# ON THE TRAIN TRACKS

## FILMING OCTOPUSSY & GOLDENEYE AT NENE VALLEY RAILWAY

MARC HERNANDEZ

ISBN: 978-90-833387-0-5

Published by DMD Digital
www.onthetracksof007.com

Written by Marc Hernandez

Foreword written by John Glen

Designed by Martijn Mulder
Edited by Simon Firth & Martijn Mulder
Cover photos by Chris Pinion

*"I was less than 3 years old when I was lifted from the platform and onto the footplate of an engine. It could have only lasted a few minutes, but the power of steam had entered my soul."*

Rev. Richard Paten (1932-2012)
Founding Father of the Nene Valley Railway

For Helen, David, Samuel and Louisa.

*Always says yes to adventure..,
especially if it's on a clownbound train.*

# CONTENTS

# FOREWORD

## BY JOHN GLEN

Out of the five James Bond films I directed, I think *Octopussy*'s one of my best films. I remember watching it again in 4K in 2013, in Sweden, at an event and it looked fantastic. I hadn't seen it for years, but I sat there and thought, 'Did I do that?!' Did I make this?!'

Normally you look at one of your old films and you think, 'I should have done this, I should have done that. Held that shot longer, or not held it long enough there' - but on *Octopussy*, I couldn't find a fault. I just sat there, looked out and thought I must've been on the top of my game when I made it because it flows beautifully and has lots of humour. The train scenes we shot at the Nene Valley were really a throwback to my childhood watching Saturday morning pictures, but trains have always been an important part of James Bond, stretching back to *From Russia With Love* with Sean Connery and Robert Shaw in the famous hand to hand fight sequence.

When we came to film the circus train scenes for *Octopussy*, the Nene Valley Railway was ideal for us doubling as East Germany, where steam was still order of the day. We had wonderful cooperation from everyone at the railway when we came to film those lovingly restored locomotives and carriages.

I did a lot of films with Roger Moore in my career. In fact at one stage he turned around to me and said, 'Am I in your contract, or are you in mine?!' and Roger was such a laugh - you only have to mention his name and you smile. It's such a shame he's no longer with us, but he was a good lad, ol' Rog.

The Nene Valley proved such a good location that after I'd moved on as a director, it was used in *GoldenEye* with Pierce Brosnan. In a funny sort of way, I had a hand in that because I shot the screen tests for Pierce some eight years previously. They pulled the tests out of the vault to view before he eventually got the job and he made a very good Bond.

I don't often return to filming locations, but I've been back to the Nene Valley on several occasions. It's a lovely part of the country and I'm delighted the railway's still going strong. They've got a good set up there and - as you'll find out - Marc's discovered quite a story.

John Glen
Film Director
2022

# PROLOGUE
## 007 SETS SIGHTS ON FERRY MEADOWS

*Peterborough Evening Telegraph, 14 June 1982*

BIG screen blockbuster James Bond is heading for Peterborough later in the year for location work for the multi-million pound film 'Octopussy'. It's the latest in the series of all-action movies from the Bond stable, and studio chiefs have decided to film some of its location work on the Nene Valley Railway.

The line has been featured many times in television films and series but this is the first time it has broken into the world of the big screen.

"And what a way to start!" said NVR publicity officer John Jeffrey.

"This is the biggest thing we have ever been involved in and may be the big break we have been looking for. The publicity value of a link like this is enormous".

Details about the film and what will be happening on the line between Peterborough and Wansford are scarce - as with all other Bond films, the makers, Eon Productions are keeping details of the plot and the fabulous stunts the films have become famous for very close to their chests. A spokesman would only confirm that the Nene Valley Railway was being used as a location set for the film, but Mr Jeffrey said the local line with its stations at Wansford and Ferry Meadows, Peterborough may be dressed up as a railway behind the Iron Curtain and it is believed that Eon is building a mock-up of the infamous Berlin Wall at Ferry Meadows.

Mr Jeffrey said "All we really know is that work on building sets will start sometime this summer for filming to start in the autumn. Apart from the fees we will earn for renting the line to the film company, we may also get extra bonuses for equipment".

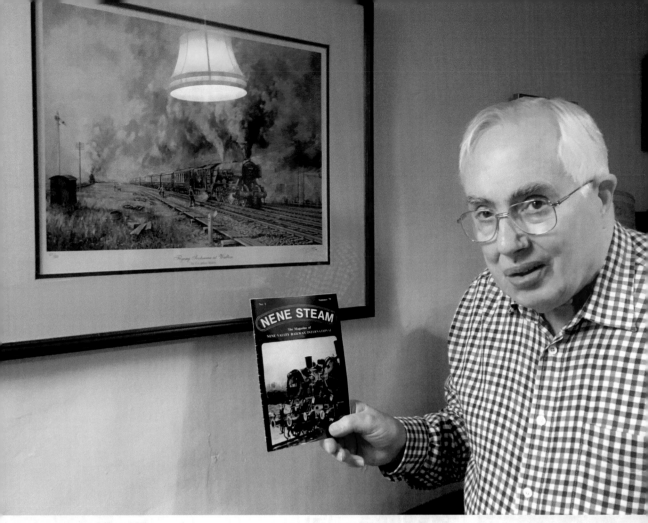

John Jeffrey with issue 1 of Nene Steam from 1979

## *Nene Steam – The Magazine of Nene Valley Railway, Issue 10 – Summer 1982*

The big news from the Editor's desk is that the railway has landed its first major 'big screen' film contract. Eon Productions have chosen our railway for scenes in the latest 'James Bond 007' epic 'Octopussy'. Work will begin on set construction in August and filming will take place during September. Details of the extent of our involvement are still being worked out but it is already clear that we will be involved in manning the railway for seven days a week for at least two months. We will therefore need all the assistance that you, our members, can give. Can you spare half a day or half a month to help out? If you can spare some time, please contact our GM John Pentlow at Wansford, or the appropriate Departmental Manager as soon as possible.

We would like to be able to roster all the duties from loco to refreshments, for the entire period of the contract so please contact us now.

John Jeffery
Press Officer/Editor

# INTRODUCTION  A SECRET LOCATION

The sight and sound and smoke of a steam train are unmistakeable at any time of day; three measures of engineering, one of craftsmanship and half a measure of nostalgia.  It's an intoxicating mix that's left generations of warm-blooded men, women and children shaken and stirred as they've steamed along railways across the world.

This is the story of how the Nene Valley Railway (NVR) – a preserved, heritage railway in Britain that operates over 7 ½ miles of track, 72 miles north of London became a filming location and the role it played in two James Bond films, one Ian Fleming bio-pic and a drinks commercial starring a future 007 actor.

The stretch of track that forms the Nene Valley Railway was originally a much larger railway line that ran 47 ½ miles across the Nene Valley, from Northampton to Peterborough. Built in the years 1843 and 1844 and following closely the route of Britain's 10th longest river (the Nene), it opened on 2 June 1845 and became essentially a branch line. It allowed Peterborough and Northampton to be connected by rail for the first time with various stations in towns and villages along the line, and then on to London's Euston railway station.

The Northampton-Peterborough railway line operated until 1964 before becoming a casualty of Dr Beeching's scything report on railway modernisation. The last passenger service along the full route ran on 2 May 1964, with a small section of approximately 10 miles to be given a reprieve and kept open between Oundle and Peterborough for freight and occasional school trains. This lasted until November 1972 before British Rail closed the remaining stretch completely.

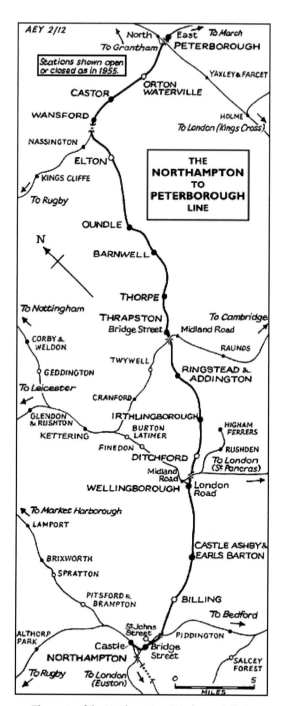

The route of the Northampton-Peterborough Railway, the first railway through the Nene Valley. NVR Archives

To mark the occasion over 300 people went on the last train, a specially chartered diesel return service from Peterborough to Oundle. Many on board were hoping to find a way to preserve at least part of the railway and would become founding members of the Nene Valley Railway when it opened in 1977, a few miles from Oundle at Wansford and running to Orton Mere, Peterborough

I grew up in Oundle, a small market town, which we always pronounced *Oun-dull* due to how unexciting it felt. The old railway station building was on the edge of town and in 1982 was run down and abandoned but not entirely forgotten. It had been built to the same design and layout as the one at Wansford (which became *Karl-Marx-Stadt* during the *Octopussy* filming). One of my school friend's parents ran *The Riverside* pub opposite and during the school summer holidays, when the haulage firm that had taken over the railway goods yard were all out, the station building became the backdrop of a cricket pavilion where we staged our own Test matches, and games of 'Wembley' football. The station building was eventually restored in the late 1990s and is now a private house, surrounded by a small housing estate on what was the railways good yard and coaling area.

When the NVR first opened, I remember being taken there as it had piqued my grandad's interest. Years earlier he'd travelled on part of the original railway line during World War II whilst he was stationed at RAF Woolfox and RAF North Luffenham which were off the Great North Road a few miles away. Steam gala weekends during the summer months and the Santa Special around Christmas were particular favourites whilst I was growing up. There was just something irresistible about being around the mighty locomotives and smaller engines. Whether thundering down the track with steam billowing, simmering on the platform or oil stained and weather beaten in the yard, the railway was looked after by scores of skilled men and women who volunteered their time. Dedicated, passionate and all with Nene Steam in their blood! They'd either worked on the British Railway network prior to steam disappearing at the end of the 1960s or had been young train spotters – each with a desire to keep steam alive and preserve the past for future generations.

Oundle Station, 1972.
NVR Archives

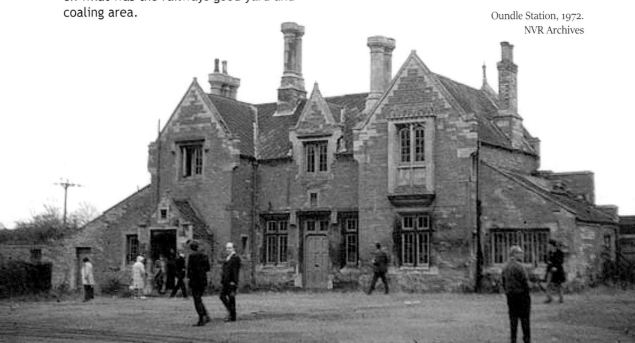

It was during a visit to the railway in August 1982 that I saw the set of the East German border crossing point being built for use in *Octopussy*. I stood gazing up at the 20ft high watchtowers looming over me. They looked awesome and ominous, hideous and beautiful. I'd been allowed to stay up late a few months earlier when *The Spy Who Loved Me* was on TV one evening; this was the first time I'd seen a Bond film after previously capturing glimpses of the films in TV commercials.

I have a vague recollection of sneaking around the station platform shaping my fingers and thumb into a gun shape and playing Blocky 123 (an eighties version of hide 'n' seek) with other local kids, but all these years later I now spend my spare time as assistant editor of the railway's magazine *Nene Steam*, shaping my fingers and thumb in order to write articles, or brushing biscuit crumbs off my Hewlett Packard keyboard.

Since opening, the railway's main source of income has come from running public trains, but due to its unique nature the NVR has been used as a filming location over 100 times in various films, TV shows, music videos and commercials. Towering above them all though is its association with the world of James Bond. The filming of the train scenes in 1982 for *Octopussy* were like nothing ever seen at a preserved railway in the UK, as was the explosive tank vs train sequence for *GoldenEye* in 1995.

Run on a charitable status the NVR employs a small number of paid staff, but like many heritage railways is supported by a large band of members and volunteers of all ages who give their time to help keep the railway running.

I'm also pleased to be keeping the NVR's connection to Oundle going. I used to ride my flame-red Raleigh Grifter past the house of Nene Steam's first ever editor, John Jeffery, in the town on my way home as a teenager. Usually, it was after being taught GCSE English by another John (Rhodes) who worked as a signalman at the NVR in the early years. He also wrote the first ever book about the history of the railway in 1981, and did a couple of shifts in the Wansford signal box whilst *Octopussy* was being filmed. A few steps away from where John J was producing *Nene Steam*, I had a weekend job in the 'B-F Video Library' on North Street, where I'd regularly put a Bond double-bill on in the background once the British TV programmes, *Going Live* and *Saint & Greavsie* had finished.

The current route of the Nene Valley Railway. NVR Archives

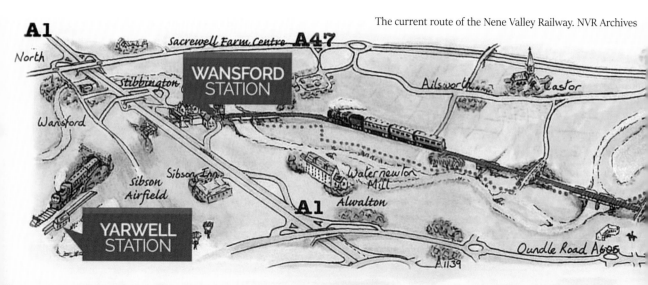

Interestingly, the guy who ran the video shop and would often leave me in charge whilst he went off to play Saturday afternoon football shared the same name as someone I'd often see on the opening titles of a Bond film. John Richardson – the special effects designer/supervisor! I remember on the day the video shop closed for good, John paid me an extra £10 which I then spent in the book shop around the corner buying *The official 007 Fact-File* book by Richard Hollis.

For me, there's no doubt that Martijn & Dirk's original *On the Tracks of 007* guide in 2008 was the start of helping bring the railway back to the attention of Bond fans. Many have found time to visit since and discover that the key areas used for filming haven't changed that much.

But there's a bigger story to tell and that's where this book comes in. So, jump on board, find a seat and get ready for a journey back in time!

Marc Hernandez
Assistant Editor
*Nene Steam Magazine*
2023

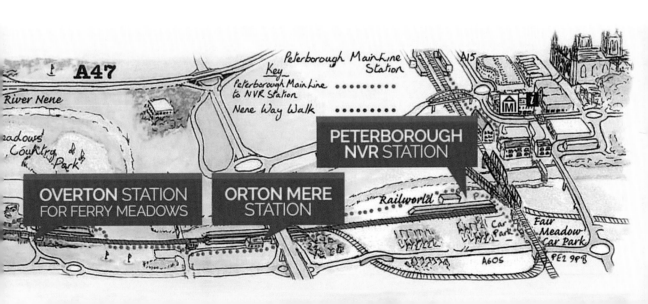

# 1 INTO THE VALLEY

It's August 1968 and British Rail are in the final stages of phasing out steam train services across the country. Their remaining workable steam engines are based in Manchester and destined to be scrapped. In a race against time, Peterborough clergyman, the Reverend Richard Paten, makes a daring 330 mile round trip to try and save one...

A former civil engineer, Rev. Paten was both a man of the cloth and the oily rag, trundling up north behind the wheel of his trusty Morris Minor 1000. He arrived at the Patricroft depot in Manchester with Horace Botterill, chief mechanical foreman of the New England rail depot, Peterborough (close to what's now the East Coast mainline from London Kings Cross to Edinburgh, Waverley.) They examined the sorry state of the run-down locomotives on offer with one standing out from the rest. A BR standard class 5, numbered 73050 that had been given an overhaul three years earlier. Built in 1954 during its mainline service it had hauled both fast passenger trains and slower freight trains on the Somerset and Dorset line, and at one point headed up *The Pines Express*, a passenger service that ran between Manchester and Bournemouth.

Rev. Paten agreed to buy it from BR with £3,000 of his own money, equivalent to roughly £52,000 nowadays, paid a deposit and headed home. Recording the moment for posterity in his diary with "It was quite a terrific day!"

A few weeks later, on the evening of Thursday 19th September 1968, he had it delivered. Initially BR had insisted it be transported by road due to the steam ban on their tracks, however, they agreed to make an exception after Rev. Paten used all his powers of persuasion. He noted dryly afterwards... "I couldn't move a 140-ton loco by road when there was a perfectly good railway route for it to run on."

It was a night that could have come straight from the pages of a spy thriller or possibly an Ealing comedy, with BR insisting that it travelled to the Reverend under the cover of darkness. Heaven forbid anyone should see a steam engine in daylight hours!

So up in Manchester it came by rail, via Wakefield, Doncaster and down the East coast main line. It even went over the metal stretch of rails that the elegance of Sir Nigel Gresley's streamlined Mallard travelled on when it captured the world record for steam on 3 July 1938 - 126mph at Stoke Bank between Grantham and Peterborough; a record that still stands to this day.

Unlike Mallard, the journey made by Rev. Paten's locomotive was achieved at slightly less speed, amid great secrecy and with him having to decline the chance to travel on the footplate as he had a pre-arranged community relations meeting that night.

And so it came to pass - that a month after the last official steam train had operated on Britain's rail network, a Thursday night Thunderbolt arrived in the city of Peterborough, pulling into the New England depot at 11.40pm.

Inspired by similar groups of enthusiasts who'd rescued steam engines and taken over abandoned lines, plans began to form to open a 'Nene Valley Railway' line on part of the original 'Nene Valley' route into Peterborough. In 1971, Paten's 73050 locomotive was moved to British

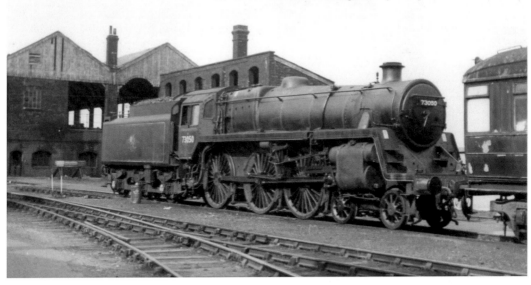

Sugar's factory sidings off Oundle Road, Peterborough adjacent to what would become the Nene Valley Railway with other smaller engines and railway stock arriving.

Slowly but surely plans for a 'Nene Valley Railway' were taking shape, boosted by a visit from another Reverend, Rev. Wilbert Awdry, author of the *Thomas and Friends* books.

He was invited to a steam day held in 1972 as a small blue tank engine that used to haul sugar beet around the factory was now under the volunteer's care. Due to its likeness to the one in Rev Awdry's books he agreed to name it 'Thomas', unveiling a metal plaque on the engine with a 'Thomas' faceboard attached to the smokebox.

Rev. Awdry had started writing the stories initially for his son Christopher and went on to publish 26 books in the series from 1947-1972. After Rev. Awdry retired, Christopher was inspired by a visit to the NVR and, with his father's encouragement, continued the book series from 1983-2011.

Between 1972-1977, the founding members of the NVR began to build up a head of steam as the dream of opening their own railway was in sight.

Due to a shortage of workable British steam engines, one member of the Peterborough Railway Society offered the use of his ex-Swedish steam locomotive No 1928.

Rev W Awdry in 1972 at a pre-NVR steam day with volunteers. NVR Archives

engine couldn't be used on the line as it was, but a feasibility study concluded that with some platform alterations and the removal of one small private bridge, the Nene Valley line could accommodate both continental and British stock. The decision was made and the NVR became the first preserved UK railway able to operate continental steam trains.

With Rev. Richard Paten as the NVR's founding chairman, the land around the old Wansford station which had been built between 1844-1845 on the original Nene Valley line, became the NVR's main base of operations. On 1 June 1977 it carried the first passenger train with two locomotives doing the honours, Swedish locomotive No. 1178 that would later 'star' in *Octopussy*, and French Nord 4-6-0 No. 3.628, which would later be used in a memorable drinks commercial on the NVR in 1987 starring Pierce Brosnan.

Continental locomotives and carriages had been built to a larger size than their British equivalent, operating on what was known as the 'Berne loading gauge'. It meant the

It had been a huge achievement to get the Nene Valley Railway open, but now an even

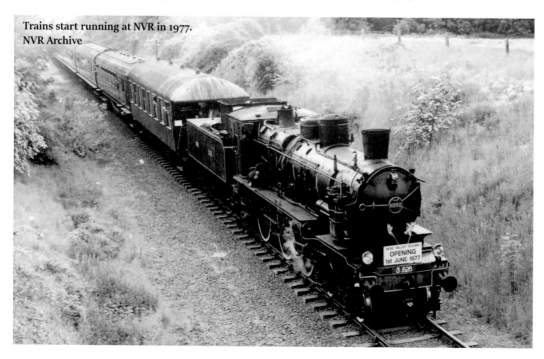

**Trains start running at NVR in 1977.
NVR Archive**

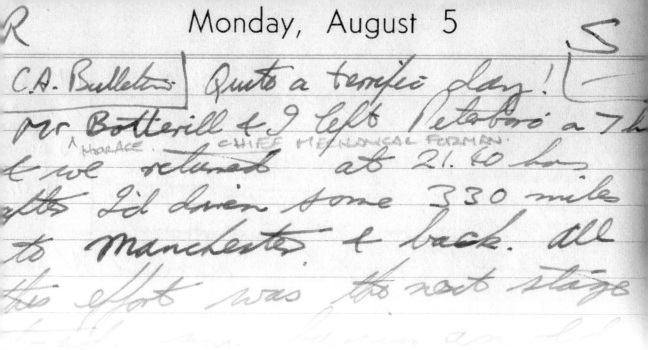

Page from Rev Paten's diary recording the day he bought a steam engine. NVR Archive

bigger one lay ahead; to attract enough visitors to make it financially viable. An unforeseen benefit of being able to operate continental steam trains meant that the NVR got onto the radar of TV producers looking to film train scenes that were set in Europe. The NVR's first use as a filming location was for the BBC drama *Secret Army* (1977-1979), set during World War II. It told the gripping story of a fictional resistance group called 'Lifeline' who organised the return of Allied airmen. The first series in 1977 had used some of the surrounding fields, woodland and farm buildings in the villages of Yarwell and Water Newton close to the NVR. Series one included the actor Christopher Neame who went on to play 'Fallon', the MI6 agent in *Licence To Kill* (1989). In *Secret Army* he played John Curtis, a British SOE liaison officer who coordinates activity with 'Lifeline' and is pursued by the Gestapo.

It was during series 2 in 1978 that the NVR featured on screen in five episodes. From members of the resistance meeting at railway stations, an RAF Mosquito attacking a train, saboteurs planting explosives on the tracks and characters trying to avoid German checkpoints.

Then the following year the NVR was used again by the BBC for *Airey Neave: Will Of Steel* – a documentary made in tribute to the Conservative Party MP. He had been the first British Officer to escape from Colditz Castle in 1942 and a dramatised recreation of his escape to reach safety by train and on foot was made with the actor Clive Francis playing 'Neave'.

A crew from Granada TV then came to film scenes for *Gossip From The Forest*, a television adaptation of a book based on the World War I peace talks. Actors Vernon Dobtcheff - Max Kalba in *The Spy Who Loved Me* (1977), John Hollis – *For Your Eyes Only* (1981) and David Calder – *The World Is Not Enough* (1999) were among the cast, but - as with the *Will Of Steel* documentary - neither programmes appear to have survived from their transmission dates to live on in the digital era.

The next three programmes, all filmed in 1980, thankfully have survived. *Caught On A Train*, a BAFTA award winning BBC television play by Stephen Poliakoff, the BBC TV mini-series *Fair Stood The Wind For France* set during WWII and ITV's *Love In A Cold Climate*, an 8-part period drama set between 1925-1940.

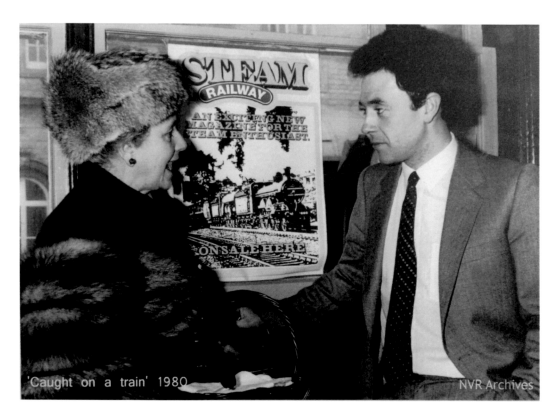

'Caught on a train' 1980     NVR Archives

*Caught On A Train* was first shown on
31 October 1980 on BBC2, and starred
Dame Peggy Ashcroft and Michael Kitchen
who'd later appear as Bill Tanner in two
Bond films, *GoldenEye* and *The World Is
Not Enough*. The story centred on a train
journey across Europe with much of the
filming taking place inside Wagon Lits
sleeping car No, 3916, bought specially by
the BBC and passed into NVR ownership as
part of the filming contract. It was then
used to make up the *Octopussy* Circus Train
in 1982.

The NVRs 'Thomas' then made an
appearance in a 1981 live outside
broadcast by presenter Keith Chegwin for
the BBC Saturday morning children's show
*Multi-Coloured Swap Shop*. This led to
another BBC show *Jim'll Fix It* using the
railway for the first of two visits. The later
disgraced host of the programme never set
foot at the NVR.

The railway next became a junction south
of Moscow for the BBC TV film *Russian
Night 1941*. Based on the novel *An Incident
At Krechetovka Station* by Alexander
Solzhenitsyn, the 55-minute drama had the
working title, 'We never make mistakes'
inspired by the last line in the novel, and
starred Ian Richardson, Liz Smith and Paul
McGann. Sadly, it has never been reshown
or had a VHS/DVD release, the same fate
afforded to Q.E.D, a 6-part comedy drama
made by the American CBS TV network. It
was shown on ITV in the UK in early 1982,
and all the episodes including the one
using the NVR survive, albeit in the form
of grainy quality recordings uploaded onto
YouTube.

Set in Edwardian England, actor Sam
Waterston played American professor
'Quentin Everett Deveril', a sort of
scientific detective. The NVR was used
throughout the 4th episode called: *4.10
to Zurich*, which featured a cameo on
the NVR tracks by Julian Glover as the
villainous Dr Killkiss, one year after he'd
played Kristatos in *For Your Eyes Only*.

These were all noteworthy, but largely forgotten pieces of filming, some clearly faring better in hindsight than others. However, in mid-1982, after serving its TV apprenticeship, the NVR graduated and received a first; a contract with a film company, Eon Productions.

The arrival of a 200 strong film crew with the supporting cast and James Bond himself, Roger Moore, was about to surpass all that had gone before. It was September 1982 and the NVR was about to play its part in helping 007 stop a renegade Soviet general from starting World War III.

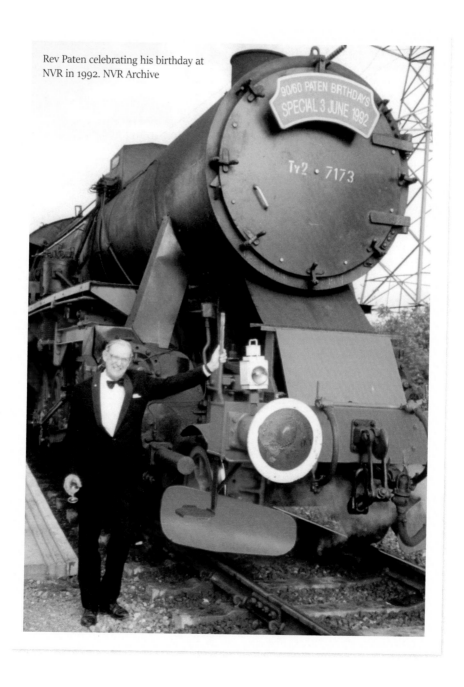

Rev Paten celebrating his birthday at NVR in 1992. NVR Archive

# 2  LET THERE BE BOND

Lasting the best part of 8 weeks, one week with the 1st unit under John Glen's supervision as director, and almost seven weeks with the 2nd unit, *Octopussy* became one of the biggest film shoots ever undertaken at a preserved railway.

The NVR General Manager at the time was John Pentlow. John has long since retired, but in his living room one morning over a cup of tea he relived what he thought was going to be just another ordinary day some 40 years ago.

"It all started one afternoon when I was sat in my office. There was a knock at the door. 'Come in!' I called out and in came this feller who said 'I'm the location manager for a film company'. All he said was that it involved a circus and steam trains, and they'd be needing three or four engines a day. At that stage I didn't know it was for James Bond, but I knew immediately it was a lot bigger than anything we'd ever done, He asked if we could meet up at a later date to talk it over properly, so I said 'That sounds perfect, I'll bring David Smith with me, one of the directors, and what I can't answer he will'."

David Smith had been one of the founding members of the NVR and a key speaker at the Peterborough town hall meeting in 1972 where the idea of a preserved 'Nene Valley' railway line was first discussed. As a chartered surveyor his expertise was invaluable during the railway's formation and early years, dealing with all the land, buildings and purchasing requirements. John continued:

"I rang David and then at the hotel at Norman Cross they went into a lot more detail. They told us that it was going to be a James Bond film, how long they wanted to use the railway for and the type of stock needed. David and I sat and listened, and after we drove back to Peterborough,

Smithy said to me 'What do you think John?' and I said 'What do I think?! It's a Bond film we've got to do it!' and that was how it started."

Being approximately an hour's drive by road from London, it made the ideal choice for Eon as with some clever alterations the NVR and its continental railway stock could be made to believably look like a railway running from East to West Germany. Life at the NVR for John and his colleagues was about to get very busy.

John Pentlow. Photo by Roy Harrison

"At first nobody believed me when I told them we were having a James Bond film made here. I can remember calling Sir Ivor Baker, who was chairman of the NVR board, and telling him that I couldn't come to the monthly meeting as I'd got my hands full with arranging all the details."

Sir Ivor Baker was a respected local industrialist, a chartered mechanical engineer and president of Baker Perkins, an Engineering company based in Peterborough since 1914, and one of the city's largest employers.

"Sir Ivor was most insistent I attend his meeting, so when I arrived he said: 'Now, come along John, you've had things filmed at the railway before, what's so special about this one? When I told him it was a James Bond film and the contract would be worth between £20-40,000, he nearly fell off his chair in shock and said, 'What are you doing here?! Get back to Wansford and sort it all out!'."

Talking with John it's clear that the film contract with Eon was one of the highlights of his time as NVR's general manager.

"Sir Ivor was really supportive about the whole thing, and allowed Gary Foster paid leave from his job at Baker Perkins so he'd be available throughout the filming. Gary was the Carriage and Wagons manager at the NVR in his spare time, but a trained engine driver so was there from start to finish working with the film crew."
John also went through some of the other members of the NVR from 1982.

"Alan Gladden was the shed master so responsible for all the locomotives, and to make sure they were ready before and during the filming. There was Malcolm Heugh, who was head of the NVR's S&T, Signals and Telecommunications; he'd worked for British Rail for years and what he didn't know about railways wasn't worth knowing. Roger Manns was our chief civil engineer, so looked after the actual track and ran the civils gang and various things that were needed. We then had various volunteers who took time off work to help out and I think Malcolm worked out the rota for everyone."

All four men had been founder members of the NVR and had laid, quite literally, a lot of the foundations for the railway in terms of the track, sidings and platforms which were now about to appear in a Bond film. Once John had agreed the contract for filming, there was then over a month of preparation required at the NVR, both by Eon's production team and NVR's working members.

"They started filming the first week of September, but we'd had a crew from Pinewood at the railway throughout August building and getting things ready. A false wall around the car park at Wansford, those big watchtowers at Ferry Meadows and all sorts of things to make the railway look like it was in East Germany. Our own Civils and PW (Permanent Way) gang were also involved with various aspects of the track, the tunnel and all the train stock that was going to be used. Nobody else had any continental locomotives or carriages in the UK like them and these were all made to look just like the ones that would've been running in Germany at the time."

The opening day's filming began on Monday 6 September 1982 with an early start for John.

"There were people everywhere. We all had to meet at 6 o'clock on the first morning, but I'd been awake since about 4!"

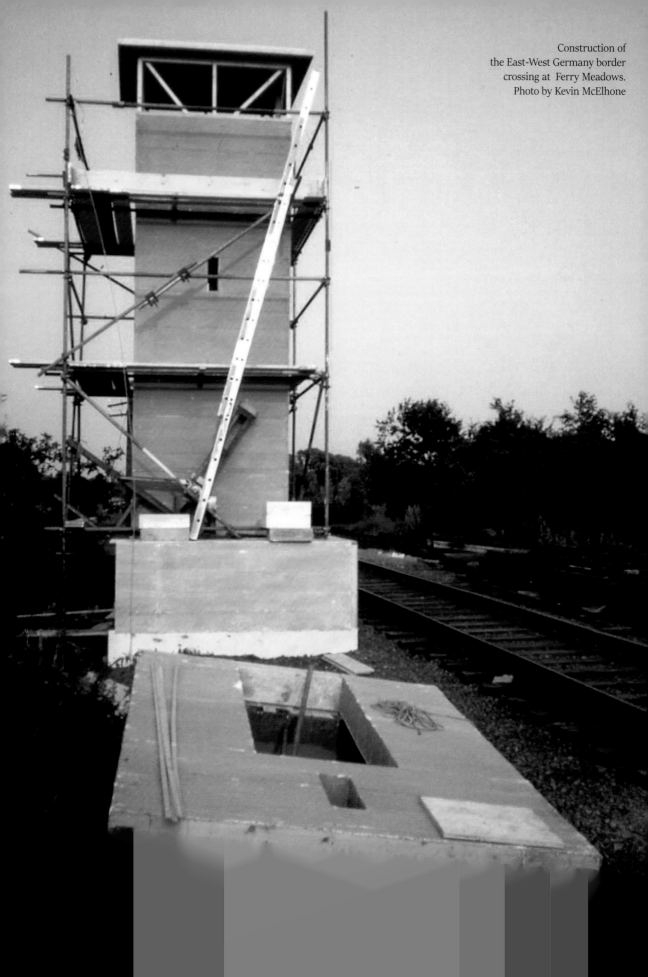

Construction of
the East-West Germany border
crossing at Ferry Meadows.
Photo by Kevin McElhone

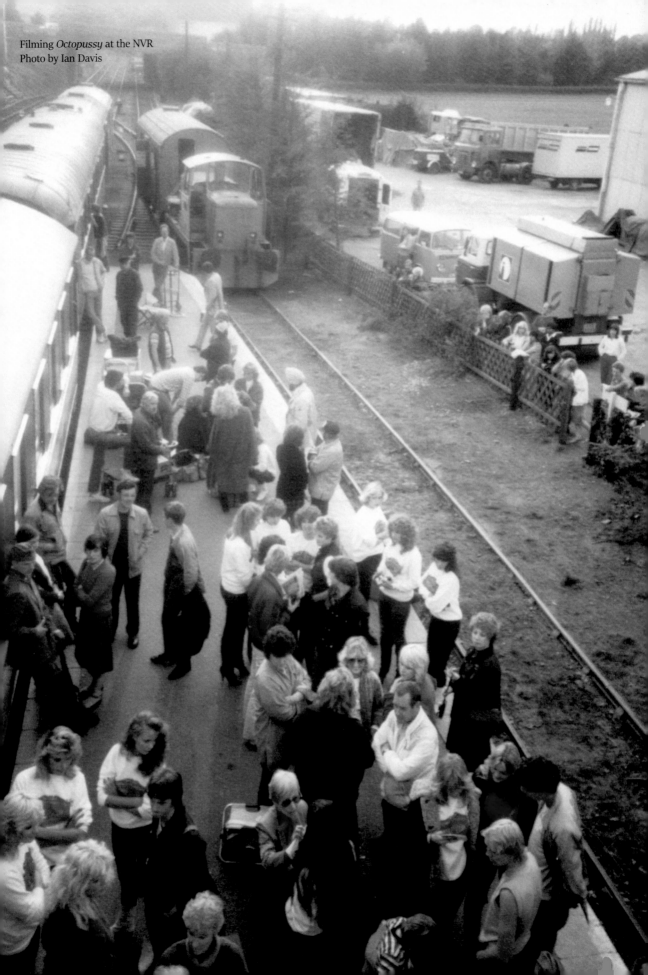

Filming *Octopussy* at the NVR
Photo by Ian Davis

PRODUCER: CUBBY BROCCOLI    DATE:    TUESDAY, 7th SEPTEMBER

DIRECTOR: JOHN GLEN    UNIT CALL:    07.30 Leave Hotel
        08.00 On Location

EXECUTIVE PRODUCER: MICHAEL WILSON

LOCATION: NENE VALLEY RAILWAY
Wansford Station
Stibbington
Nr Peterborough

Prod.Office: 0780 782437
Unit Office: 0780 782530

SET:
EXT. KARL MARX STADT STATION    SCENE NOS:
Carpark and Platform    596, 597, 598, 599, 626, 628, 629, 630, 631A, 642 to complete DAY

EXT. RIVER BANK    733 DAY

WEATHER COVER    633pt, 634, 635, 637, 638A, 638B,
INT. TUNNEL    638C, 638D, 638E, 641, 641A, 641B, 641C, 645A, 646, 655, 657, 680 DAY

| ARTISTES | CHARACTER | PICKUP | MAKEUP | ON SET |
|---|---|---|---|---|
| | | | 8.30 | 9.00 |
| ROGER MOORE | JAMES BOND | 7.00 | 7.30 | 9.00 |
| MAUD ADAMS | OCTOPUSSY | 8.00 | 8.30 | 9.00 |
| LOUIS JOURDAN | KAMAL | 8.00 | 8.30 | 9.00 |
| KABIR BEDI | GOBINDA | 7.00 | 7.30 | 9.00 |
| KRISTINA WAYBORN | MAGDA | 7.40 | 8.00 | 9.00 |
| STEVEN BERKOFF | ORLOV | | Standby at Hotel | |
| DAVID MEYER | TWIN 1 | 7.40 | 8.00 | 9.00 |
| TONY MEYER | TWIN 2 | | Standby at Hotel | |
| DERMOT CROWLEY | KAMP | | Standby at Hotel | |
| PETER ENSOR | KAMP's ASSISTANT | | To be advised | |
| WALTER GOTELL | GOGOL | | To be advised | |
| EUGENE LIPINSKI | VOPO HEAD | | | |
| SUZANNE JEROME | GWENDOLINE | | | |
| CHERRIE GILLESPIE | MIDGE | | | |
| ALLISON WORTH | OCTOPUSSY GIRL | | | |
| JAN MICHELLE | " | | | |
| JONI FLYNN | " | | | |
| MARIE FLISE | " | | | |
| LOUISE KING | " | | | |
| CHERYL ANN | " | | | |
| JANINE ANDREWS | " | | | |
| JULIE MARTIN | " | 5.30 | 6.00 | 9.00 |
| MARY STAVIN | " | | | |
| TINA ROBINSON | " | | | |
| SAFIRA AFZAI | " | | | |
| CAMELLA THOMAS | " | | | |
| CAROLYN SEWARD | " | | | |
| CAROLE ASHBY | " | | | |
| HELENE HUNT | " | | | |
| GINA GIOVANNI | JUGGLER | | | |
| VERA FAWCETT | JUGGLER | | | |
| ROBERTO GERMAIN | RINGMASTER | | | |

continued /

---

| STANDINS: | FOR: | |
|---|---|---|
| JAMES LINTON | ROGER MOORE | 7.30 leave hotel |
| JENNY ROBERTS | MAUD ADAMS | } |
| DAVID ATHERALL | LOUIS JOURDAN | } 8.00 on location |
| RICHARD HUNT | KABIR BEDI | } |
| A.N. OTHER | WALTER GOTELL | } |

| CROWD: | | |
|---|---|---|
| 10 MEN | VOPOS | 8.00 on location |
| 15 MEN | SOLDIERS | " " |
| 23 MEN | ROUSTABOUTS | " " |
| 2 MEN | LUG DRIVERS | " " |
| 13 GIRLS | OCTOPUSSY GIRLS | 7.30 on location |
| 20 MIXED | PASSERSBY | " " |
| 1 MAN | STATION MASTER | " " |
| 10 MEN | FISHERMEN | " " |
| 10 MEN | COUNTRY VOPOS | from above " |
| 1 MAN | GOGOL'S AID | from above " |

STUNT CO-ORDINATOR: BOB SIMMONS - 7.30 leave hotel.

STUNT DOUBLE:    FOR:

ROCKY TAYLOR    JAMES BOND    7.30 leave hotel

STUNTMEN:

JIM DOWDALL    ORLOV'S CHAUFFEUR    7.30 leave hotel

OCTOPUSSY GIRLS' CHAPERONE: BARBARA BROCCOLI: to standby with girls from 05.30 a.m.

ANIMALS:
Guard Dog and Handlers - 8.00 on location
2 Chimpanzees with Handler - 8.00 on location
6 Horses with Grooms - 8.00 on location
1 Elephant and Handler - 7.30 leave hotel

ACTION CARS:
Orlov's Car (Bond's Car)  )
Orlov's Command Car (Volgar)  )  To be available from
Military Vehicles  )  8.00 on location
Circus Vehicles  )

ACTION HELICOPTER:
Gogol's Helicopter to be on location at 8.30 a.m.

TRAINS & CARRIAGES / BOX CARS:
Circus Train  )
Lug  )
Jewellery Boxcar  )  To be available from 8.00 a.m
Bomb Boxcar  )  as per The Nene Valley Railway
Armoured Car Train  )
Crane on flat bed with engine  )

PROPS:    Jewellery Canister, Bond's Gun, Dummy Guns and Actual for soldiers, Vopos, 'Heavy's' with blanks, Circus Props, Weed, Fishing Rods, Radio Telephone, Ropes, Live Fish, Jewellery.

continue

---

John still has a copy of the call sheet from the 2nd day of filming that provides a fascinating insight into the scale of production taking place. Over 220 members of the cast and crew, along with approximately 100 extras, were at the NVR as it became *Karl-Marx-Stadt* railway station in East Germany.

"On top of all that, we had about 50 working members and volunteers on hand and a huge crowd of on-lookers; hundreds of people had come down to watch as well as members of the press, I'd never seen the railway as busy! There was camera equipment everywhere, lorries, army vehicles, circus equipment, cars, a helicopter; it was quite staggering, but of course I didn't have time to sit back and take it all in as there was always something I was needed for."

The opening day saw the principal cast of Roger Moore, Maud Adams, Steven Berkoff, Louis Jordan, Kristina Wayborn and Walter Gotell all on set, but it was the arrival of Roger Moore that everyone was waiting for.

"He arrived at the NVR around mid-morning and of course everyone wanted to meet him. I don't think I ever saw him turn anyone away for an autograph and June Sanderson, one of our volunteers, got to him to sign the NVRs visitor book.

Call sheets from the second day of filming at the NVR.
Courtesy of John Pentlow

What I remember most is helping to look after Roger's son. Around the back of the NVR station, there was the haulage firm's Hutchinson's yard. Roger's son had brought along a quadbike which I remember him riding around on there. My friends' son, Andrew was a similar age, so he and Roger's son spent a lot of time together, putting coins on the railway line so that when the engines went over them, they'd split them in half. At one point I had to say to Roger's son, 'I'm sorry, but I'm all out of spare change, you'll have to ask your dad. I'm sure he'll have some!'"

Towards the end of filming, John proved instrumental in ensuring that the NVR was given an onscreen credit during the films end titles.

"I'd seen filming locations on the credits of other films so asked a few times until word came back to me that it'd gone all the way up to Cubby Broccoli, and Cubby had agreed to it. He'd apparently said something along the lines of 'They've been good to us, so we'll be good to them' and I was over the moon about that, I really was, especially when I saw our name up on the cinema screen at the crew screening. 'The Nene Valley International Steam Railway,' which is what we were called at the time."

John received an individual invitation to the crew screening along with some additional tickets to divide up amongst the NVR staff and members that had helped. "The fairest way I thought was to put everyone's name in a hat who'd helped and draw them out. There were a few people disappointed, but when the film came out in Peterborough, everyone got to see it at a special showing at the Odeon. The film premiere in London was on a Monday night which Prince Charles and Princess Diana went to, but we went on the Sunday, the day before for the crew screening."

On the Sunday, John and around 10 other NVR members, attended the crew screening at the Odeon Leicester Square. To add to the occasion, John arranged for commemorative ties to be made for the NVR's steam team to wear.

"They were a cream colour with a red 007 Octopussy logo that I got a local firm to print, not thinking much about it other than we'd all look really smart in matching ties. When we got to the screening though the ties nearly got me into trouble! 'Where did you get them from?' 'Who made those?... that kind of thing. After I explained they were something I'd had made just for us to wear at the screening, they let me off. I think if we'd have been trying to sell them in the NVR shop, it would've caused a problem, but it was all sorted out. We sat down, watched the film, thoroughly enjoyed it and of course when we saw the railways name on the end credits, we were all nudging each other with big smiles on our faces."

John stood down as NVR general manager in 1985, but continued to work as the NVR's accountant until his retirement and still keeps in touch with a number of people from the railway, many of whom have become life-long friends.

"When I look back on my working life, the Nene Valley Railway was a major part of it. I can honestly say that my biggest achievement while I was General Manager was *Octopussy*. It was the first big film contract the NVR had. I was there every day working all hours to help and it all paid off, because it put us on the map for future filming.

Over the years it has helped bring in so much important revenue. The location fee we got from Eon benefited every single department at the NVR. It sounds silly now, but it meant we were finally able to

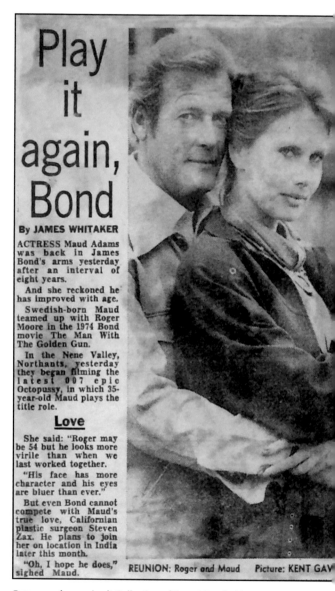

# Play it again, Bond

**By JAMES WHITAKER**

ACTRESS Maud Adams was back in James Bond's arms yesterday after an interval of eight years.

And she reckoned he has improved with age.

Swedish-born Maud teamed up with Roger Moore in the 1974 Bond movie The Man With The Golden Gun.

In the Nene Valley, Northants, yesterday they began filming the latest 007 epic Octopussy, in which 35-year-old Maud plays the title role.

## Love

She said: "Roger may be 54 but he looks more virile than when we last worked together.

"His face has more character and his eyes are bluer than ever."

But even Bond cannot compete with Maud's true love, Californian plastic surgeon Steven Zax. He plans to join her on location in India later this month.

"Oh, I hope he does," sighed Maud.

REUNION: Roger and Maud    Picture: KENT GAV

Octopussy has arrived! Collection of Steve Woodbridge

build a proper carriage and wagon shed at the railway and also a permanent station building at Orton Mere, as we only had a portacabin up until then."

# 3 CRANES, TRAINS AND AUTOMOBILES

Doreen Foster, who ran Orton Mere station for over 25 years, was one of the true pioneers of the NVR. After retiring from NVR duties in the mid-1990s, Doreen began volunteering at the Railworld Wildlife haven that was situated at the end of the NVR in Peterborough and was set up by Rev. Paten along with another NVR pioneer, Brian Pearce MBE. Doreen received the Queen's award for volunteering in 2019 for her altruistic efforts, but told me she was also very proud of her time at the NVR.

"I did a bit of everything, worked the signal box, station master, catering, membership secretary and I was also the first firewoman on the steam crane, but trains have always been in my blood. There was a group of us that put the track into Orton Mere in 1976 before the NVR opened including my son Gary who was only 11 or 12 at the time."

Her main memory of *Octopussy* was an unexpected meeting whilst waiting to see Roger Moore.

"They'd just come out of the Norwegian coach where they'd been filming and I was walking up the platform to take a picture when all of a sudden, a chimpanzee grabbed hold of one of my legs and nearly pulled me over! I did get to meet Roger Moore on the first day he was there, which was much nicer. I got his autograph and still have it in a photo album with a few snaps I took. My son Gary was one of the train drivers for *Octopussy*. There were a few of them that drove; him, Malcolm Heugh, Peter Bools and Pete Hanson. They used to call him Horizontal Hanson because he'd always stretch out the driver's window when he was driving."

In 1983, part of the location fee NVR received from Eon went to build a permanent station building at Orton Mere which Doreen ran, and was opened by Radio Two DJ, Ed 'Stewpot' Stewart; it is still in use today.

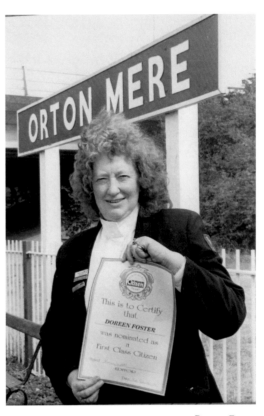

Doreen Foster.
Peterborough Citizen Archive

"We started off with a portacabin at Orton Mere but I was ever so pleased when some of the money we got from the James Bond film was used to build a proper station."

Whilst Doreen was busy running the portacabin station at Orton Mere during *Octopussy*, her son Gary was at the other end of the railway and heavily involved.

"I was the Carriages & Wagons manager at the time, but I'd been at the NVR since the start. I joined the Peterborough Railway Society in 1970 so would have only been what, 11? But railways were in the family. My Great-Grandad was an engine driver and my Dad worked on the railways for a while as well."

Around a month before filming began, Gary's C&W crew including Paul Jennings were asked to prepare the wooden sided CCT wagons that formed part of the Octopussy Circus Train. CCT stands for Covered Car Transport as this was what the wagons were originally designed for when they were built in the 1930s.

"Someone in the crew sent me a lorry load of this pink paint; *Octopussy pink* they called it. There was so much, I didn't know where to put it all. Every winter we used to repaint everything in Octopussy pink because there was gallons of the stuff left over."

For filming, a number of modifications were made to the CCT wagons. Roof hatches were put in and a number of strategically placed metal bars were added to assist the stuntmen as they were climbing up and down.

"For the roof-hatches I fitted the three non-opening dummies and Eon fitted the two that opened. We also had to paint the roofs and chuck sand over so when they ran along the top of the train, they had some kind of grip and didn't fall off." They fitted the end doors, but we had to fit the bars for the stunts guys to climb up. We put large bolts right through the side of the wagon, with a steel plate the other side so that the stunt guys could push on

to climb up. I then got a welder in to do the bars underneath the wagon from where they were going to hang from."

There were also other additions added to the wagon's roof to aid the stunt team during the fight sequence.

"If you look, you'll see there's two or three strips of wood. They were angled to help them keep their footing, but you wouldn't do that for a wagon normally because you'd want the rain to run off."

When the railway had originally been built in 1844, the largest part of the construction on the line had been the Yarwell Tunnel. Over 1,000 navvies had been employed to complete the 617-yard tunnel, but in 1982 it presented a different sort of challenge.

"They wanted to be able to swap the wagons in the tunnel, so the wagon with the jewellery for the one with the bomb, but that meant there had to be a point"

"Now normally you'd never have points in tunnels in case of a derailment but, it was needed to make the scene work so we were asked to install one. I was one of the two drivers of the steam crane along with Malc Heugh to install the turnout/point in the middle of the tunnel. We then got a firm in to do the lights in the tunnel ceiling and to run the cable all the way down the length of the tunnel."

The 'point' is the part of a railway track within a 'Turnout' that switches the train from one track onto another whilst allowing it to cross smoothly. For the tunnel scene, a 'Turnout' which is like a two in one section of track, had to be installed in order to connect the existing track to a new section laid by the NVR civils gang. Then the 'point' within the turnout was mechanically opened by a manual 'ground frame' lever to allow the wagon to be switched in the darkness of the tunnel.

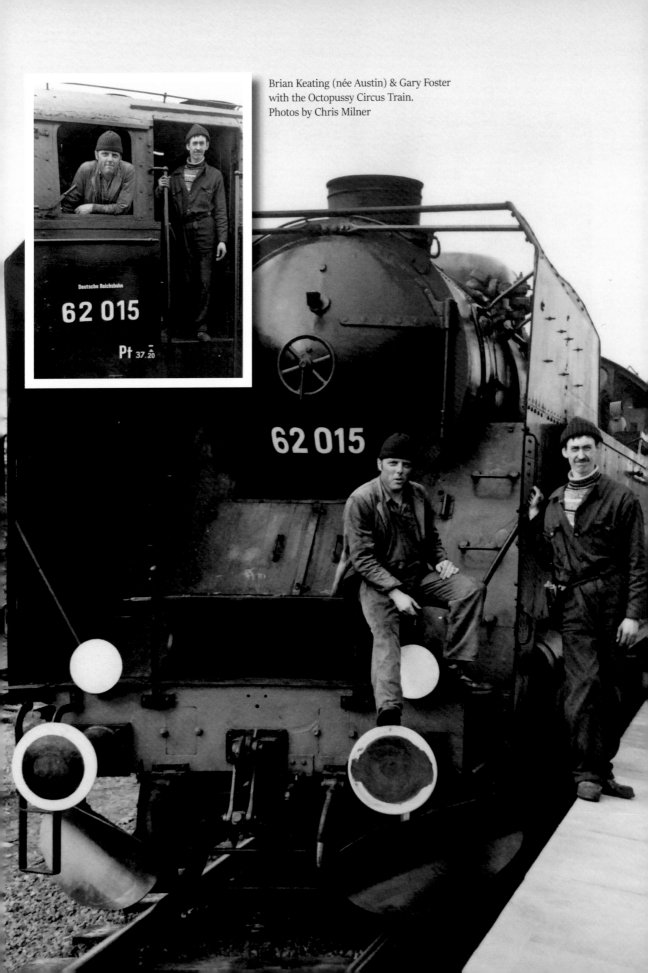

Brian Keating (née Austin) & Gary Foster
with the Octopussy Circus Train.
Photos by Chris Milner

Deutsche Reichsbahn

62 015

Pt 37.20

62 015

Once filming began, one of the first scenes to be shot was Roger Moore hiding underneath one of the CCT wagons and suspending himself as the wagon was shunted off. Gary was driving the yellow diesel shunter named 'Horsa' and given a pair of blue overalls and a cap to wear.

"They were too big for me so I looked a bit funny wearing them, but then again, I was a bit skinnier back then! On the first shot I was driving 'Horsa' and they'd G'clamped these boards to the underside of the wagon. I started moving across the cross over and these G clamps started falling off. 'Woah woah' they shouted so I stopped as Roger Moore had come off the boards. One of the stunt men then went to take over and Roger went back to doing his crosswords".

Filming continued and Gary again drove 'Horsa' in the tunnel scenes with Roger Moore. The blue overalls and oversized cap Gary had to wear also earnt him a nickname from the crew.

"They decided to call me 'Wing-nut'. Small head and big ears y'see and wearing that cap made my ears stick out even more! There was one shot in the tunnel that I remember didn't quite go according to plan. The part where Roger comes out the end door of the wagon, gives a thumbs up, and shuts the door. Well, I was going too quickly in Horsa, there was a wet puddle on the track as the tunnel leaks and I hit the parked wagon far too fast. I stopped instantly, but all the energy went into the wagon and it shot off down the track. It only had ten foot of electrical cable so

it went 'Pling' and all the lights in the wagon went out. There was a few seconds of silence and then everybody started laughing! Driving into a tunnel to hit a wagon at speed, in the dark where you couldn't judge the distance? it was only ever going to end one way. Bang!"

After Bond escapes from the tunnel up the staircase, Steven Berkoff's 'General Orlov' is now up on Horsa with Gary's 'Wingnuts' visible as he drove the diesel shunter. Orlov summons some of his troops to 'Get back to the station!' and the scene cuts to Bond driving Orlov's black Mercedes, skidding around the coaling crane located at the top of the NVR car park.

"The old coaling crane's gone now, but during the film I had to coal up every night because we were suddenly using the trains seven days a week for the filming rather than just at weekends. We'd got it from the sugar beet factory and it had a bucket on the end, but every time you tried to pick up a bucket of coal, the ropes would keep going and they'd flip off the jib. I had to climb up the jib and put the ropes back on so it took forever to coal anything up."

In the final film, a head on smash with an Express train catapults the Mercedes Bond has just jumped clear from off the track and into the river. Once again Gary was involved.

"In the film, that's me driving the steam crane that's lifting the Mercedes out of the river. There were lots of holes in the floor of the Mercedes to drain the water out, but when I pulled it out of the river, I had to be careful it didn't tip me over in the crane because I was on the tracks above and I couldn't put the riggers out. You can see me on the bridge in the blue overalls leaning on the bridge. They had me lock it into position to do this scene, so we were just there taking it all in."

Perhaps Gary's biggest claim to fame throughout the filming is that he was one of the main drivers of the Octopussy Circus Train. The NVR's Danish DSB S 740 locomotive disguised to look like a German state railways (*Deutsche Reichsbahn*) engine and renumbered 62.015.

"The 740 was a helluva beast, one of the biggest tank engines ever built. It was ginormous; a huge great thing. I was also driving it when the Mercedes switches tracks. Peter Bennett the location manager was up in the signal box and I remember saying to him 'For Christ's sake don't pull the bloody levers while I'm going across otherwise we'll derail!'"

There isn't a clip of Gary and his distinctive 'Wingnuts' in the film driving the train, but he has two black and white photographs that were taken of himself and fireman Brian Austin on the footplate of 740. As we're watching the scene on DVD of the train leaving *Gutenfürst* (Ferry Meadows) station, Gary said... "Wait, a minute, stop a second and rewind it. Yeah, look that's Brian with his head out the window! I've never noticed that before, but look, there he is. He was on the fireman's side wearing the same hat in the photograph. They also did loads of camera work where they'd film one way and then the other. So, one minute you'll be watching the film and we're heading towards Peterborough, and then another minute, the train's going back to Wansford where we had to turn the train around on the turntable."

One reason for this happening was after the accident involving stuntman Martin Grace. A behind the scenes documentary on *Octopussy: The Ultimate Edition* DVD/Blu-Ray covers the incident and it's something Gary's not forgotten.

"I was one of the people who'd taken them down there, and recce'd it. The day of the shoot I was back at Wansford and Malcolm was on the engine driving, and they were filming along the part we'd recce'd with Martin Grace on the outside. But then they said something like 'do it again' or 'Keep going'. Now they should have stopped and gone back to the start, but they decided to carry on from where they were and of course, because they hadn't gone up that far to recce it, they hadn't checked the bridges for obstructions. It was about the 2nd bridge in. Martin Grace managed to get his bottom over the first one, but the second one had iron railings on the top, a small culvert bridge and that's what hit him. God knows how he managed to hang on. Malc stopped the train and Martin Grace was rushed to hospital."

It's testament to Martin Grace's strength and bravery that after spending time in hospital he made a full recovery and was back again doubling for Roger Moore on the next Bond film, *A View To A Kill*. The accident meant that Martin's replacement to complete the sequence and double for 007 were stuntmen, Jim Dowdall and Paul Weston.

The next major sequence was the fight that took place on top of the train carriages.

"That was filmed near the tunnel at Wansford with further filming at Pinewood Studios. We spent quite a few days trying to get that one shot of the train coming out of the tunnel when they're fighting on top, as every time they came in to

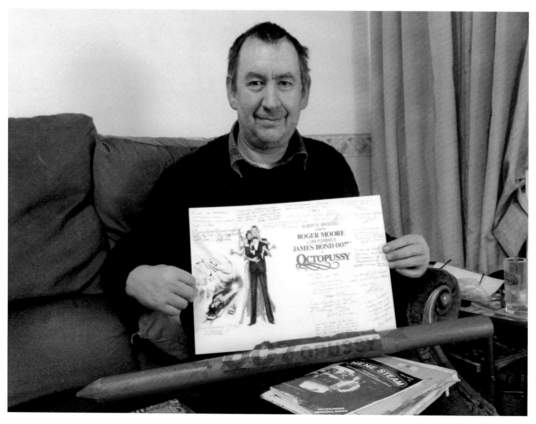

Gary Foster. Photo by Marc Hernandez

the sunlight, the camera they were using seemed to mist up. The part where they fall off the train was back past Ferry Meadows going to Orton Mere. Where they'd planned to fall off, they laid out all these boxes with mattresses underneath and I drove the train along, passed it all, looked back but the stuntmen were still up there. 'I thought they were meant to fall off?' 'No, no, they won't go off. It's not long enough' said one of the crew, so we went back to Wansford to turn around and then they lengthened the landing area. The next time we passed the landing area, they were still up there 'What's going on?' I asked. 'No, no, they still won't jump. They want it longer' So this thing kept getting longer, and longer, and longer and because the crew had a nickname for everything, they started calling it 'The F1-11 landing strip'."

By October 1982, filming had passed the agreed scheduled date at the NVR. A previously arranged event at the railway, Eurosteam '82, was set for the first week of October with many of the locomotive engines and carriages used in *Octopussy* to be present. While the 2nd unit film crew took a break, Gary took the chance to blow off a bit of steam and got behind the wheel of one of the Mercedes cars that had been converted to run on the railway. He took it for a spin.

"I knew where the keys were, so I used to get it out, run it up & down the track on the Sunday for people to see and then put it back. They came in on Monday and were saying 'This thing's out of petrol, it must have a leak'. But it didn't; it was because I'd been driving it on the rails!"

Half way through week 8 of filming, the final film shots were done and Gary returned to his day job at Baker Perkins. He also went to a wrap party held at *The Bull Hotel* to thank all the NVR volunteers.

"I remember John Pentlow telling me one of the crew came into his office with about £500 in cash to divide out amongst everyone involved. John knew that'd cause arguments so they threw a party at *The Bull* instead; a lot of the crew were staying there during filming, so it made sense."

From behind Gary's sofa, he produced the gift that was presented to him by the crew at the wrap party; an oversized pencil painted in pink paint with 'Octopussy' sellotaped to the side. "They got somebody in the art department to make it and send it down. I don't know why they made me a pencil, probably just said 'Make this idiot something we can give him' and big pencils were a bit of a thing at the time. We then took the wagons to Pinewood for filming and then when the film came out, I went to the crew screening in London."

Ticket for the wrap party for film crew and NVR volunteers. Courtesy of Gary Foster

1st CLASS RAILWAY TICKET EON PRODS Kar. Marx stadt to . BULL HOTEl 8·30pm

```
HELICOPTER:        To be on location around 8.00

ACTION VEHICLES:   2 X Mercedes on wheels
                   Command Car (Volga)

SFX:               Broken window required for some shots.
                   Sparks for car wheels
                   Steam from between carriages.
                   2 X Car on Rails (1 for each unit)
                   Tyres to shred.

PROPS:             To include swords, knives for Twin.
                   Bonds Gun, Kamals Gun, Bonds Watch.

RAPTYS:            On Location for 8.00 with Bonds Gun,
                   Kamals Gun.

TRAIN:             Octopussys Train
                   Armoured Car )
                   Circus Train )  Dressing for Splinter Unit.
                   Gary Foster to collect pen from Production
                   Office for Purpose of Signing autographs.

                                              Cont:
```

Call sheet with message for Gary Foster to pick up his 'gift', courtesy of John Pentlow

"I think I know exactly why they made you a big pencil," I told Gary, and passed him one of the 'Call sheets' that John Pentlow had kept. It's dated the day of the wrap party at The Bull Hotel. Assistant director Gerry Gavigan had written under the notes section...

*'Gary Foster to collect pen from Production Office for purpose of signing autographs'*

Gary laughed at seeing this and said:

"Well, I can tell you now, you're the first person who's ever asked for my autograph because of *Octopussy*."

Gary carried on working at the NVR until 1999, contributing to the railways continued success and becoming a director. After leaving Baker Perkins he set up his own engineering business and now drives on The Great Central Railway, Loughborough. The big question, all these years later though is what would he say if he was called upon to drive another train in a Bond film?

"I can't see it happening, but yeah, I'd be up for it. I've still got the overalls and at least they'd fit me now."

# 4 FIRING ON ALL CYLINDERS

Brian Keating, née Austin, had been the fireman on the footplate with Gary Foster driving the day the scenes were shot of the *Octopussy* Circus Train crossing from East to West Germany. Now in his mid-70s, and with a cheeky smoke-stained laugh that tells you he's lived a life, he sat down at his kitchen table to talk about how he became the fireman on the *Octopussy* Circus Train in 1982. A story that begins 21 years earlier...

"I started at British Rail on 9th October 1961 up at Kings Cross. I worked on the railway properly at Top Shed, 34a. I had three years on steam engines, and I use to get a regular job when the Flying Scotsman came in. 'Go with driver so-and-so and turn it', I'd be told."

Once steam was phased out on the BR networks, Brian drove Deltics on the East Coast mainline from London's King Cross up to Newcastle, via Peterborough. His Father-in-law at the time worked in Biggleswade and Brian recalls how he'd speed past him on his way through.

"He was a boiler man and worked at a factory next to the line. I used to tell him what time in the morning we'd be coming through and as we came down the mainline, I'd see him standing on the boiler house roof and give it 'arseholes on the horn', and whoosh, we'd be gone. At Kings Cross I'd get on in the 2nd man's seat with whoever was on with me and we'd swap over half way. He'd hold the dead man, and I'd still have the controller open, he'd slip in the seat behind me and that's the way we'd do it. The same process coming back from Newcastle."

Some of the train terminology Brian explained to me had gone straight over my head, but I've heard enough trains going past in my life to be familiar with what *'Giving it arseholes on the horn'* means!

"I came off the railway around 1976. I was living in Wood Green, London in a block of flats, 3rd floor up of a 16 block and my two children were young at the time. My father-in-law told me there were jobs going at Grace's; the factory where he worked and that were looking for people. They had an open day, and if you worked there, you got a house with your job. That kind of thing was happening in Stevenage, Harlow and around here in St Neots, so I weighed the situation up and packed the railway in."

Brian worked at W.R Grace Ltd for 28 years. A food packaging business, it was whilst there that he heard about the opening of the Nene Valley Railway.

"My mother saw something on TV saying they needed volunteers, this was in the late 1970s. I went down and thought 'Oh I like this!' It was simple to get to, just off the A1. I started chatting to a few blokes, kept going up; I met Ian Holt who also lived in St Neots so we used to help out with anything going. One of my favourite engines to work on was Britannia. I remember putting an air-pump on that and because of its history, it always had a lot of visitors."

The Britannia class 7, 70000 locomotive had pulled the funeral train of King George VI from King's Lynn, Norfolk to London in 1952 following his death at the Sandringham Estate. After being saved for preservation, Britannia was based at the NVR from 1980-2000 during which time the

Royal connections meant Prince Edward attended events at the NVR including the railways 10th anniversary in 1987.

Brian also got a chance to work on the NVR's 73050, which he'd seen in his BR days travelling past it as volunteers who'd formed the NVR were working on it.

"We went by one day, driving in the Deltic on Leeds or Doncaster return and I said to my regular mate 'Cor bleedin 'ell look at that!', cos they'd unsheeted 73050 to start work on it. So the next day we were on the same route and I took a small camera I could fit into my overalls. I slid the canopy back as we came into Peterborough 'click click'."

That instinct to have a small camera he could slip into his pocket whilst driving would be one that resulted in some priceless snaps taken during the *Octopussy* filming.

"I must admit I had a brilliant time on the Bond film. I was asked to come down to help, as Gary was the rostered driver and I said 'Yeeeah fine'. I then had 2 days off work, got fed well, the film crew canteen - Cor that was good - we were sat there having a nosh up with Roger Moore and then for two days it was just me and Gary, going up and down in the Danish from Wansford to Orton Mere."

Brian still had his firing shovel from Kings Cross Top shed, the one he'd used all those years earlier to fire the Flying Scotsman and he now used it to fire the DSB 740 for the Octopussy Circus Train. He then explained to me his role as a fireman.

"I had to give Gary information that was given to me, 'cos he can't see anything my side so I'm giving right of way to whoever's giving us right of way. The crew would come up and say to Gary 'OK, we're

doing so and so' but the film crew all had walkie-talkies, and we'd have to stop for a while for them to set up the cameras. Although I was older than Gary it didn't make any difference to me, he worked up there regularly and I liked Gary so we got on well."

Brian showed a photograph of him with Roger Moore and recalls how it came about.
"If you look closely, you can see someone up in the cab. That was Christian, Roger's son. Roger's wife was there and she was getting a bit concerned because Christian was getting covered in soot standing up there, but Roger was just cool as you like, he said something like 'Don't worry he's fine' because he could see the state we got in! The small camera Brian had in his pocket meant he was able to get some shots from on the bridge looking down on the riverbank while they were setting up to shoot the Mercedes into the River. The shots included Cubby Broccoli on set with Roger Moore and another of Brian, Gary and a border guard receiving instructions from one of the assistant directors, Michael Zimbrich.

"I'd got my camera stuck in my pocket, a small 120. When you're in the cab, just waiting there it was perfect to take a few and the ones of me in them were when my missus came down and I gave the camera to her."

Brian left the NVR in the mid-eighties, but also worked on a memorable sequence for the film *Biggles* (1986) which used the French Nord No. 3.628, and which later starred in the 'Orient Express' Diet Coke commercial starring Pierce Brosnan.

"When I did *Biggles*, I was driving in the Nord and we had to drive 30mph exactly, cos this plane had taken off at Sibson and was coming around to come up the track

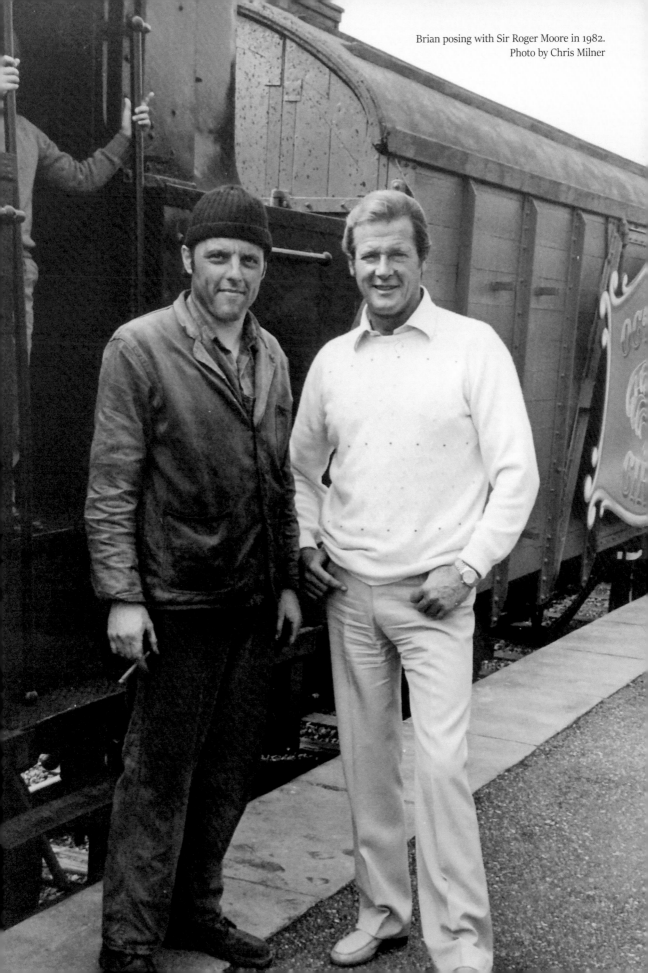

Brian posing with Sir Roger Moore in 1982.
Photo by Chris Milner

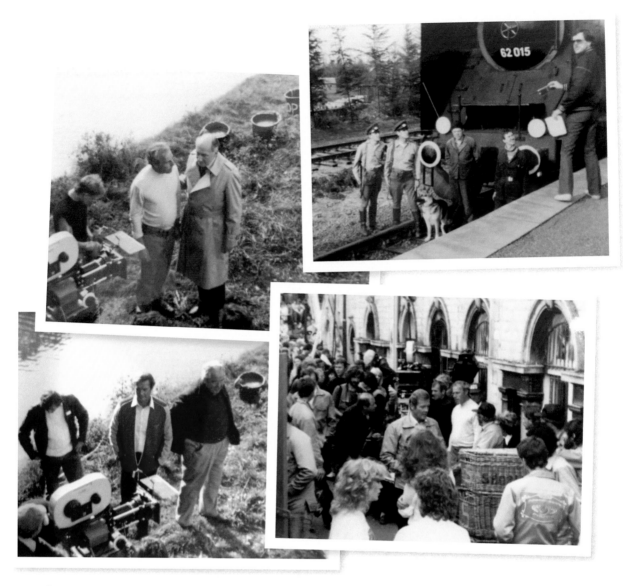

Some of Brian's snap shots taken during the Octopussy filming

towards us, and I'm stood right up in the corner on the fireman's side to get the picture of the airplane and I got it. So I'm in two feature films, haha, although I don't think you see my head in that one!"

Brian's time at the NVR came to an end when he found he was starting to neglect things at home, but looks back on his NVR time with a lot of fondness.

"They were a good crowd of blokes, but it got so time consuming that I couldn't go every weekend. I was starting to spend more time down there than I did with my own family. I regret it a little bit now, but not too much."

Opposite page: Brian back at the NVR in 2019.
Photo by Marc Hernandez

# Nene Valley

THE FLYING SCOTSMAN
LEAVES KINGS CROSS AT 10AM EVERY WEEKDAY

L·N·E·R

LONDON & NORTH EASTERN
RAILWAYS

LONDON MIDLAND & SCOTTISH RAILWAY
WANSFORD STATION

NVR
NENE STEAM

No.11

Winter 1982/83

35p

# NENE STEAM

**The Magazine of
NENE VALLEY RAILWAY INTERNATIONAL**

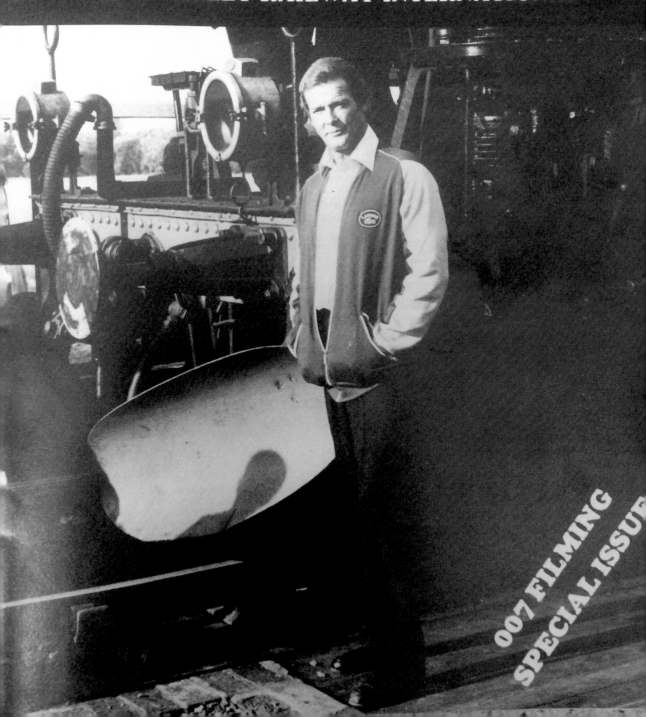

007 FILMING SPECIAL ISSUE

# 5 SHOOTING WITH THE CREW

Amongst the hundreds of Nene Steam magazines in my collection, the Winter issue No. 11 from 1982 holds a special place. A photograph of Roger Moore on the front cover, '007 FILMING SPECIAL' diagonally emblazoned across the bottom corner and inside a series of behind-the-scenes photographs by Chris Goodwin, one of the NVR working members. Nearly 40 years later Chris relived how he became involved..

"I'd been in the RAF working at the photographic reconnaissance intelligence unit at Brampton. I joined in 1971 and did seven and half years, bought myself out and arranged to do a mechanics course at the motor vehicle training place in Peterborough. It was around this time that I started visiting the NVR so '78/'79. I've always had a passion for the steam world so I'd pick various vantage spots to take photographs until one day one of the Loco crews persuaded me to join the railway because they needed volunteers.

Chris started out as a ticket inspector before moving on to guard duties and would regularly take black and white photographs that would appear in Nene Steam. In early 1982, he took photographs during the filming of the BBC2 drama *Russian Night 1941*. Wansford station was made to resemble Krechetovka Station, a railway junction south of Moscow, not far behind the front line of WWII, and the Swedish B 101 locomotive sported the Russian red star on the smokebox.

"It was an adaptation of a Solzhenitsyn play and I remember they covered the platform with salt, smoke machines and it was tipping it down with rain. It didn't look very nice but was very conducive to the setting and then the Bond people came along... and that was a kind of a shock to the system because I wasn't ready for the level of activity and the level of glamour that came with making a Bond film."

Just before filming commenced, John Pentlow called him over.

"He came along with Alec Mills and Alan Hume and introduced me to them. I think he must have shown them some of the photographs I'd taken for Nene Steam, as Alan Hume asked me if I was a professional photographer. I said it was just a hobby and that I did it for the railway magazine. I'll be the first to admit the photos I took were pretty basic, but my skill was in processing rather than the taking of them, but from then on I was being invited by the likes of Alan and Tony Waye to take photographs and it was pretty much where they went I went, which was very generous of them."

Alan Hume had made his name for his work on the *Carry On* films and was the director of photography for *Octopussy*, whilst Tony Waye, the 1st unit assistant director, worked on a number of Bond films throughout his career.

"I'll always be grateful for their generosity, because it gave a whole insight into what life was like filming. I didn't lose sight of the fact I was in a very privileged position, but after a day or two I just felt like one of them. But I always waited until I was told I could take a photograph, or invited, I never assumed and when I did, I was just a part of their group."

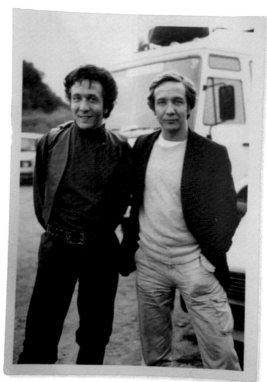

Walter Gotell (L) and David & Tony Meyer captured by Chris' camera

Unfortunately, the majority of the photos Chris took later went missing, but the handful that survive show just how close and personal he was allowed to get on set.

"The Meyer twins were cracking guys and I was there for most of their scenes. I think the hardest one was the one at Orton Staunch when 009 cops it. It was quite chilly and shot in darkness so I remember feeling sorry for Andy Bradford who had to fall into the water and drop over the weir."

Some of Chris' most vivid recollections are the time he spent with Roger Moore, including taking the photograph that appeared on the Nene Steam front cover.

"The first instance of the kind of person Roger was came after I'd just met Alan Hume. We walked back up onto the station platform and Roger appeared. I was introduced and he said 'Very pleased to meet you' and I thought no more of it.

There were hundreds of people around, but the next day I was down there quite early with hardly a soul around, and this very recognisable voice from out of the blue called out, 'Morning Chris!' and Roger carried on walking. I had to do a double take to see who it was because I was shocked that a) he made a point of saying good morning to me and that b) he actually remembered my name! This is a multi-million dollar film star who I used to idolise as a young lad. I can still remember being allowed to stay up late to watch *The Saint* on TV, and incidentally when they introduced me to him, you know how you never know what to say to famous people, you just bumble words out? Well, I said something like 'I have fond memories of watching you as a young lad when you played *The Saint*' and he said 'Well Thanks Chris, you've just reminded me how old I am'."

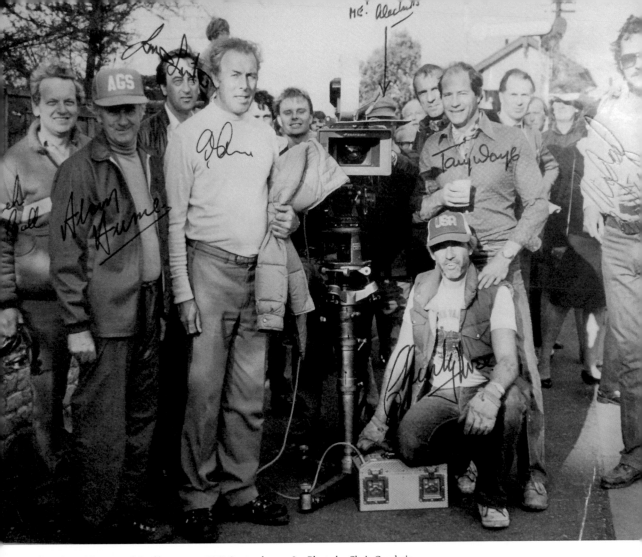

John Glen with some of the film crew at NVR September 1982. Photo by Chris Goodwin

It wasn't long before Chris found himself on the receiving end of one of Roger's on-set pranks which he recalls with a wry smile.

"We were in the tunnel and he picked up the walkie talkie from my lap and recited a poem down it, which caused Tony Waye to stop filming and walk up the tunnel towards us. Roger then said to me, 'Chris, when they say Turn over, action! you need to keep quiet' and I didn't say anything but I was laughing to myself thinking, 'He's stitched me up here'. I think Tony Waye knew what the joke was, but I hid the walkie-talkie after that so it wouldn't happen again. Then on another take

Roger picked up this megaphone and said something like, 'Mary had a little lamb, she also had a cat, Tommy Cooper came along and killed it just like that!' There was another 'CUT!' and he dropped this megaphone thing into my lap. I said 'Not again!' and Roger just winked at me. I also remember standing just outside the tunnel and Alec Mills came past muttering 'Has anyone seen my hat?' He used to wear this little blue denim cap and Roger turned around and said 'Here it is, Alec' and he picked his hat up and had filled it with ballast, but apparently this was the true Roger Moore. He must've played tricks and gags on so many people when they were filming."

41

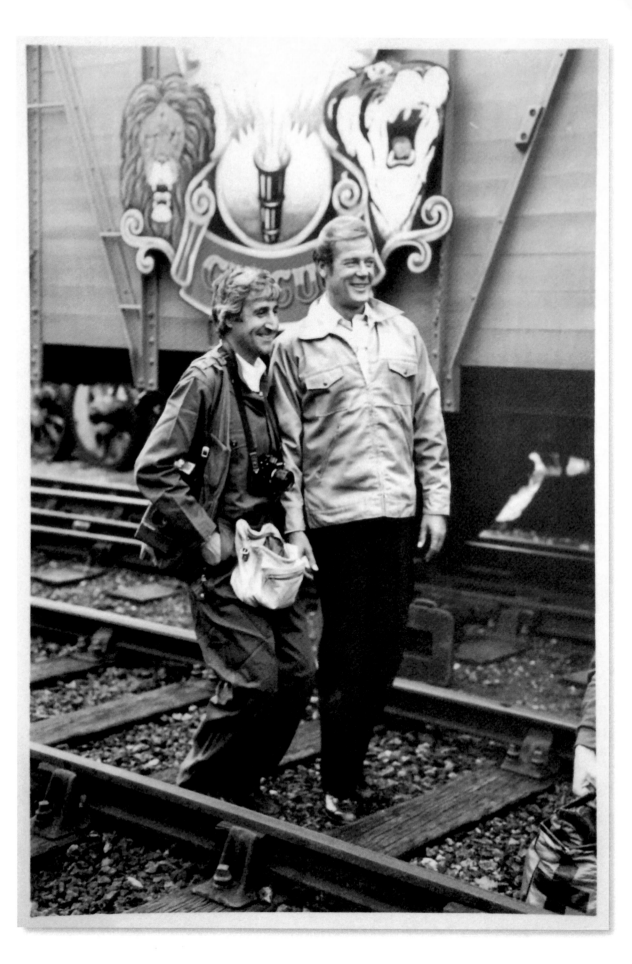

Opposite page: Unit photograher Frank Connor with Roger Moore.
Photo by Chris Goodwin

Chris was also fortunate enough to see Roger on the receiving end of a prank played by the special effects team.

"It was the last scene Roger did before they went off to film in India. Well, just about anybody that was near the location that day was up at the back of the tunnel watching it. All the other scenes had been shot in the railway yard with John Glen and around the tunnel, so Roger just had to run up a few steps at the back of the tunnel, come around the corner, jump in this Mercedes and start the engine. Simple. A few seconds, an easy shot. So, he came up the steps got in, turned the key and just about everything electrical on this car sprang into action! The windows were going up and down, the sunroof was going backwards and forwards, the hazard lights were flashing on and off, the wipers were going up and down, the car horn was going beep, beep, beep. This car had erupted into life and Roger got out the car, folded his arms on the roof, sunk his chin into the car, then shook his head laughing while two hundred people burst into a round of applause and cheered."

Taking behind the scenes photographs also had other compensations, like the time Chris was literally swept off his feet by the Octopussy girls.

"I was with another NVR member, Phil Seaton, when I plucked up the courage to ask if I could have my photo taken with

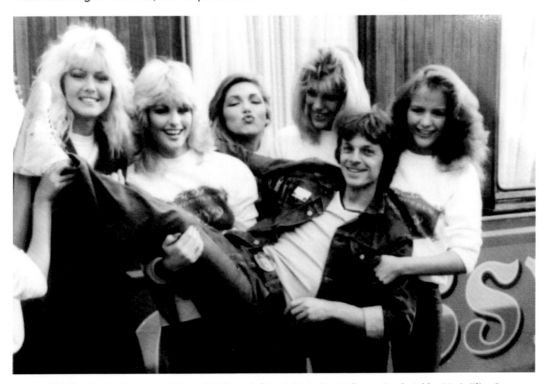

Swept off his feet by the Octopussy Circus girls! From left to right: Janine Andrews, Carole Ashby, Marie Elise Grepne, Julie Martin & Louise King

them. Carole Ashby, who was always my favourite, agreed and before I knew what was happening, her, Janine Andrews and a few of the others picked me up and held me across them! It was just one of those spontaneous things, but something I'll always remember."

When he wasn't taking behind the scenes photographs, Chris was also rostered on for guard duties when the 2nd unit were filming the scene of the Express train 'hitting' the Mercedes.

"Both me and Mickey Wadsley were on the train that day and the guards brake was immediately behind the tender of the Swedish B loco that was used in the scene. So they backed it up, building up a fair old pace. We couldn't look out the window, but Mickey was saying 'They ain't gonna do it, they ain't gonna do it' and then all of sudden it went 'BANG!' and we heard this thing thump on the grass below. We stopped and went 'Bloody hell that was good !' and then to our amazement the train backed up. There was a bit of discussion and we had to go again, and me and Mick looked at each other in disbelief and they said, 'We've got to get it closer'. 'CLOSER! You're having a laugh' I thought, but then off we went again and heard this WHOOSH, BANG and then a CLANG and saw the car going flying. It wasn't until

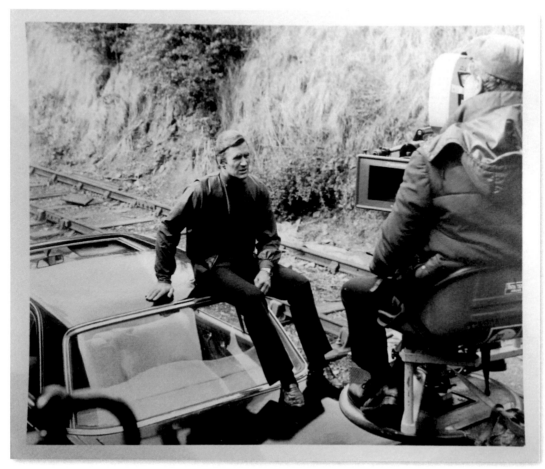

Stuntman Martin Grace relaxing on top of the Mercedes. Photo by Chris Goodwin

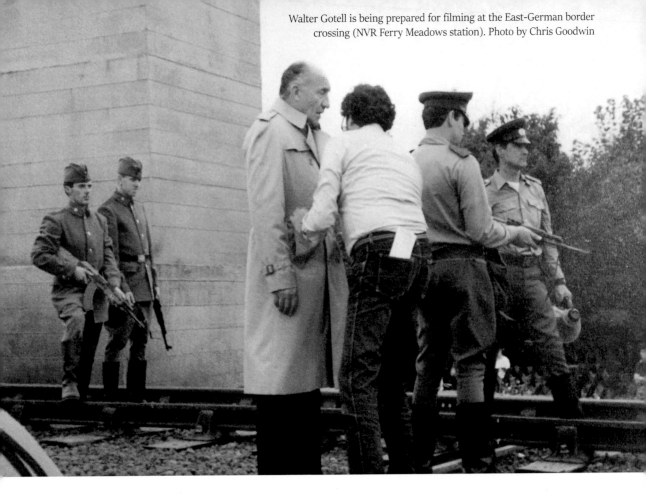

Walter Gotell is being prepared for filming at the East-German border crossing (NVR Ferry Meadows station). Photo by Chris Goodwin

afterwards that we were told it was that close that they hit the chimney of the Swedish B's engine with the car and it ripped the car wing off! We heard about it within seconds of the take and I was thinking 'Don't you dare say that wasn't close enough', you can't get any closer than that!"

Another incident remains firmly in his mind: An encounter with Walter Gotell.

"It was the scene where he was chasing Steven Berkoff as the train disappeared over the border crossing. Walter fell over, got up but with a cut under his right eye. He reappeared some days later to re-do it and as it was going to be his last scene on the railway I walked up to him and said, 'I hope things turn out successfully and you don't take away a bad memory of our railway' and with that he threw his arms around me, hugged me and said, "Oh I think it's a wonderful railway!" and I thought what a nice chap, but because he towered above me and had a thick rain

mac on, my head was buried in his chest and I couldn't speak!"

Among the photographs that have survived are some Chris took of Martin Grace. Chris was one of those who travelled down the track with Martin in preparation for the stunt that saw Martin on the outside of the train and climbing along the side.

"There must have been 15 people or more on this huge flatbed and I can remember Elaine, the continuity lady, sat there calm as you like typing away on her typewriter. We went down the line to recce it, slowing down, making notes, so Martin knew where every telegraph pole was, where the crossings were, where the culverts were; even where the grading signs were, 1 in 100, that sort of thing, basically making a note of anything which would have presented a problem to him. And then we stopped and they said this is as far as we needed to go."

45

After returning to his day job at Perkins, Chris was then horrified to hear Martin had been severely injured, as he'd got on well with him whilst on set.

"They'd gone beyond the point they'd checked for obstructions and Martin had hit a culvert bridge. I could only get a couple of weeks off work so wasn't there when it happened. I was back at work, but as soon as I heard, the first thing I did was go straight to Peterborough hospital. He was there for around a month before they transferred him to Stanmore. I used to take him books, magazines and things like magnetic puzzles, because knowing what a live wire he was, I became acutely aware that this guy was going to be stuck there and bored senseless."

News of a stuntman being injured came to the attention of a freelance journalist who wrote for the national press and lived in Peterborough.

"A guy who wrote for one of the tabloids turned up at the hospital one day when I was sat with Martin. Martin made it clear he wouldn't be talking to him, but when I saw a copy of the Sunday People, what the guy had done was put two and two together and came up with eight."
Martin also allowed Chris to take a photograph of him in Peterborough hospital. It shows Martin in recovery and with a special gift arranged by Cubby Broccoli in the room.

"As I recall, the 2nd week I was in there he was still grateful of things I was taking him, but Cubby Broccoli had brought him a colour portable TV. This was in the days when hospitals didn't have TVs by every bed like nowadays. It was around this time that he showed me his injuries. The pipe of the culvert bridge hit him at 40mph and completely shattered his pelvis, split his leg and thigh and ripped his backside. The stitches and bruising were horrendous to see, and he told me when he hit the bridge he flipped up but managed to hang on with one hand. He was determined he wasn't going to end up under the train. Given the nature of his work, Martin was one of these

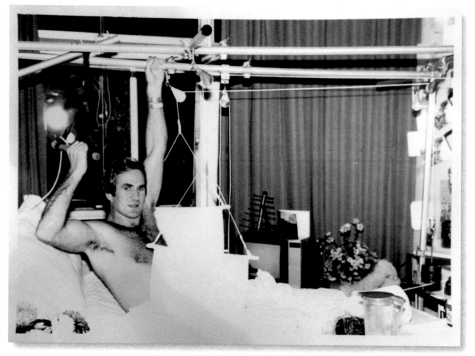

Martin Grace in hospital. Photo by Chris Goodwin

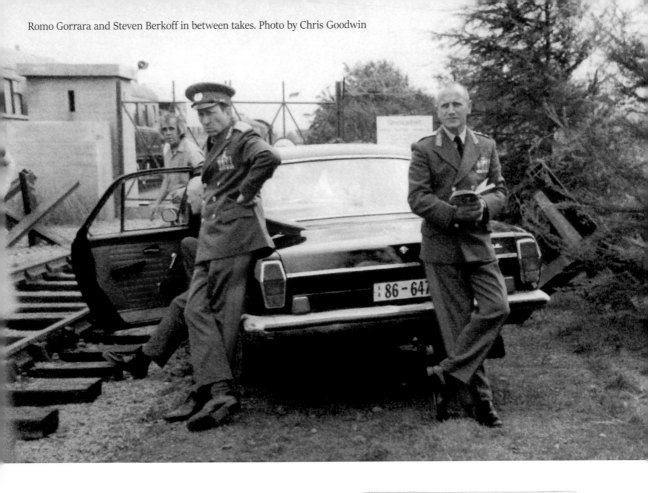

Romo Gorrara and Steven Berkoff in between takes. Photo by Chris Goodwin

people who was always very composed, so despite the pain and severe injuries he managed to hold on until the train came to halt, and those around could help him."

Following Martin's discharge from Stanmore hospital he invited Chris down to see him at his home in Bushey, Hertfordshire. "I went down with my then wife and met him and his other half Anya, who we'd met when she'd come up to visit him in the hospital here. At one point Martin said to me 'Would you like some pistachios?' So I said 'What are they?', as I'd never had them before, and he took some out from a large jar he had. 'They're nuts', he said. I took a bite of one and he started laughing.
'You're meant to take the shells off first!' He told me he'd got a taste for them from filming *For Your Eyes Only*. Topol is using these pistachio shells to catch the villains and they had loads of them during the filming."

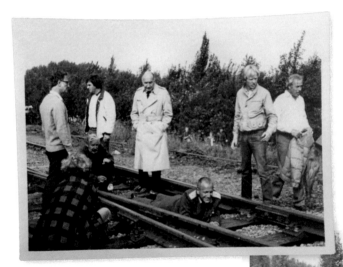

Filming the death of General Orlov at Ferry Meadows. Photos by Chris Goodwin

To thank Chris for his help and support, Martin then gave Chris one of his bronze stuntman belt buckles, engraved with 'Martin Ryan Grace 007 stunts'.

"That was the last I thought I was going to hear from him. Then about 18 months later I was at my Mum and Dad's for Sunday lunch when the phone went and my Dad came through saying 'It's Martin for you'. I picked up the phone and heard this unmistakable Irish voice. He said he was doing a film called *Top Secret!* over at Rockingham Castle, and would I like to help do some rigging, so I said 'Yeah, great'.

They'd set a shot up where they were breaking into Rockingham Castle and built a special rig so they could climb up, and I was helping Martin with it. We had a big pulley system with an anchor staked into the ground, quite a complex set up and after they did this scene, a guy in this Elvis suit came walking over and Martin said 'Val, come over here, I'd like you to meet a friend of mine.' Of course I'd never heard of Val Kilmer, but he was quite chatty and a very nice guy. I then got the odd call from time to time where Martin would tell me what he was working on. I remember him ringing to tell me he'd be on TV that weekend doing a stunt with Rocky Taylor on *The Generation Game*;

the pair of them being cowboys in a bar room brawl scene before showing the contestants how it was done. But I lost contact with Martin after that, I suppose the natural progression of time."
"I was then very shocked when I heard he'd passed away in 2010. He'd had complications following a bike accident, but it brought back a lot of these memories. He was a great guy and there were some very heartfelt tributes to him that I saw."

Following *Octopussy*, Chris took part in one last piece of filming before he left the NVR. A music video in 1983 for a new up and coming band. "I was on guard duties on the train again when John Pentlow asked me to do an extra shift because we'd got a band coming down to shoot a video. This was *Big Country* and I remember being up in the cutting in one of the southern

Chris Goodwin at his 65th birthday bash in 2019, holding a signed photo from Jim Dowdall. Photo by Marc Hernandez

Jim Dowdall. Photo by Chris Goodwin

electric cars and they suspended filming because it was peeing it down with rain. I was sat in a carriage with Tony Butler and Stuart Adamson and we were basically just shooting the breeze. They were ever such a nice bunch of chaps and a great band. Very underrated and of course Stuart's sadly no longer with us either."

After leaving the NVR in 1984, Chris put his photography skills to good use on a regular basis for the Peterborough Pirates ice hockey team in his spare time and said "I then spent 33 years at Perkins Engines. In hindsight it gave me a decent living so I can't complain really."

Chris' other big interest is being part of a WWII re-enactment society, 'Foxhole 44', who take part in events in the summer months across the country. During our chat Chris reeled off half a dozen RAF bases he'd been stationed at in the 1970's. One of them, RAF Cosford, sounded familiar and when I checked my grandad's Second World War diary he'd noted he'd undertaken his basic training there in 1943. At the next 1940's event, 'Life on the Holme Front', I took my two sons along and Chris took us all for a ride around the village in his RAF jeep; a similar type to one that my grandad would have travelled in, all made possible thanks to a Bond film he'd taken me to see in 1983 that Chris had been involved with.

# 6 MACARONI CHIPS IN

When I started writing for *Nene Steam*, the editor, Mr Brian White, aka the Pale Ale King, told me he'd recently been given close to a thousand photos for the archives! They'd been taken by another working member, Kevin 'Macaroni' McElhone, and covered various events at the railway over the years. Close to a hundred were from the Octopussy shoot so I was interested to find out more from Kevin.

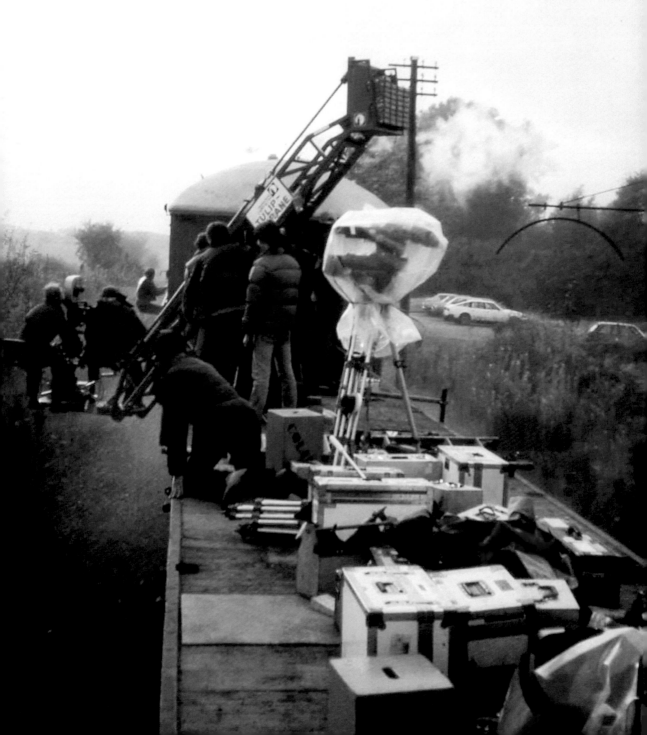

Kevin in the tunnel as part of the civils gang who installed the turnout. Photo by Neil McGregor

Kevin with the commerative folder from the NVR opening in 1977. Photo by Marc Hernandez

"I started in 1972, so when it was still just the Peterborough Railway Society. I took photos right from the start, and became a life member of the NVR when it began. I was the NVR company secretary at the time of *Octopussy*, so spent a lot of time there that summer, helping to get the railway ready and involved with some of the filming."

Kevin then went through the photographs, explaining how he was involved with some of the work needed before filming commenced.

"We spent several months preparing for the film, as Eon wanted us to lay a point in the middle of the tunnel which was very expensive. I think we paid £3,000 for it. It was flat bottom rail and we had to have a very slight angle, because if we had a sharp point the coach would've hit the wall of the tunnel. We then took the track into the tunnel on little trollies and crowbarred it off. We had working lights assembled to work with before an electrician fitted them in the roof of the tunnel and my story of that is that a special cable was laid to just power the tunnel and I believe the village of Stibbington was overloaded and short circuited. They had to lay on some kind of special extra supply because 615 yards of lights is an awful lot of lights to suddenly add."

Further down the line from the tunnel at Ferry Meadows, work began to get the station ready for filming.

"We had to lay extra track in the siding in the yard at Ferry Meadows because at one point we stationed another steam loco there. The film people put a false pitched roof onto Ferry Meadows station building

51

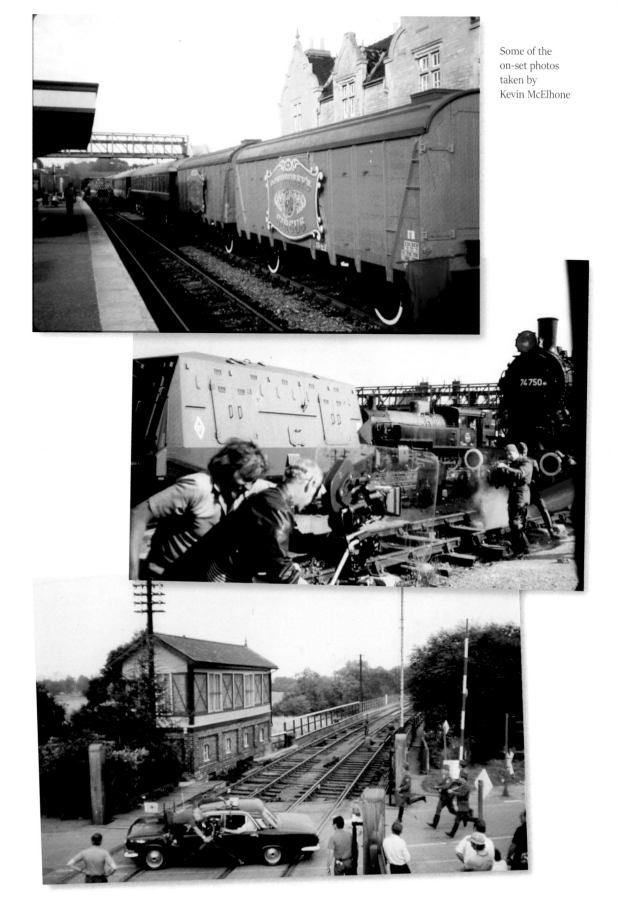

Some of the
on-set photos
taken by
Kevin McElhone

on top of the flat roofed portacabin. While they did that, we continued to lay sleepers in the siding along with an enormous amount of shunting. Every piece of rolling stock that was not needed in the film had to be taken to the British Sugar factory and we spent what felt like weeks taking the stuff. We couldn't take more than six or eight coaches at a time because of going up the steep incline to the sugar factory on the Fletton loop. It would take an hour each way because we'd got no brakes on a lot of the stuff; we had to be very careful. Then they wanted all the telegraph poles removing from the line side because they were the wrong kind of telegraph poles; they were British with three or four cross bars. Foreign ones would only have one cross bar and would be a different design. I was also a works train driver so went along using the steam crane, put a chain around every one and yanked all the telegraph poles out; they were all about three feet in the ground and it took about a day to complete."

During filming Kevin worked as a rail guard for some of the stunt work.

"They had a tulip crane with a huge weight on the right-hand end to counterbalance the cameraman and his director. People from the crew performed the rotating and lifting. Martin Grace was dangling from the side of the Norwegian coach and I was guard on the train. I had my right hand around the bar on the steps of the wagon lit, and with my left hand I had my camera; I was taking pictures of the crew in front of me who were filming him on the side of the carriage!"

Kevin wasn't on duty when Martin Grace was injured, but recalled some of the background detail that is only briefly seen in the film.

"In the car park they put up new criss-cross fencing and made three gates; one of which was a real gate and two of which were balsa wood that were sawn in half way through the middle. This meant that when the car hit them, they'd break easily without damaging the car. The ballast in the car park had to be skimmed off with a JCB, because it wasn't smooth enough for the Mercedes to drive over it on two wheels. With their first attempts to drive the Mercedes it took something like four or five hours, because they weren't happy with the bounce of the so-called oil drums. They tried metal ones and they didn't bounce. They tried cardboard ones and they just collapsed. Then they tried plastic ones and they bounced lovely, but it was the 3rd attempt, so of course it all had to be set up each time.

They also put a red and white sign on the platform wall, an East German propaganda banner *"Unser Beitrag zur positiven Bilanz: tägliche Planerfüllung!"* (Our contribution to positive balance: daily fulfilment of the plan) but you'd have to pause the film to actually see it. I loved being involved in the filming though. It was blooming hard work, but we'd built the railway up from very little so to have it used in a Bond film was very satisfying. I only had two weeks there filming as I was a computer manager at the time and couldn't get any more time off."

The stunt work involving the Mercedes being driven through the car park, going up on two wheels and eventually skidding onto the railway tracks were all performed by members of Remy Julienne's stunt team with Remy being present to supervise and help arrange the sequence.

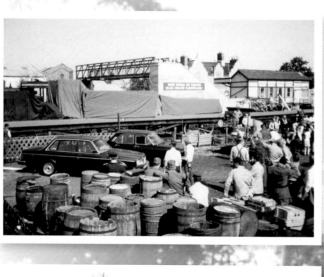

Some of the
on-set photos
taken by
Kevin McElhone

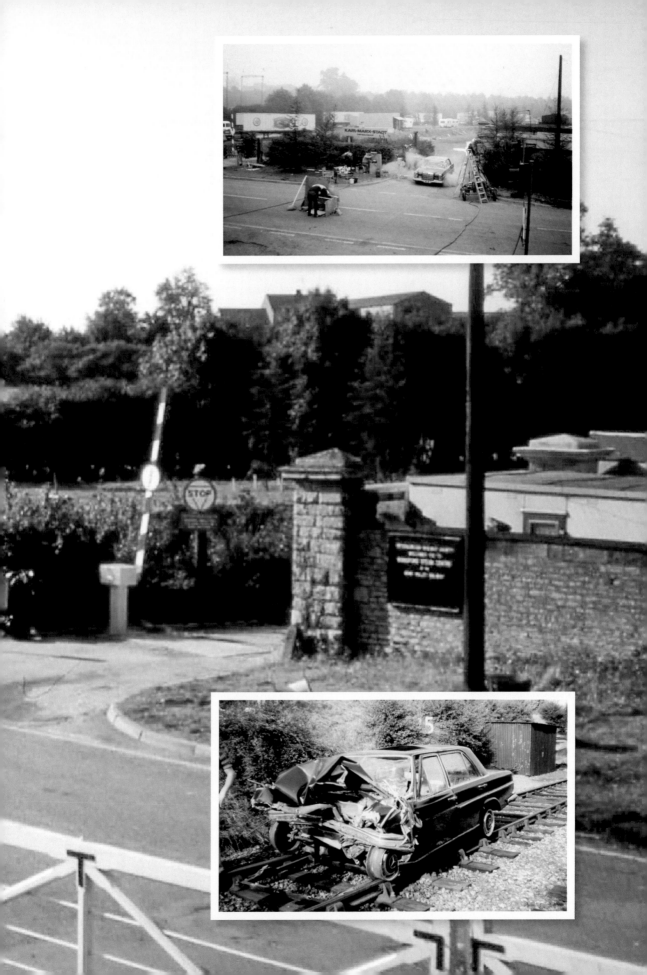

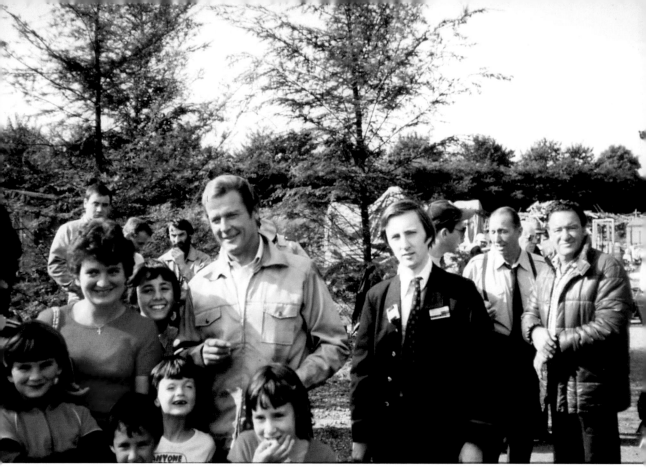

Photo bombing '82 style: A local mother and children mingle with Roger Moore in the NVR car park as Kevin McElhone in his rail guards uniform looks on. Also visible behind him are legendary James Bond stuntman/co-ordinator Bob Simmons (green jacket) and Romo Gorrora (Steven Berkoff's stunt double)

Filmed between 13-20 September 1982, Remy's son Michel doubled for Bond along with Henri Trautman, who celebrated his birthday on 15 September 1982. A note at the bottom of that day's call sheet read "Henri – one of our stunt drivers is 30 today – Vive Le France !!"

Part of the fight sequence on the roof of the train called for it to head into the tunnel from the Wansford end. This section of the line was double track, but the part coming out at the other end was single track. To make it appear both ends were double track, Kevin and some of his colleagues worked late into the night to make it possible.

"The way we did that was to have the entire train turned around. Each item of rolling stock had to be turned on the turntable. We did it one night after the days filming had finished. We did it all in the dark, just with hand lamps, no radios because we didn't have anything like it, but we turned the whole train and it took about 2 hours without a single mishap all ready for the next day, so the whole train could be seen to come out the same end of the tunnel."

# 7  DOWN THE LINE

The other members of the NVR's 'Civils gang' that had carried out track work along with Kevin shared their contributions. Starting with Roger Manns MBE, who oversaw the work. He was the NVR's chief civil engineer from 1977-2014 and in 1994 was awarded an MBE for community service due to his NVR involvement. Another pivotal figure since the early years (and currently Vice-President and still an active working member), Roger recalled the work carried out for the turnout point in the tunnel.

"I had to get that from Trackwork Doncaster, and was I believe the first time a turnout had been installed in a tunnel of a preserved railway. A year later we took the point work out and re-used it elsewhere. The staircase the film company put in for Octopussy, also went up to their catering establishment at the top of the Yarwell end. That wooden set of steps isn't there anymore, but as a result of filming for London's Burning there's now a permanent set of steps."

One criticism often levelled at Roger Moore was his reliance on a stuntman during the Bond films, but Roger Manns is full of admiration for something he saw.

The NVR's Roger Manns, MBE,
Photo by Marc Hernandez

"Roger Moore did one of the stunts himself, which was underneath one of the CCT wagons. I wouldn't have done it because it was just above rail level and travelling backwards so he had to suspend himself underneath as it's shunted along. Another thing I remember was that the catering for the filming crew was at the far end of the tunnel, the Yarwell end where they had lunch. But the film crew also wanted afternoon tea and clearly when they were filming in the middle of the tunnel, it was too far to walk back to the canteen which was on top of the cutting at the Yarwell end. So they got the caterers to provide a trestle table in the middle of the tunnel, just near the point work we'd installed as there was sufficient width for it with table cloths. So you had the trestles, white linen table cloth, sooty walls, and then tea and scones on the table for the filming crew including Roger Moore."

Another key member of his 'Tunnel turnout gang' was Neil McGregor, the now NVR company secretary.

"My main contribution was being one of the Permanent Way gang putting in the turnout in the tunnel. The turnout was subsequently installed at Longueville Junction to Orton Mere and I believe that the turnout was used as one half of the crossover between the Oundle and Nassington lines immediately west of the A1 bridge. It remains there to this day."

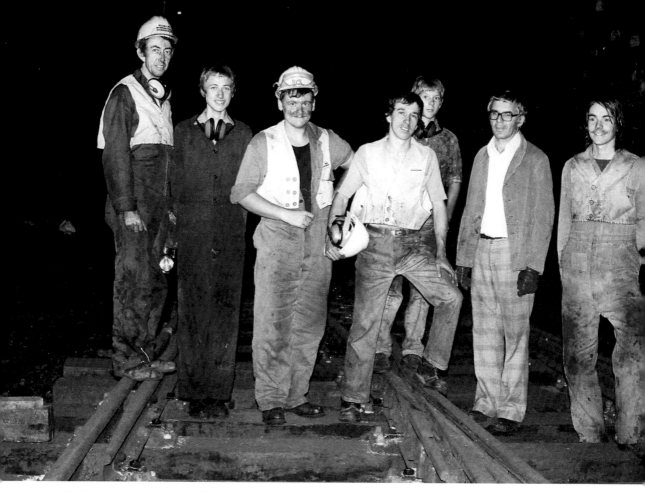

Civils Gang in the tunnel. Roger Manns all the way to the left, wearing a helmet, just like Neil McGregor, next to Peter Brelade, who has his helmet in his hand. Photo courtesy of Neil McGregor

NVR'S Neil McGregor.
Photo by Marc Hernandez

Neil also participated in laying the siding at Ferry Meadows, as the station portacabin was adapted to become the East-German station *Gutenfürst*.

"As I remember we were putting in the siding over the winter but had only got as far as the trap point. Then in the Spring when we heard that Eon wanted the siding finished, rapid progress was then made to get it done!"

Peter Brelade was also in the civils gang and involved.

"I seem to remember a Stibbington guy by the name of John Tickle who brought his mobile crane to help us with some of

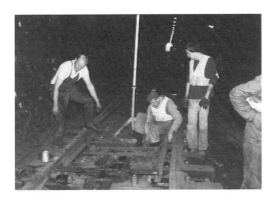

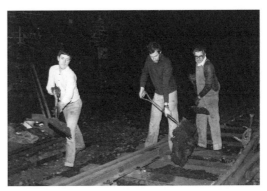

the pointwork in the tunnel. He burned out the clutch on his crane driving over the sleepers from the Yarwell end. The NVR 10-ton steam crane did the bulk of the heavy work; it made marks high on the wall inside the tunnel during some manoeuvres but much of the ballast had amalgamated with lime dripping down through the roof brickwork and was almost like concrete. The point in the tunnel was laid around 2/3rds through where the redundant Northampton line was lifted from; the end being slewed over to meet

the turnout. I remember myself and Kevin McElhone being asked to work the point lever together after it was connected. We pulled and pulled, but barely got it to move. Malcolm Heugh came across and said 'Get out the way', got hold of the lever on his own, pulled it backward and forward several times until it eased, then he said 'That'll do'. Kevin and I were still stood open mouthed at his strength!"

Once filming began, Peter has a clear memory of observing proceedings.

"I can remember standing at the east end of the tunnel when the buffet car was brought up; a couple of the guys I was with stopped talking and looked at this tremendously tall guy and realised who it was. Kabir Bedi, Kamal Khan's henchman, Gobinda. He sort of came out the darkness into daylight, blinked a bit, saw us, came over looking all mean and then ever so friendly said "Morning, what are you boys doing here?" and got himself a cup of tea! It was like when you see the first appearance of 'The Mummy' in one of those horror films, because he was such a tall guy and it was so atmospheric."

NVR's Peter Brelade
Photo by Marc Hernandez

Around Ferry Meadows station, Peter recalled:

"I'd been involved from the start with ground preparation at Ferry Meadows. We helped laying the siding and positioning the stock prior to filming. The border crossing was built of timber framework with ply boarding and specially textured plaster to look like stone, together with tank traps made from thin plywood resembling steel RSJs welded together. In reality they were very light and several of us had photos taken holding one of them on our shoulder. The boom on the crossing barrier was made of a plastic pipe.

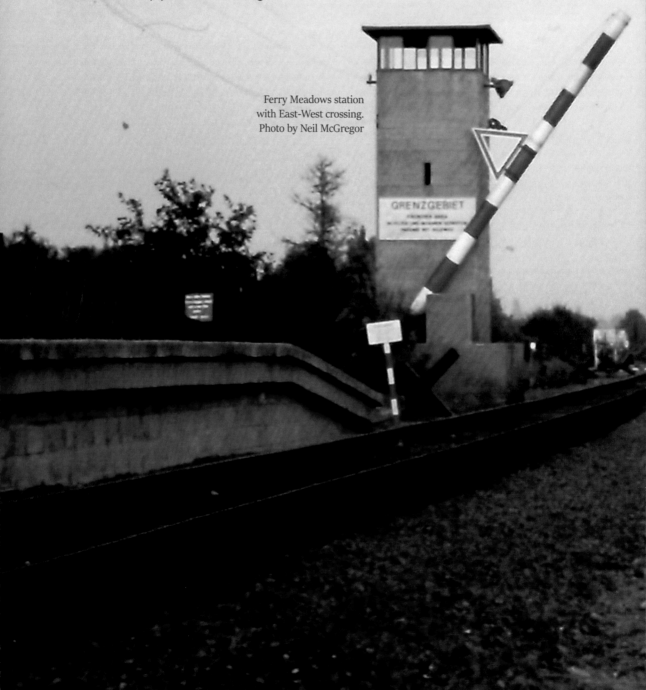

Ferry Meadows station
with East-West crossing.
Photo by Neil McGregor

GRENZGEBIET

I was present for the first week of filming, including the part where Steven Berkoff runs after the train as it passes through the border. After several run throughs, each of which required the train to be backed up, the soldiers to resume their positions, continuity checking consistency, the armourer checking guns to make sure they had plenty of shots left etc, I had quite forgotten about the machine guns firing. I was squatting down about six feet behind and to the left of the camera with the sound man crouched next to the left

of the cameraman and John Glen himself stood to the right. The various calls came 'Go train', 'Go Steven', 'Go Walter', 'Go guns'...

Machine guns start firing just feet away from me and I exclaimed 'F**K ME!' before slapping my hand across my own stupid mouth. Too late. John Glen looks down at the sound man, he is looking up at John Glen and nods!! John Glen shouts 'CUT, starting positions everyone please' before adding 'NOW, CAN WE HAVE SOME QUIET'."

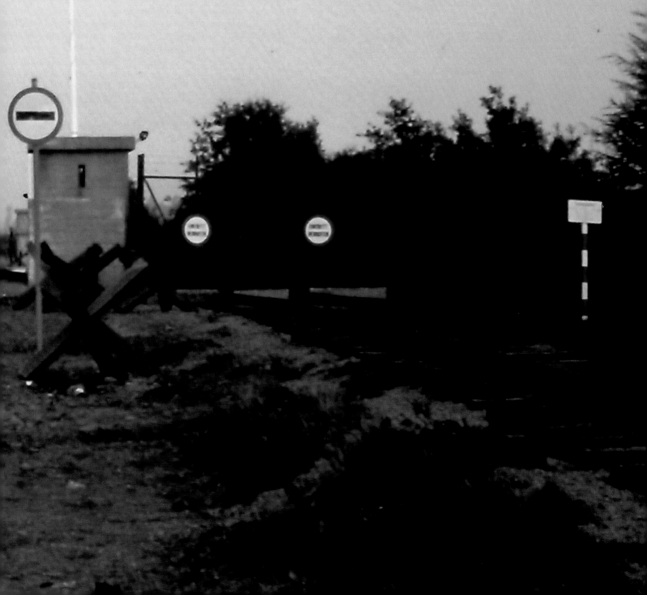

NVR's Yarwell Tunnel in August 1982 showing
the wooden steps put up for the Bond filming.
Photo by Neil McGregor

Another man in the civils gang was Mickey Winter, also one of the NVR founding members who's still helping to run the railway to this day.

"I was involved at the very beginning and went on the very first train of any sort that we ran. We called it the PHST 'Paten's High Speed Train' but it was just a little petrol engine and one wooden wagon! There was myself, Roger Manns, Richard Paten and a few others going down the line to check a few things out."

This would be the day they checked the measurements of the Lynch Farm bridge and concluded that if it was removed, the continental engines would fit. What was left of the stone stanchions is where the pipe was placed across that stuntman Paul Weston dived over doubling as James Bond during *Octopussy*.

"When we were fitting the facing point lock in the tunnel for *Octopussy*, I think it took about 2-3 weeks. I was there every day for the first two weeks of filming, doing whatever they needed from a railway point of view. So if they wanted anything moving or anything done by Nene Valley people, I was helping do it."

Mickey was signed off as a passed driver and kept the Swedish locomotive No 1178, renumbered 75 561 to look like a German loco, in steam during the shoot.  It was used to pull the green armoured wagon that had been built on the GNR low-mac wagon he owned. (low-mac being an abbreviation for low-machinery).

"After the filming, they took it all off. We still use the low mac in the civil engineering work we do, working in the civil's train to carry sleepers and timber."

NVR's Mickey Winter. Photo by Marc Hernandez

Assisting Mickey with the 1178 locomotive was Brian Pearce, MBE, who acted as the loco's fireman. Brian now runs the Railworld Wildlife Haven, which was founded in 1985 by his great friend, the late Rev. Richard Paten. After working with him to help to start the NVR, Paten purchased the land that had been the old Peterborough Power Station Coal Yard, initially with the idea to create a Museum of World Railways (MWR) before turning it into an environmentally focused project which Brian has headed up ever since. He received an MBE for his tireless work in 2019.

It's located just behind the NVR's Peterborough Nene Valley Station, which first opened in 1986 and is home to an array of railway memorabilia, a model railway, a lush Wildlife haven and an indoor visitors' centre. Brian works alongside the NVR to promote both. Working with schools and local businesses, he is enthusiastic about that summer of '82.

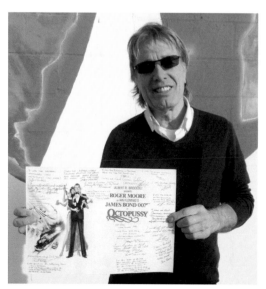

NVR's Brian Pearce. Photo by Marc Hernandez

at the end of filming. I got his autograph on a piece of paper which he signed 'Roger Moore' and drew The Saint logo joined up to the end of his name. I'd still got it at the time he came to film with us at NVR and he was so approachable. I walked up to him in-between filming, he had a big cigar and I said 'Roger, please can you give me your autograph?', he looked at this piece of paper he'd first signed in 1965 and said, 'But you've already got my autograph'.

'I know', I countered, 'but that was from when you were The Saint. You're 007 now. I want to see if it's changed!' He smiled and signed it again for me."

"Do you know what, it was just fantastic. Me and Mickey had 1178 in the siding at Ferry Meadows with the green lug on the back and it looked so realistic as if it really was armoured plated. But it was all made out of wood and then painted. I remember saying 'I can't believe how good this is!' because all the joints and bolts they'd made for it looked like they were welded. Mickey was the loco driver and I was up there with him telling me what to do when we had it in steam. I wasn't a trained fireman like some of others, but they needed a second man and Mickey talked me through it all."

The chance to meet Roger Moore on the set of a Bond film was a golden opportunity for Brian to get his autograph, even though he'd already got it as a 16-year-old when Roger had starred in The Saint.

"I went down to London on my push bike in 1965 to see a friend called Bruce Barker. I'd been at scout camp with him in the Lake District. Bruce's Dad was an electrician at Elstree studios and I was a big fan of The Saint so his Dad told us to wait outside in order to see Roger Moore

Meanwhile, Dave Reason was part of the Carriages and Wagons team that had painted all the CCT wagons in copious amounts of *Octopussy pink* paint.

"I started in '78 on the Nene Valley and there we were a few years later with 5 litre cans of pink paint all over the place. It was quite funny because the wagons were sat in the siding with another track in front of that and we had a trolley on flange wheels. We put all the spray gear on it and just went up and down, up and down, spraying away to our hearts content."

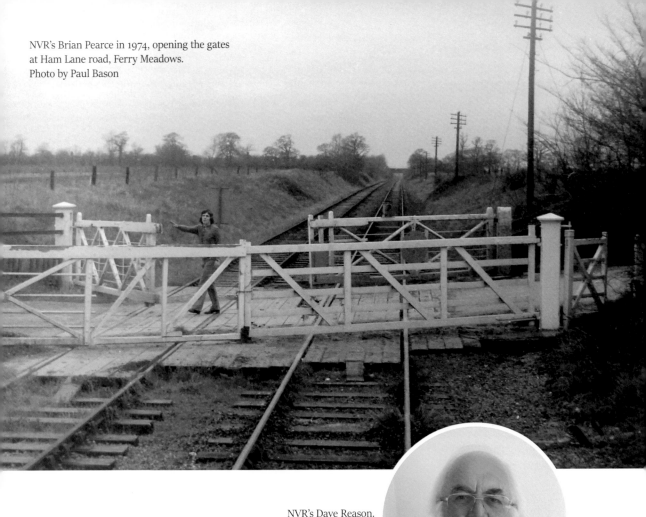

NVR's Brian Pearce in 1974, opening the gates at Ham Lane road, Ferry Meadows.
Photo by Paul Bason

NVR's Dave Reason.
Photo by Marc Hernandez

The CCT wagons had been built in the 1930s by LMS (The London, Midland and Scottish Railway) and were used for moving stately vehicles around in safety.

"In those days people would have their cars or whatever taken by train, hence the end doors so you could load a vehicle in and then the carriages were attached to trains. So, if Lord So-and-So was going off shooting in Scotland, they'd put his car in a CCT. He arrives at wherever, they back out the Rolls, Daimler or Bentley, and it's there for him. So that was the idea behind it and in those days the people who had the money could charter their own train."

Over the summer of 1982 Dave saw some unusual sights around the NVR as it was being turned into the East German station *Karl-Marx-Stadt*.

"Hutchinson's Haulage yard was directly behind the station building and of course you couldn't have all that on show. One day this vehicle turned up with an Auger and just drilled lots of holes in the ground and another turned up with cut down pine trees in the back and they just dropped them in the holes – instant green trees!"

Dave was friends with another Dave; David Martin, one of the NVR signalmen throughout the filming. In the Nene Steam 007 Filming special issue' he was mentioned by John Jeffrey, the NVR's publicity officer, in an article, re-printed on the next page.

## OCTOPUSSY – THE NVR EFFECT

*"There is no doubt that the 'James Bond' film contract is the biggest thing to happen to the Railway in years. Thanks are due to everyone who worked so hard, firstly during the weeks of preparation in July and August, and then during the eight long weeks of filming in September and October. The extension of the filming beyond the original agreed date and into October created many problems for us. These arose particularly from the fact that many working members had arranged their holidays to allow them to spend a week or two on the Railway during August and September, and the extension into October, although a welcome boost to our finances, did bring severe problems in manning, as members' holiday entitlement or special arrangements ran out. Still, we did manage to cover all the requests made of us by Eon productions and although many people played their part in our achievement, four in particular should be mentioned as being the backbone; John Pentlow, Alan Gladden, Gary Foster and David Martin. At least two out of these four were on site every day that the film crew was present, as well as on public operating days and all put in extremely long hours, often from 4am to 9pm on successive days. Thanks are also due to the management and staff of Peterborough Sugar Factory who allowed the Railway to store most of the rolling stock and locomotives not required for filming on their sidings during September and also for permitting some of the specialist work required on our rolling stock for Octopussy to be carried out at the factory."*

Over a pint of his favourite beer, David Martin remembered his summer spent with James Bond.

"For *Octopussy* they clad the signal box building to give it a continental look, which made it very tricky for me because you couldn't see your trains completely as it blocked your view. I was up in the signal box and sometimes there until midnight if we had to turn trains. I was then back again at six in the morning and you'd sometimes spend hours and hours with nothing happening. But they had to have a signalman in the box for insurance purposes. But I enjoyed it; we got fed enormously well, breakfast, elevensies, lunch, then afternoon tea, dinner and if we were working late, supper. I can remember having several chats with Roger Moore and after a while you'd forget he was a movie star as he was just so down to earth."

Being up in the signal box meant David had a good vantage point for seeing the NVR adapted for filming.

"We started off in the summer and finished

NVR's Dave Martin.
Photo by Marc Hernandez

up nearly in winter. The old somersault signals were replaced by dummy continental signals and they took the level crossing gates off and put continental barriers on which was difficult because it was still open as a main road between where Hutchinson's yard is up near the other end of the cottages. As the barriers were continental, they were on the wrong side of the road so it was a bit hairy at times particularly with Hutchinson drivers, but they soon got the idea. Then there were the trees. They were put up all over the place to make it look like Bavaria, and when they shot the Merc into the river,

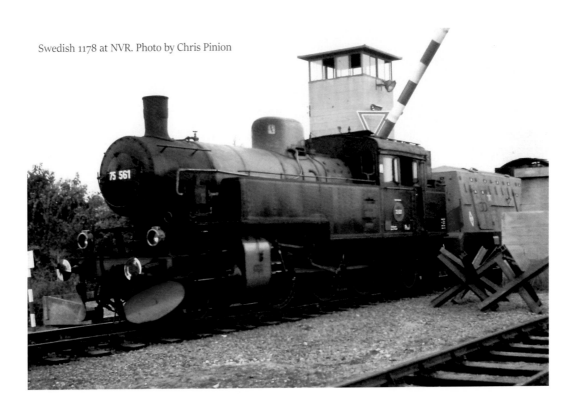
Swedish 1178 at NVR. Photo by Chris Pinion

I had some of the crew up in the signal box. I remember they got through no end of Mercedes because the engines seized up as they ran a lot of them in reverse when they were coming backwards all the way from Orton Mere up to Castor crossing. They had Thermic-siphon cooling in the engines, which was ok going forwards but going backwards they overheated very quickly, went red hot and seized."

Further down the line at Orton Mere is where the scene was filmed of a signalman pulling the levers that changed the tracks the Mercedes was travelling on. The signalman was played by Production Manager, Peter Bennett, but David also had stints during filming in the Orton Mere signal box.

"I had trips down to Orton Mere during *Octopussy*. The regular signalman was there, a lovely old guy called Dick Vickers. He was a retired driver, but was limited

as to what hours he could do. If they were shooting down at Orton Mere out of hours, I used to leap in my car and go down there, then race the train back by road to sort Wansford out. It was quite an experience."

Another person who helped cover shifts in the signal box, was one of my school teachers, John Rhodes.

"I'd been interested in railways ever since I was a young lad. I was a trainspotter like everybody of my age was. You'd go down to the local station and there'd be hordes of kids all with their little books collecting numbers. I also had an Uncle who was a signalman on the East Coast mainline and he used to let me go and sit in his signal box when I was down there. That was lovely. I'd sit and watch the A4's come down the hill to Grantham, the Mallard type engines as he was in the signal box at Great Ponton."

NVR's John Rhodes.
Photo by Marc Hernandez

So I was in one of the first batch of signalmen to be trained, passed my exam and was then let loose in the boxes! The big Wansford box which I think was originally about 60 levers and the little one at Orton Mere, so I worked both of those and I did it for around seven years."

His memories of *Octopussy* are short but memorable.

"I was in the signal box for a couple of days taking my turn as it were, so I had a good view of them setting up this rocket ramp on the side of the river as you could see that from the signal box window. They had about half a dozen cars that they were running up and down the track to see how they went and driving the train down towards them, but what I wanted to really see was them shooting the car into the river. Unfortunately, I wasn't there when that happened."

Also talking through his involvement was David Smith, former NVR chairman, who'd been with John Pentlow at the negotiations with Eon. He was also the guard on the train the day Martin Grace was seriously injured.

"It was explained to us that Martin would be going hand-over-hand down the outside of the Norwegian coach, and we set off. I was told he pulled himself in to get past one bridge, but the second one hit him. He hung on, where most other people wouldn't have been able to. He was being filmed from a helicopter running parallel to the train. Seeing what had happened, they landed in the next field and rushed across to the train. I was out the carriage by then along with the two qualified nurses that were part of film crew, and an ambulance driver who was with them. I suggested they flew the ambulance driver back to Wansford so he could bring the ambulance to the location. Then warn the signalman to have the gate shut, collect Martin Grace, put the ambulance on the

John's interest in railways waned after he went away to University and started teaching. But after getting married and with a young family, his interest was rekindled when he came to teach as head of English at Prince William School, Oundle in 1971 until he retired in 1999.

"I'd often go for walks at lunchtime down the track at the back of school. It led down to what was the old 'Nene Valley' track bed and over one of the bridges where the River Nene ran underneath. It wasn't until early 1977 that I joined the Peterborough Railway Society. By then I was getting interested in preservation, as in the intervening years all the steam trains and engines had disappeared. I went over to the Nene Valley and got involved with carriage painting, maintenance work and building further down the line. Then they were asking for volunteer signalmen and because I'd had an interest in signalling through my Uncle, I thought I'd give it a go.

road to rush him straight to Peterborough hospital off with blues and twos going.

Chris Pinion, fireman on the locomotive that day, helped bring the train to a safe halt with the late Malcolm Heugh, NVR chairman, driving that day. Chris recalled:

"I was on the right-hand side of the engine as fireman, with Malc driving. Where Martin Grace was moving along the train, I was on the same right-hand side and could see that he'd hit something. I called to Malc and we immediately slowed down to a halt. We had a walkie-talkie in the engine with us and were in contact with the helicopter, but there was a breakdown in communication because we hadn't been told to stop or anything before then. It was a terrible, terrible thing to happen, awful in fact and after Martin was taken to hospital, everyone was shaken up by it, the film crew and the train crew."

NVR's Chris Pinion.
Photo by Marc Hernandez

Location Manager Peter Bennett holding walkie-talkie as the water tank of the loco is filled courtesy of the Peterborough Voluntary Fire Brigade. Photo by Chris Pinion

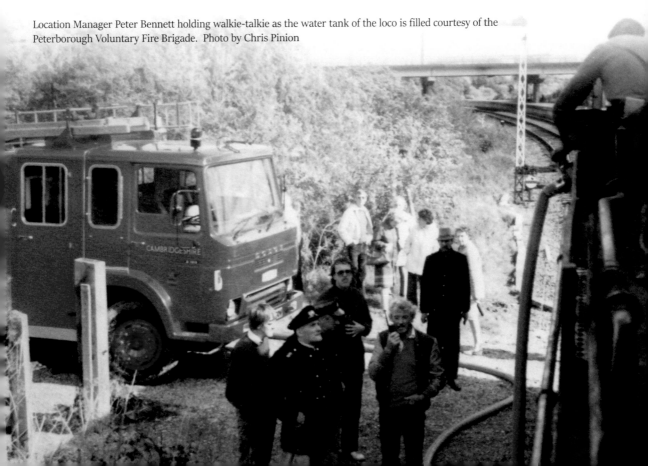

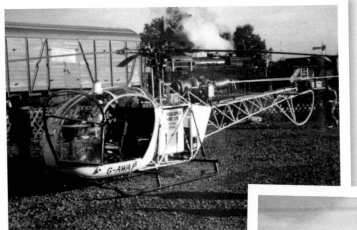

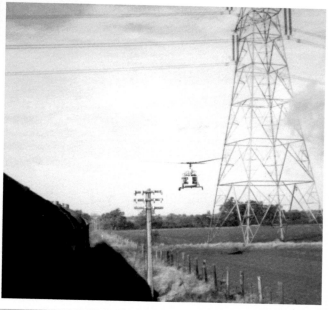

The aerial unit capturing the action.
Photos by Chris Pinion

# 8 THE GREAT DANE

The steam locomotive used to haul the *Octopussy* circus train during filming was owned by Mike Bratly, another of the NVR's founder members. He'd gone all the way to Scandinavia to find some of the continental locos that helped get the railway started and to later play such a key part in *Octopussy*. Sitting in his farmhouse kitchen, he told his story.

"I'd always had an interest in railways as we had the Midland line close by and as boys we'd go down to Lolham crossing and watch the big 178 Engines of LNER come rolling through. For me, everything started the day Richard Paten brought the 73050 to Peterborough. I read about it in the local paper, went down to have a look, met him and a few others and that was that. The first thing I ever did was help them build a makeshift engine shed. Richard acquired some old telegraph poles and I had some spare tarpaulin that we used for the roof."

For a Bond film that was based around the threat of a Russian invasion of Europe, the Swedish locos brought to the Nene Valley Railway in the late 70's had all been caught up in real life cold war politics.

"Sweden had electrified all their main lines, and in those days if Russia had invaded, they would've swept down through Sweden and the railways were the main form of transport, particularly in the winter when it was minus 40 degrees. They'd only have to knock out half a dozen power stations and all the electrification had gone. So, what Sweden did was put several hundred locomotives into storage in tin sheds with everything in the engines ready to go. They called it their 'strategic reserve'. All they had to do was fill them full of water; there was even coal and wood in the fire ready to light and go. They'd hung bags of silicone gel in the boiler to stop them from rusting, so within a few hours they could muster a fleet of steam engines, which meant the surplus became available. By the late 1970s they started to release all the steam engines that'd all been properly stored, and they were spot on. When you got them out they worked straight away and had seven or eight years of life in them before you had to do major overhauls. They were also relatively cheap to buy; you still had to get them over to the UK of course, but it meant we had something in working order to start with at the NVR, whereas most of the British ones were worn out and needed major work and huge sums of money spent on them. Money which we didn't have."

NVR's Mike Bratley
Photo by Belinda Moncaster

Amongst those that arrived was a Danish S Class DSB no. 740, the main engine used to haul the *Octopussy* Circus Train. In the film, it's implied that the train is owned by the mysterious 'Octopussy', played by Maud Adams, but in real life it was owned by Mike, who'd purchased it and arranged for its transport over to England in 1981.

"A few of us went over in 1978 and I got to know some Swedes who said there was a Danish one for sale, and that's when they told me about 740. There were 20 in the class. It was a tank engine which was used for suburban services between the capital and Helsingborg."

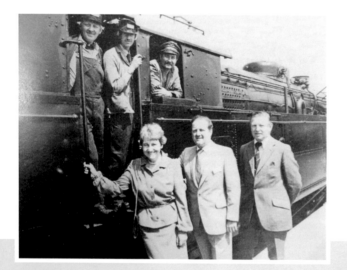

Dame Margaret Weston, the Director of the London Science Museum from 1973-1986, came to the NVR for the unveiling of DSB 740 following its arrival in the UK in 1981.

"The Science Museum had a railway branch at the time and were interested in the different aspects of the design of continental locos from a scientific design point of view. We had name plates cast and

**Insert:** Dame Margaret Weston at NVR for the unveiling of DSB740
**Main photo:** DSB740 after its Octopussy make-over. Photo by Chris Pinion

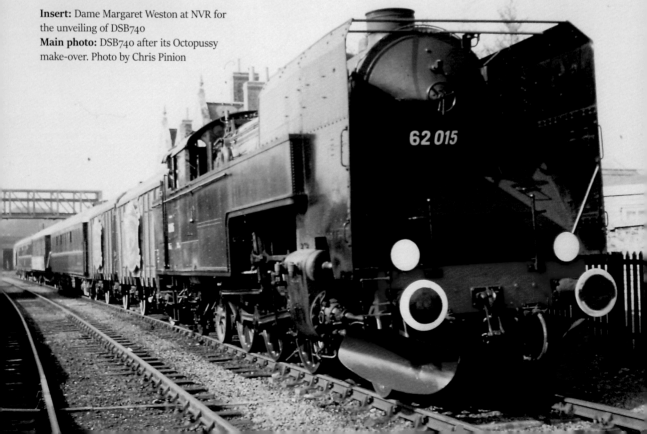

Dame Margaret came to unveil it. Everyone at the NVR referred to 740 as 'The Great Dane' and this was the one they disguised in *Octopussy* with the no. 62.015 as it was near enough to what looked like a German engine. We did roughly 30-40 mph during filming, but it could get up to a lot more. The line was 70mph during its live years, and we maintained it a lot better than it was in its last BR days. Any rotten sleepers had been replaced and the metals were just the same if not better. This was required in order to satisfy the Government railway inspectorate who gave us a clean bill of health and the light railway order for NVR to operate. I look back on those days with a lot of pride at what we achieved."

Mike was good friends with Malcolm Heugh, who passed away in 2010, but during *Octopussy* was involved in a lot of the film work as many of the other NVR old boys have mentioned.

"His father was a driver at Boston, so he'd been brought up on the railways and would hop on his Dad's engine when he was a boy. Malcolm had the experience and knowledge and was a very practical sort of man. We all came in to it new, so we learnt a lot from him as he passed his knowledge on. But he was head and shoulders above the rest of us. No two ways about it. I worked with Malcolm a lot over the years, and if I could fire for him on the Christmas trains, we were happy as larks."

Despite owning the DSB 740, Mike looked after the Swedish locomotive, S.J 2-6-4 T 1928, that was used for background shots at the station throughout much of the filming.

"I was in charge of the steam engine (1928) but couldn't be there all the time, as I had a farm to run. They showed a shot

of the side of the engine in the film and at times they set up a smoke machine to make it look like steam was coming out. It was marvellous the way they married up all the scenes."

Breaks in filming gave Mike an opportunity to see some of the methods the production crew put into operation.

"For the bullet holes in the side of the Mercedes they got a round chisel, bashed holes in every two inches or so in a line from the outside where the bullets were going to go. Then they inserted a little explosive charge, only the size of tiny lightbulb with a wire, filled it full of filler and then inside the boot they had a rotary device with an electric motor. This effected a serial contact with the next bulb so when they wanted to go, they pressed a switch, and each one blows up and blows the filler off. Hence you got the bullet effect in sequence. Very clever. They'd then have to re-do it but within a couple of hours it was all beautifully smooth again! They were all past masters and only employed the best. This included the carpenters who built the watchtower at Ferry Meadows, all out of wood but covered with a thin skin to look like concrete. All the people working on the scenery were absolutely top class. It was tremendous what they did."

Mike also gave a brief explanation of the art of firing a steam engine by one of the NVR's first masters.

"Steam engines are difficult things to fire. You see them on television and think 'They're just shovelling a bit of coal in', but if you watch, you'll see they just tip it down, and then after a bit the fireman will say 'I'll put a few on'. I always used to tell the youngsters 'When you first try to fire a steam engine, you can't make the blasted thing steam. Then after a while you can

make it steam but can't stop it. But when you're a good fireman, you can have the correct amount of steam in hand. If you're blowing off, which looks impressive, I used to tell them 'That's your elbow grease and the company's money going up there!'"

The 'Great Dane' DSB 740 left the NVR in 1995 and returned to its native Denmark after years of dedicated service and steam engine immortality as part of the *Octopussy Circus* Train.

"I was at the NVR until the end of the 1990's, but I had broken my leg so wasn't as mobile as before. There were plenty of others involved at that stage, but 1995 is when 740 went back. The DSB's hadn't been as well preserved as the Swedish ones so it didn't last as long, only three or four years. Then one of the big tubes had started leaking. We took it out of service and said we'd repair it, but we didn't know a lot about repairing them in those days. That's all come since, and now they can do major re-tubes and everything. But she stood there not doing anything for years, which was a shame. Then a Danish club enquired about buying her, which I was pleased about, and they took her home."

Mike then told me a little about his late daughter Rachel, who became an extra in the film as one of the circus girls.

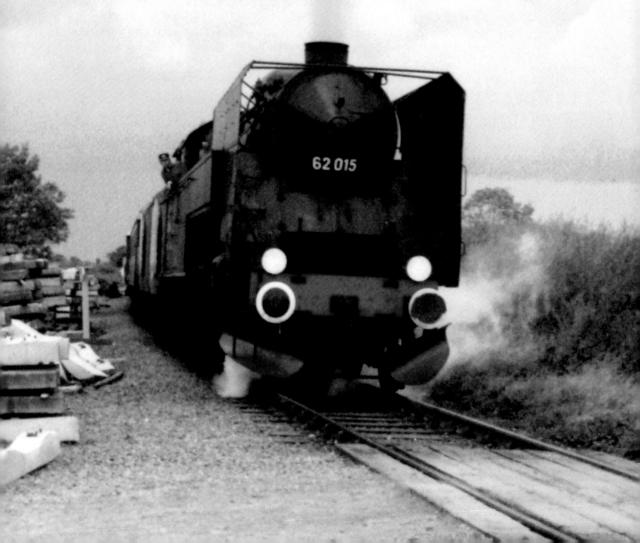

"One of my daughters, Rachel, was an extra. She appears in it, a fleeting glimpse in one of the coach windows. We lost her some years ago..."

Mike's voice trailed off and I didn't want to bring up painful memories, but my conversation with Mike made me wonder what had become of one of the least known vehicles in James Bond history. Mike dug out some correspondence from (NSJV) the Danish Rail Club that had bought it in 1995 and I was able to get in touch with them. Michael Randrup, NSJV chairmen replied telling me:

"Yes, we still have the S740, however not in operational condition. The Danish Railways are in the process of installing the new ERTMS signalling system, and this will affect our ability to run on main-lines, and until we have found a solution to this problem, S740 is "downgraded". Michael's colleague Knud Sinding then sent me a more detailed email:

"As you may remember we acquired this mighty locomotive. No. 740 from Mike Bratley, but nothing has happened for a long time, not least because of signalling uncertainties. However, before the project to return the loco to main line service ground to a halt around 2000, quite a lot had been done. The boiler had been retubed and the frames stripped, cleaned and repainted. Axle journals turned and bearings turned and bearings re-metalled, chassis re-wheeled, a new coal bunker constructed and mounted on the chassis. Lots of work remains and at the moment the loco is stored under cover and as soon as we are able, the next major task will be the manufacture of a new boiler and the installation of a completely new electrical system. It is an annoying fact of life that we can't do overhauls by magic, particularly for me. I went on my first steam special with this loco in 1967 at the tender age of 6, which is why I was also involved in setting up the project to repatriate the loco."

I rang Mike to tell him, and we were both encouraged to hear '740' hadn't become another relic of the cold war, broken up for scrap or languishing at the bottom of an icy Nordic fjord. It made sense that if it wasn't at the NVR that it should be back in its homeland and being looked after by someone who had fond memories of it from their own childhood.

DSB740 still bearing the 62 015 number, in 1995
Photo © M. Søhus

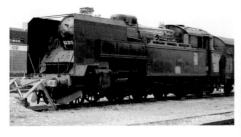

DSB740 back in Denmark, 2003
Photo © Jernbanen.dk

# 9 A SMASHING GOOD TIME

The other main steam loco used in filming was the NVR's Swedish B 101. It was used as the express train that appears to smash into the Mercedes and send it flying into the river. Keith Hopkins, one of the longest serving NVR engine drivers, was on the footplate back in 1982, having just started as a fireman.

"I joined in 1980, first just painting the insides of a carriage, but then I went into the engine shed and it went from there really. I soon got onto the footplate, because you start off as a cleaner, a trainee fireman. I progressed from there and I've been going ever since."

By the time of the Octopussy filming, Keith had become one of the NVR's regular firemen and was rostered to work the day the head-on smash with the Mercedes was filmed.

"The film crew were arriving at 8 o'clock in the morning and wanted to be able to do filming straight away with the train, so we had to be there at 4 o'clock in the

morning to get the engine in steam. Ideally you want a minimum of 4 hours to get the engine in steam; you can do it quicker, but if you rush it, it's easy to damage the boiler. So, they were all early starts at 4am for the engine crews. I only did two or three days on the film, but didn't know exactly what I was going to be involved with until the day. They obviously had a schedule, and the driver that day was Malcolm Heugh, the NVR chairman, who was a part owner of the Swedish B 101 engine. He was a lot more heavily involved and almost certainly knew what we were going to be doing. But I just went, lit the fire, got it in steam and waited."

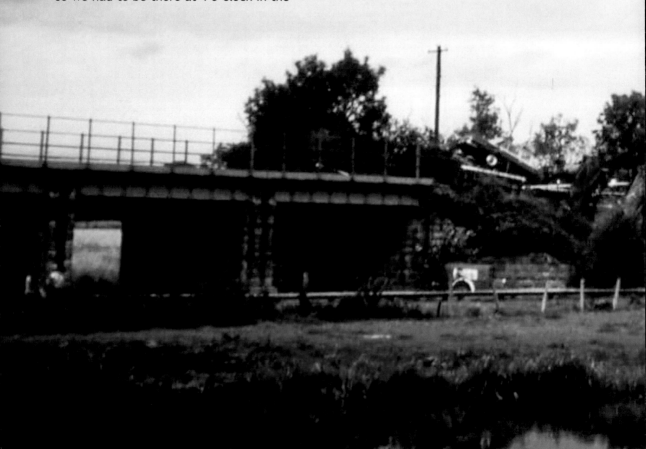

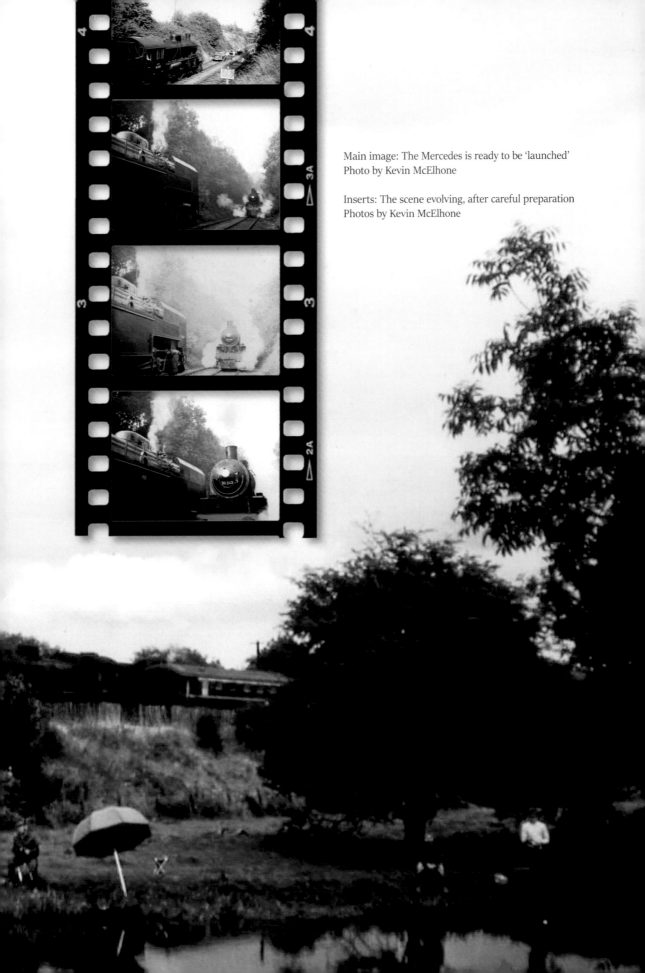

Main image: The Mercedes is ready to be 'launched'
Photo by Kevin McElhone

Inserts: The scene evolving, after careful preparation
Photos by Kevin McElhone

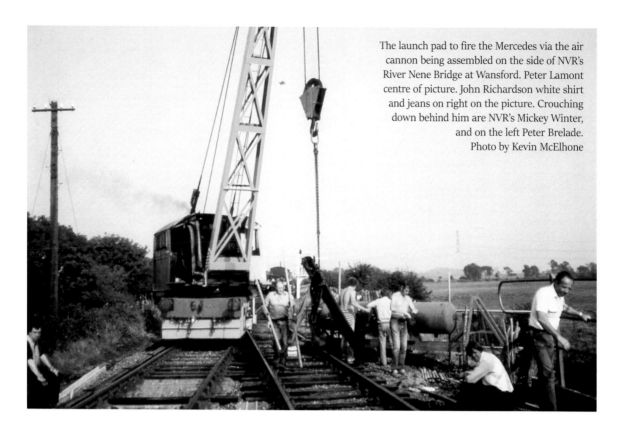

The launch pad to fire the Mercedes via the air cannon being assembled on the side of NVR's River Nene Bridge at Wansford. Peter Lamont centre of picture. John Richardson white shirt and jeans on right on the picture. Crouching down behind him are NVR's Mickey Winter, and on the left Peter Brelade.
Photo by Kevin McElhone

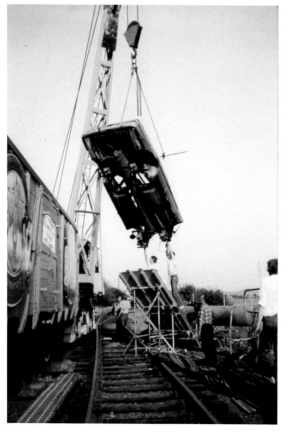

The Mercedes being lowered on the purpose built ramp and air cannon. The crew nicknamed the launch pad area *Cape Canaveral* which is referred to on the call sheets. Photo by Kevin McElhone

When Keith found out what they had planned, he took it all in his stride.

"On the front of the engine they built a cow catcher which was engineered particularly strongly. They wanted to make sure that when we ran into the car it didn't go underneath the engine, and possibly de-rail us. It had to be quite substantially engineered to make sure it crunched the car up, and we didn't run over the top of it. A cow-catcher isn't something they use on European Railways, but it was ideal for filming and that one shot is all we filmed that day. We had the Mercedes tied to a steel rope and we just kept pulling it slowly towards us.

Then, backing up and pulling out slowly, it just stretched the steel rope until they knew, and were confident, of where we were going to hit it. They made sure they got the cameras in the optimum position, and then it was a case of us just going for it when they shouted 'Action'. We then came out of the tunnel, not particularly fast, I should think we only got up to 25mph."

If you watch that particular scene in slow motion, you'll see that on the moment of impact you get the briefest of glimpses that shows the cow catcher Keith refers to.

"I also did a day just sitting about on the Swedish 1178 that they used, but just keeping it in steam on the turntable to create an atmosphere for background shots. Again that was an early 4am start and I had a couple of dinners in the big tent, but the stars had gone by then. I remember when they came to fire the car into the water, they couldn't get it into the river in one shot. For shot one, they had to fire the car across the engine to make it look like the engine had hit it. And for shot two to see the car flying up in the air, they shot it into the river."

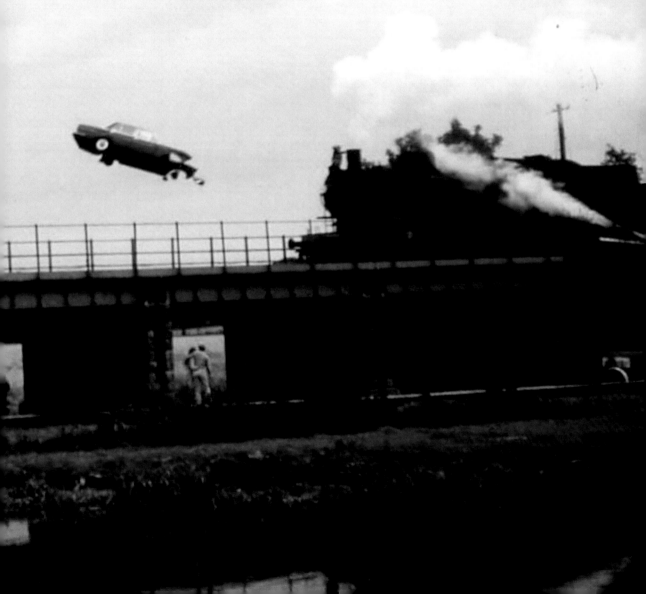

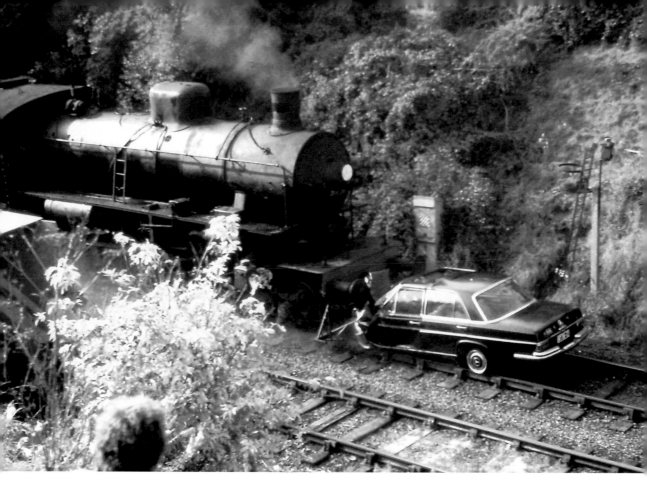

Swedish B 101 hitting the Mercedes. Photo by Chris Pinion

Thanks to Keith's involvement, he was fortunate enough to attend the *Octopussy* crew screening at the Odeon, Leicester Square on 5th June 1983 which began at 10.30am.

"They gave Alan Gladden and Gary Foster tickets which were personally sent to them. However I won a pair of tickets in a raffle because there were a few spare that the NVR had been given. They had decided the fairest way to decide who went out of the volunteers was to raffle them off. I took my wife, Di. I remember going down on the day and being with Chris Pinion and his wife Carole, who was one of the NVR directors. There was around 10 or 12 of us."

NVR's Keith Hopkins
Photo by Marc Hernandez

80

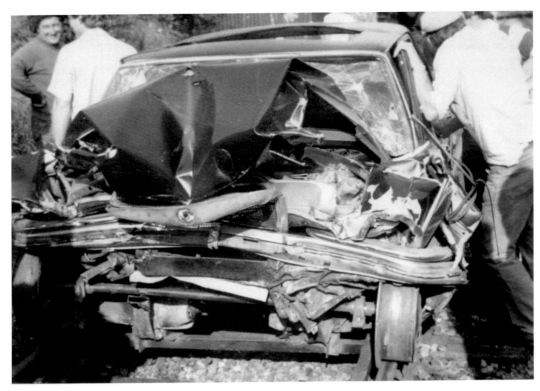

What would be left of your Mercedes after hitting B 101
Photos by Chris Pinion

Over the years Keith has continued his involvement with the NVR and is now one of the railways most experienced engine drivers, still driving when time allows. He's served as the NVR Chairman and now runs 'Keith Railwayana' at the NVR HQ at Wansford, specialising in all sorts of railway related items.

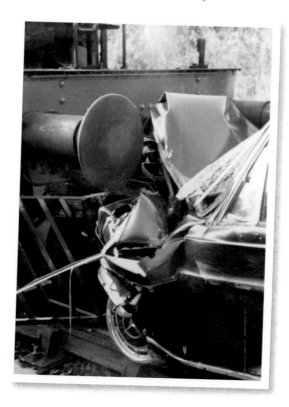

# 10 THE SHEDMASTER'S MUM

In the *Nene Steam 007 Filming Special* issue from 1982, Alan Gladden wrote the below article detailing his department's role. Alan's life was tragically cut short in 1988 after battling with a rare lung disease, but as one of the founding members of the NVR and shed master during *Octopussy* he made a significant contribution to both. Keith Hopkins was a close friend, and put me in touch with Alan's mum, Olive, who ran the NVR Shop during 1982.

## LOCOMOTIVE NOTES

"Work has revolved around the James Bond filming since August. Three locomotives have been directly involved, 1178, 1697 and 740 but several others notably 64- 305, 80-014 and 1928 were used as backgrounds. Initially work was concentrated on 740 which although it had been steamed during 1981, had not worked in regular service since 1964. After much effort this impressive machine made its debut in NVR public service at the end of August and, once one or two bugs had been ironed out, gave sterling service during the eight weeks of filming. At the same time 64-305 was given a complete repaint and renumbered, temporarily, 64-330. It was not possible to steam this locomotive as some work remains to be completed on the boiler but the bulk of work is now completed and this popular locomotive should be back in service for next season. Little work was required on 1178 or 1697, although the latter was fitted with a 'cow catcher' or perhaps it should be more properly called a 'car catcher'."

NVR's Alan Gladden. Photo: Peterborough Volunteer Fire Brigade

"Alan worked at Baker Perkins for a long, long while and then him and his mate Colin Pick decided to leave and go for a smaller rate of pay at the Nene Valley Railway. Alan was working full time there as he was the shed master and the way they used to do it then was the shed master was in charge of all the loco crews. I ran the shop and Alan would go along the track at the end of each day they filmed *Octopussy* and pick up all the empty shells. Rather than throwing them away, I then sold them in the shop for 50p each! I sold no end of them. I got a letter from Sir Ivor Baker saying that I'd made more money that year in the shop after *Octopussy* then they'd ever done."

Olive recalled how Alan found a kindred spirit in Roger Moore when it came to headwear.

NVR's Olive Gladden
Photo by Marc Hernandez

"Alan was one for wearing different kind of hats. That summer I remember he had a straw one on a lot of the time, and at one stage he had some of those swingy things you'd wear on your head. (deeley boppers). Alan had one and he gave another to Roger Moore. He put them in his pocket and Alan thought that was it. Then during one of the scenes, Roger Moore walked out from behind a train wearing them on his head! We all had a good laugh at that, but Roger Moore was ever so nice. Whenever I see a film of his on the telly I always watch it."

It wasn't just the bullet shells Olive was able to recycle from what was left behind by the Bond film crew. She pointed to her wall and said:
"They had paint left over from doing up the wagons and they gave us some. For a while this whole house was painted pink. I don't know how Alan kept it up because he'd started to get poorly before then and he couldn't get to the cinema preview. On one of those call sheets is a message from a day Alan had to go to hospital for tests. They wrote something like 'Get back quick, else the bloody film will pack up!" A flick through reveals the specific call sheet Olive is referring to. Under 'Additional Notes' is a typed message from one of the 2nd unit Assistant Directors, Michael Zimbrich, wishing Alan a speedy recovery.

Standby Crew Leave Hotel 7.00am.

Standby Truck )
Camera Truck ) on Location 7.15am.
SFX Truck )

We would like to say a big thankyou to Alan Gladden and hope his trip to the Hospital is successful and if we don't get this Bloody! Train right we'll all be joining him by next weekend!
We wish him a speedy recovery.

MICHAEL ZIMBRICH
ASSISTANT DIRECTOR

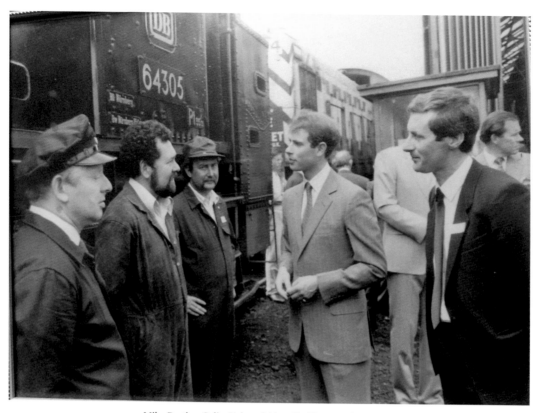

Mike Bratley, Colin Pick and Alan Gladden meeting HRH Prince Edward at NVR in 1986.
Photo by Olive Gladden

It showed what a big part he played and how popular he'd been with the film crew. Unbeknown to everyone, Alan had contracted a very rare heart and lung disease and, after a brave and courageous 5-year battle, passed away on February 27th 1988. Alan's funeral took place on Friday 4th March at Peterborough Crematorium with Rev. Richard Paten conducting the service. It was attended by nearly all the NVR working members, many of whom had to stand around the door of the crematorium due to the large numbers.

Following their son's death, Olive and husband Les both became involved at the Bygone Village, Fleggburgh, Great Yarmouth in Norfolk, close to where Les grew up. The two locomotive engines Alan owned at the time, the Swedish 2-6-4T (1928) that had been seen in Octopussy in the background at the station, and a

Swedish Railcar (1212 Y7) that arrived at the NVR in 1983, were both put on display at the Bygone Village.

"At the unveiling ceremony, the local paper was there to cover it and one of Alan's favourite comedians, Bobby Ball, came to it. He was doing a summer season on Great Yarmouth pier and read out a speech that me and Les had written."

As the years have gone by, and following the passing of Olive's husband Les, the Swedish 1928 locomotive is now in private hands with a train collector. Swedish Railcar 1212 Y7 was eventually bought back to the NVR and restored to full working order. In 2012 Olive was invited to see its return to traffic and it now regularly features in special events at the NVR. Most recently it was used in a segment on BBC1's Saturday Kitchen with presenter

Olly Smith, a big James Bond fan and friend of Roger Moore, using it to arrive at the Peterborough NVR station for a look around Railworld. Olive and Les also had a memorial bench dedicated to Alan which can be found on the platform at the North Norfolk Railway, Sheringham.

I showed Olive the NVR Octopussy photos from Macaroni and I notice the blurred figures of four men. One is wearing a straw hat which prompts Olive to say "That's definitely Alan…. Well I never… good old Macaroni!"

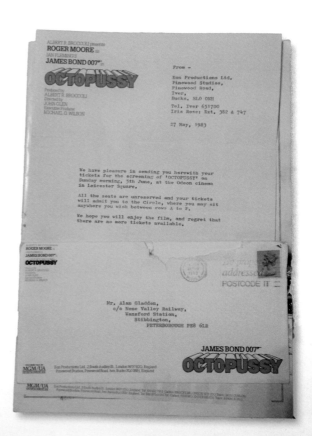

**Main image:** Alan Gladden (with the straw hat) in one of Kevin McElhone's many *Octopussy* photos
**Insert:** Alan's *Octopussy* screening invitation

# 11 20/20 VISION

Having heard from the majority of NVR personnel involved, it's time to focus on the local extras who took part in Octopussy. In early August 1982, the following article appeared in the Peterborough Evening Telegraph.

## NENE VALLEY SPY TRAIN

"A chance to team up with Britain's best known secret agent and appear in a blockbusting film is being offered to local people. The producers of Octopussy, the latest James Bond film, are looking for extras when they come to the Nene Valley Railway to film next month. About 20 young men with short hair are needed to act as soldiers and about 20 "nice looking" girls are also wanted. A moving circus is going to feature in the film, and circus people of all ages are also wanted. Anyone interested should contact Eon Locations production manager Mr Peter Bennett on Stamford 782437. Carpenters and painters are busy converting the station at Ferry Meadows, Peterborough into a German border post for the filming which starts next month. Twelve men from Pinewood Studios have built a watchtower and clothed the station in a new wood frame. Roger Moore and other big-name stars will be visiting the railway, and the filming will take about a week."

Two days later a follow-up to the appeal for extras appeared in the newspaper...

## BITS PART BONANZA

"Hundreds of would-be film stars are lining up for walk-on parts in the latest James Bond movie. An appeal in the Evening Telegraph for extras for the new film, Octopussy, brought a flood of more than 200 inquiries in less than 24 hours. Roger Moore and other big-name stars will visit the Nene Valley Railway in Peterborough early next month to make part of the film, and workmen are busy preparing the sets."

Scouring through the newspaper archives I was hoping to find a black and white photograph of the 20 men chosen to be soldiers and the 20 "nice looking girls" all standing back-to-back with each other, hands raised and making gun shapes with their fingers. If I had been a local journalist at the time and not a 9-year-old school kid, that is what I would have had them to do; preferably along with their names to make it easy for someone to find them in later years. Instead, the next mention of the extras is dated Wednesday 8 September, two days after cameras began rolling at the NVR.

## THE HARSH REALITY OF AN EXTRA'S LOT

"Ready when you are... but the happy state of "cameras roll" is punctuated by long periods of waiting in the wings. The so-called glamour of the film world boils down to the harsh reality on a dull day in Peterborough. While the likes of super star Roger Moore and his leading lady Maud Adams take the new Bond film Octopussy all in their day's work, the extras on set are in a new world. It's a world where time costs money and plenty of it - but where shots lasting a very few seconds seem to take forever to record, And that spells hours simply waiting around until the scene is set and the cameras are ready to roll. During the Peterborough filming many of the extras being used are from the area. Almost 1,000 young men and women besieged the film makers when the call for volunteer extras went out. Around 20 men and 10 girls were picked as extras from the area.  Their day on the set at the NVR started at 8am with a costume fitting, make up, hairdressing... then began the big wait. Life as an extra consists of standing around in groups waiting for someone to tell you where to stand and what to do."

The article continues with a short quote from one of the people interviewed, Rachel Bratley, Mike Bratley's daughter, who sadly passed away in 2008.

*"Rachel Bratley from Bainton, near Stamford is one of the extra Octopussy girls. 'It took about two hours for us to get made up as there is a lot of waiting as you queue up for the make-up artists. It's all very interesting especially when you have done nothing like this before. It's amazing how they can just get people together and make them do what they want. There's a lot of waiting about but I brought a book with me to keep me occupied'."*

I printed off a copy of the newspaper page which also had a photo of Rachel in it and contacted Mike Bratley to let him know. When later at his farmhouse, I handed him the cutting and he's a little taken aback at seeing it. I expected he might have been, but I did not expect this.

"I've got something here you can have if you like", and from his jacket pocket pulled out a tie. The one with the Octopussy logo that he wore to the crew screening at the Odeon, Leicester Square in 1983! It was one of half a dozen John Pentlow had had specially made for the NVR members to wear.

"I shan't be needing it anymore, but I'm sure you'll look after it." I'm happy to accept it, but under the proviso if he ever needs it back to wear at any point all he's got to do is ask. Being handed the tie that belonged to the man who owned the Octopussy Circus Train locomotive and whose daughter had been one of the extras travelling on it, felt like Mike was subconsciously telling me to go off and find as many of the surviving extras as I could to document their stories; either that or it was his subtle way of telling me to stop bothering him about James Bond.

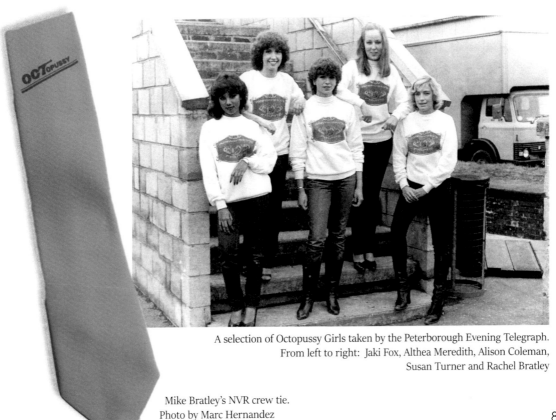

A selection of Octopussy Girls taken by the Peterborough Evening Telegraph. From left to right: Jaki Fox, Althea Meredith, Alison Coleman, Susan Turner and Rachel Bratley

Mike Bratley's NVR crew tie.
Photo by Marc Hernandez

87

# 12 THE FISHERMAN IN THE BROWN JACKET

In 1982 Britain was in the grip of a crippling recession. Unemployment was at a record level with over 3 million people out of work and Peterborough, like many cities, was heavily affected. Sitting on his sofa to discuss that summer of '82 with me, was John Atkins.

"I was 26, had a wife, a 2-year-old daughter and at the time was struggling to get a job after being laid off at the place I worked at. When I saw the advert in the paper that they were looking for extras it was like heaven sent, the chance of paid work. And even though I'd never done anything like it before, I phoned up and was invited to an audition".

These were held at *The Wirrina* in Peterborough, a popular indoor entertainment venue with a big sports hall that was used to audition hopefuls.

"You went down to *The Wirrina*, queued up, gave your name and you sat in twos in chairs. They took a polaroid picture of you, and then you waited for a phone call. I was one of the lucky ones."

On the first day of filming, Monday 7 September 1982, John went to Wansford Station which was standing in for *Karl-Marx-Stadt*. He went with his friend Paul Carrington who he'd grown up with, and who also had a role as an extra.
"There was a queue of people going into a cottage by the side of the railway that they were using as offices. All those that were going to be soldiers were having their heads shaved and because I had shoulder length hair I said 'What's all that about?' because you got no extra money for having your hair cut. They said, 'You've got to have your hair cut' and I said 'I'd rather go home! I'm not having my hair cut'. I mean, now I prefer my hair short, but in the end they said, 'No, no no, don't go, we'll find something for you'."

Refusing to have his hair cut ultimately would lead to John taking part in a pivotal action scene, but before that happened, he had a few minor background walk-on parts, none of which made it into the actual film.

"The first day I was civilian on the station, they were filming with the Russian soldiers, and I was stood with another guy, like we were waiting for a train. It was part of the scene where Bond drives through the border post, but there's only so many times you'll turn and act surprised when you hear gunfire. So at one point me and the other guy were having a 'Pop quiz'. He'd got a book and was asking me questions on 50s and 60s music. I also kept cracking up because I kept seeing Paul dressed as a soldier marching, patrolling if you like. I just kept laughing because I know what he's like, what a character he is and it was funny because I could tell he was really trying to act."

John became part of the filming for the duration that extras were needed and has clear memories about his time on set

NVR's John Atkins
Photo by Marc Hernandez

"What used to happen is you'd turn up at the railway every day and wait for your name to be called. You were then given a piece of paper, a day contract, and it'd have your name on it. You'd keep that piece of paper because that was how you got paid. You'd go into the office they set up in one of the cottages at the end of each day and they'd pay you day by day. It was £15 and I always remember they stopped your national insurance out of it so you came home with about £12.75, somewhere in the region of that. But for the time, it was really good money. The thing that struck me, because I knew nothing about filming on location, was that all down the street they had trestle tables of food. When you first got there in the morning there would be teas, coffees, orange juices and breakfast foods, but the one rule was 'The film crew went first' and then you went. But there was masses of food, so no one went hungry. All those trestles would be set out and you could have as much as you liked. And the great thing about the food was the amount and how well they fed us. The £15 you were paid for a day's work, now became £25 with the quality of it. Then they'd commence filming and they'd say 'Right what we need today is..' and away we'd go."

After being a civilian standing on the platform, John was asked to be a circus roustabout and wore one of the grey circus roustabout jackets similar to the one Roger Moore dons to blend in at the station.

"You had to sign for the jacket, in and out. I think everybody was trying to get one as a souvenir because it had '*Octopussy's Circus*' on the back. I had one of them on for a day, running about in it and around the station area, just being one of the crowd if you like, looking busy and making up the numbers. There were people rolling elephant stands and things to do with the circus ring. I remember Roger Moore being there, because at one point he was hiding behind this truck and then came around with a pair of moon-boppers on his head. Other than that, I only saw the stars from a distance."

John then became a passenger on the circus train and explained how the extras wiled away the hours during the fight scene between Bond and Gobinda

"They were running on top of the train and all we did for over eight hours was sit in the train. We stopped in between filming for food, but there was a guy on the train that knew how to connect the beer barrels up in the refreshment wagon, so we sat there and had some beer. We didn't drink it all, only two or three pints. This particular day they were filming from a helicopter and we weren't supposed to look out the window at the helicopter; that was an instruction we'd been given. As we were riding along, you could see the shadows out of the window of them up on the roof.

After being a passenger on the train, John landed his biggest role as an extra and the only one that made it into the finished film. He was the fisherman in the brown jacket standing in the river when

the Mercedes lands on top of the fishing boat. You can even see his shoulder length blonde hair.

"Refusing to have my hair cut worked in my favour and because I was willing to do anything I think that's why I was asked. On the days when I wasn't needed as an extra, rather than go home and not be paid, I just helped clean up and tidy things away. I think it was Peter Bennett who said 'How good a swimmer are you?' When I confirmed I was a good swimmer, he said 'Well, we'll pay you extra if you stand in the water when we do this next scene'. I said 'Gladly, I'll do it!' so they gave me an old brown jacket, a pair of body waders, bib and brace type of thing and I just stood into the waders. The rod I was given was a proper rod, but it hadn't got a reel; it'd got a piece of line tied to the end with a float, no hook or anything because I wasn't actually fishing. Once everything was set up, they shouted 'ACTION!' and everybody was quiet on the set. The two stunt men are sat in the boat and I was stood in the water like I'm fishing. They told me to expect a loud bang and said 'We want you to act surprised'. 'Act surprised?' Well it frightened me to death and you can see it from my reaction in the film!"

John's reaction at hearing the sound of the air-cannon firing the Mercedes into the river caused him to stumble and almost topple into the water.

"The loud BANG was absolutely incredible! People won't realise but all this water came into my waders from the river. They were waist height and filled up with water but I managed to step out and when I walked back up on the bridge after the scene had been done, one of the crew was smiling and he said 'Great bit of acting. But it weren't acting was it?!' I said 'Not at all, I've never been so frightened in my life!'"

While John was counting his lucky stars, the Mercedes had been flying through the air away from him, the stuntmen sat in the boat narrowly avoided being hit by it.

"They were trying to find a boat to use for the fishermen and they went to 'Cuddler' Tyers, as he was the only person with a rowing boat. He lived a bit further down in one of the cottages set on the right-hand side under the bridge. I remember them saying to the stunt guys 'This has cost us £35 so look after it!' They told me 'You'll be in the water, but it's all been calculated and worked out. The car's going to land 10 feet away from the boat which will cause a bit of a tidal wave and the stuntmen will fall out the boat'. That was all planned, but the car actually hits the boat, so it was fired off the bank, came down, hit the boat, I'd got one eye on them and one eye on not falling over, but I had a look and one of the stuntmen had come up. But the boat had gone down! Bang! Sunk! The other stuntman didn't come up for what seemed like a lifetime. Then all of a sudden he popped up and we knew he was alright but he was yelling 'I thought it was meant to land 10 feet away!' "

The two stunt-fishermen in the boat who had to jump clear were Richard 'Dickie' Grayson, and Reg Harding. In the film it looks like the car flies over the bridge and lands in the river in one take; however, this was down to careful editing as the scene was shot in two separate sequences.

"First they fired the Mercedes over the railway bridge so that it landed on the riverbank, then they set it up again on the riverbank to fire off an air cannon into the river and to come from my left-hand side. It flies over and lands in the river. But if you look at it logically, the danger wasn't towards me, it was all towards the stuntmen."

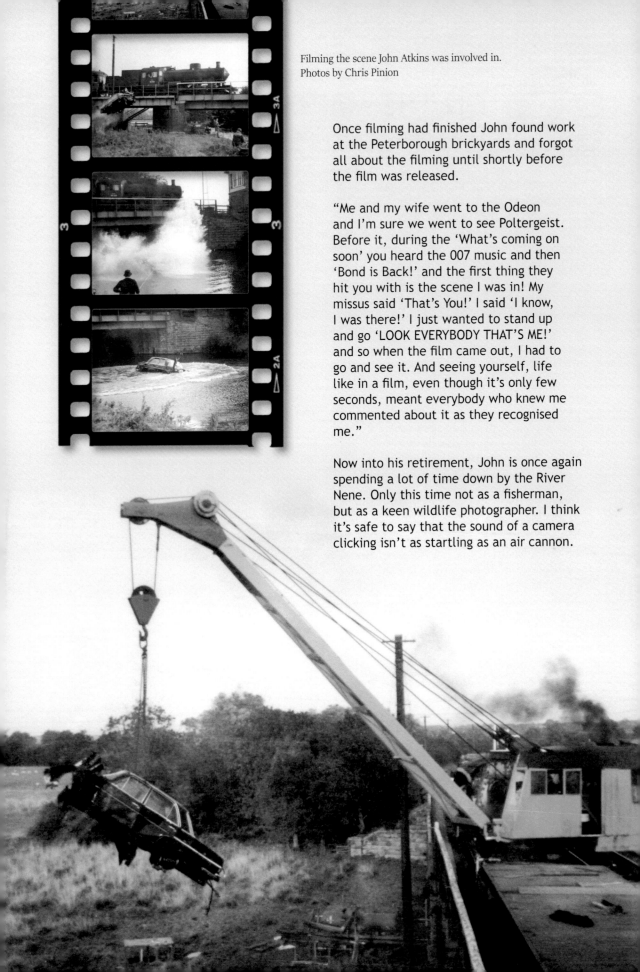

Filming the scene John Atkins was involved in.
Photos by Chris Pinion

Once filming had finished John found work at the Peterborough brickyards and forgot all about the filming until shortly before the film was released.

"Me and my wife went to the Odeon and I'm sure we went to see Poltergeist. Before it, during the 'What's coming on soon' you heard the 007 music and then 'Bond is Back!' and the first thing they hit you with is the scene I was in! My missus said 'That's You!' I said 'I know, I was there!' I just wanted to stand up and go 'LOOK EVERYBODY THAT'S ME!' and so when the film came out, I had to go and see it. And seeing yourself, life like in a film, even though it's only few seconds, meant everybody who knew me commented about it as they recognised me."

Now into his retirement, John is once again spending a lot of time down by the River Nene. Only this time not as a fisherman, but as a keen wildlife photographer. I think it's safe to say that the sound of a camera clicking isn't as startling as an air cannon.

# 13 ON THE MARCH WITH ORLOV'S ARMY

Paul Carrington, who played the part of a Russian soldier, was a pal of John Atkins. Paul agreed to meet me at the A1 services not far from the NVR. I was a few minutes late and found Paul in the café; his motorbike parked up and sitting with his 'Live to Ride, Ride to live' Harley Davidson leather bikers jacket draped over the chair. Paul looked more like he'd stepped off the set of a remake of *Easy Rider*. He had brought along some photographs of himself as an extra in *Octopussy*, dressed in a Russian soldier's uniform and looking like a young Tommy Steele!

"Looking back now, it was the equivalent of getting a golden ticket for Willy Wonka's chocolate factory. Let's be honest, how many people can say they've been an extra in a Bond film? There's not many and it's something I'll never forget."

Paul was working as a lifeguard at the Peterborough *Lido* at the time, so with filming beginning after the outdoor swimming season had finished, it proved ideal for him.

"It was my then wife who saw the advert in the paper for extras and thought I fitted the bill. I was tall, fair haired, blue eyed, knew how to hold a rifle and march; which was what they were looking for. You then got invited for an audition and I wasn't sure what to expect, but *The Wirrina* was next to the *Lido*, so it wasn't far for me to go. When I saw they were sitting behind a table, I thought they were going to ask us to lie on it and act out the scene from *Goldfinger* with the laser!"

Paul laughs, adding "...but it happened exactly like Acki (John Atkins) said. They were looking to see if we looked the part, and had the right height and build."

Once chosen, Paul was there on the first morning of filming, experiencing the joys of being fitted with his uniform.

"When I was given mine, there wasn't a pair of trousers with less than a 37 inch waist. So mine were kept up with safety pins by the wardrobe ladies to stop them falling down."

The Nene Valley Railway's Wansford station, renamed *Karl-Marx-Stadt* for filming, is first seen on screen when Roger Moore disguises himself as a circus roustabout on the platform. Paul remembers one of the takes that had to be re-shot.

Paul in costume on set.
Image courtesy of Paul Carrington

"Roger Moore had to pick up this wicker basket and put it on his shoulder, but it took ages to get it right for one reason or another and just when it looked like they'd got it, someone shouted 'CUT!! CAN SOMEBODY GET THAT BLOODY PANDA CAR OUT OF SHOT!' A police car had driven into the background and could be seen by the camera. The next time they called 'Action', everything was perfect, until Roger emerged wearing these deely boppers on his head! Everyone laughed because he was looking so serious."

Paul also recalls being around the set as they prepared for the scene at Orton Mere lock, where 009 falls into the water and floats down the weir.

"There were a few of us on set that were Stanground boat boys. I grew up with Acki so we were all good swimmers. When they came to do the scene at Orton Mere, the stunt team came to check it out. I remember them asking me if I knew how deep it was and of course I'd grown up around the Nene and swam in it as a kid. I was also a lifeguard at the *Lido* at the time, so I said to them 'I'll show you how deep it is'. Not to show off, but I'd been swimming in there for years and being a lifeguard I always knew what I was doing."

On screen Paul was in the scenes around the tunnel and chasing after the Mercedes.

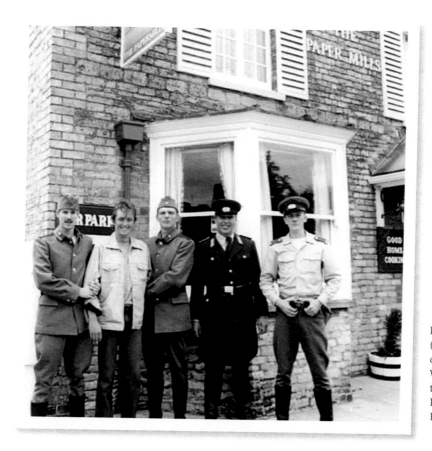

Escape from the set - Paul (third from the right) outside *The Papermills* pub, Wansford, during a lunch time with a group of extras. Image courtesy of Paul Carrington

Paul in costume on set.
Image courtesy of Paul Carrington

Whilst it's difficult to specifically spot him in these scenes, Paul can be recognised in the 'Death of Orlov' scene at the Ferry Meadows border crossing, renamed *Gutenfürst* in the filming.

"I was on the platform when Walter Gotell runs through to try and stop Steven Berkoff. I had to jump off and run behind him. My sister sent me a photo recently where she'd paused the film and you can just see me over Walter Gotell's shoulder. He was very friendly. And Maud Adams, well, she was stunning, just beautiful. When I look back, the whole thing was brilliant really."

In the years following his summer with 007, Paul went on to run his own personal security and chauffeur business around London.

"I'd got into martial arts in a big way and went to study *Tang So Do* at the main Do-Jang temple in Seoul learning *Moo Duk Kwan*. I then worked in the personal security business for years, anything from regular events like Wimbledon, Ascot and the Henley Regatta to one-off events.

Paul had another brush with fame when he became part of Madonna's security entourage whilst she went jogging in Hyde Park in the early 1990s.

"I think it was a bit of a publicity stunt by her people, as she was touring over here. The thinking being 'surround her with a group of burly security guys, tip off the press and suddenly we've got a news story'."

Before he rode off down the A1, Paul showed me a photograph of a motorcycle trip across Europe a few summers ago. I was pleased to see he was standing in front of a sign at another Bond film location: The Furka Pass in Switzerland, as seen in the Aston Martin DB5 chase from Goldfinger.

Paul Carrington
'on the tracks of 007'

# 14 HIDDEN EXTRAS

Trying to identify all of the extras who appeared as soldiers with Paul proved a difficult task. However, I was able to locate a handful of men who, like Paul, are visible in the film. Tony Lawton was one of the four soldiers running out the tunnel shooting as Bond makes his escape up the wooden stairs. Tony is the soldier on the far right of the frame. When we met up, it was the day before Tony went into hospital for a laryngectomy operation to remove his larynx subsequent to being diagnosed with throat cancer. He was keen to tell me about the part he had played in the Bond film.

"I was a sales manager at Sheltons, a local department store at the time, but what made it a little bit different for me was my then wife, Elizabeth Crowson, was employed by Pinewood studios as a nurse. She worked for the British Nursing Association who had a contract with Pinewood, so she also went to Upper Heyford and Northolt where they shot various scenes. When they came up here to Peterborough, I went along to see her. I had a big Honda Goldwing motorbike at the time and one of the crew said to me 'It's a pity you haven't got a union card for acting, because if you had we could use you!' Now, I'd been a musician for years and I'd always had an equity card so that's how I became involved. The first thing I did was help set up the tables and chairs in The Wirrina for the auditions. There were three or four people that worked for Eon as casting and there'd be a line of people who'd walk along, fill out a form and a woman from casting would tick something on a card. That tick meant they were in. So those people who she'd chosen were contacted straight away, and then others she'd made to contact later needed them."

During the first week of filming, Tony got to see one of the pranks Roger Moore played on stuntman Rocky Taylor.

"Rocky was sitting in Roger Moore's seat on the side of the railway holding up a newspaper to read and Roger crept up and lit the paper with his lighter! Rocky jumped up, dropped the paper on the railway line and stamped it out; by which time Roger was sat back in the chair smoking a cigar!"

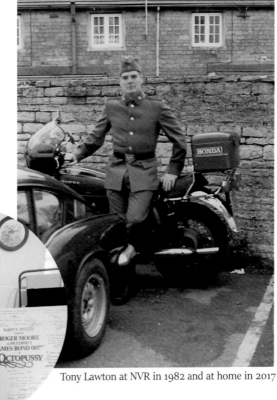

Tony Lawton at NVR in 1982 and at home in 2017

After being in the tunnel shoot-out scene, Tony was then asked to drive one of the jeeps when the Russian soldiers jump out to try and stop the Mercedes.

"With the 2nd unit it became like a little community with the extras. I had all my hair shaved off, was put in a Russian car called a Volga to find myself dressed as and doubling General Orlov!"

Tony showed me the original call sheets he had kept from the filming that shows him listed as 'Gen. Orlov Double'.

"I wish I had a picture of me in Orlov's uniform because it looked so smart. I was in the back of the Volga during the scene where the train was coming along and the car had to cut across the tracks behind it.

Then when we left there, we went back through into Castor Village because we had to go back to Wansford. The driver pulled up outside the newspaper shop and we both walked in, dressed in these Russian army uniforms, not really thinking too much about it until we saw the looks on people's faces!"

Tony and Elizabeth split up in 1986 and she sadly passed away from cancer in 2002. However, her training as a nurse proved vital in saving Martin Grace's life.

"Martin, as you know was very badly injured and it was Elizabeth who held his leg together following the crash. She said he had terrible *crepitus*; the bones were drawn together but she had both hands pressed on to his thigh holding it together, all the way from Wansford to Peterborough hospital.

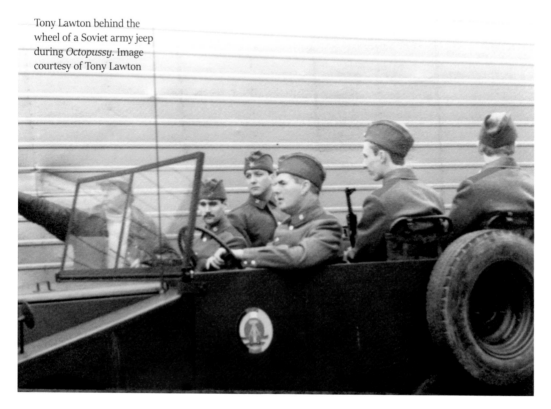

Tony Lawton behind the wheel of a Soviet army jeep during *Octopussy*. Image courtesy of Tony Lawton

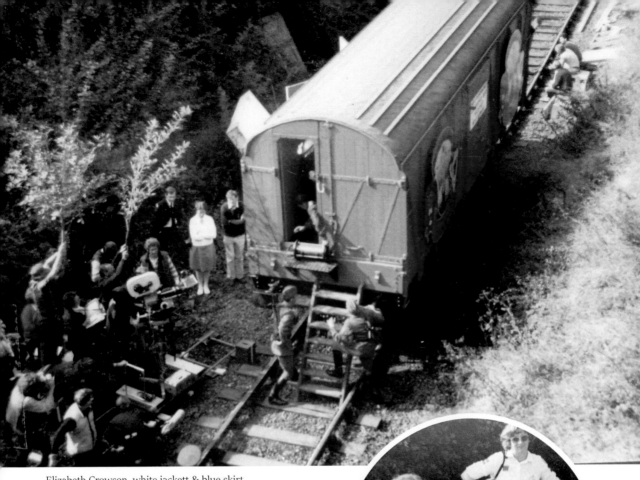

Elizabeth Crowson, white jackett & blue skirt,
on set during the filming of *Octopussy* at NVR.
Photo by Chris Pinion

When they got him into the treatment
area, they had to try and release her hand
off his skin because it was completely
stuck to him. The doctor said that if she
hadn't done what she had, he would have
lost all his lifeblood into his thigh. That
part of the thigh is capable of holding nine
pints of blood and the main artery had
been completely sliced through. She had
managed to hold it together. I remember
he later wrote to her via the British
Nursing Association to thank her for what
she'd done."

Elizabeth Crowson, 1st unit nurse with Tracy
Wyld and Maureen Angell - Red Cross first aiders.
Photo by Tony Lawton

Tony is also full of praise after seeing
Martin work on the stunt scenes.

"When Martin Grace put the wig on, he
could actually become Roger Moore. How
he did it I don't know, but he could be
there, somebody call him over, he'd put

the wig on and he became Roger Moore.
It was absolutely amazing. I've stood next
to him and thought 'how did he do that?'
That's how accurate he was. The way he
could do it was incredible."

Tony then returned to work at Sheltons department store, but around ten years later in 1994 he became the regional co-ordinator of *Operation: Christmas Child*.

"Somebody at my church on Midland Road knew someone in Wrexham was starting a shoebox appeal. My Pastor asked me to go over and see what I thought of it and I brought the idea back to Peterborough. In the first year we gave away 23,000 fully laden shoeboxes to the needy. It was just amazing and we followed it on every year; it was a tremendous campaign."

One of the extras who didn't appear in *Octopussy* until one of the hidden extra features on the *Octopussy Ultimate Edition* DVD was released in 2003, is Steve Beech. In the final edit of the film, Steve was one of the circus roustabouts that had his face obscured from the camera as he was rolling an elephant stand when the Mercedes speeds through the car park. However, during '*Ken Burns: On set movie*' on the DVD extras, it briefly shows Steve; he had curly black hair and a moustache!

"I was 25 at the time and heard an advert on Hereward Radio asking for extras. So I applied, went down to *The Wirrina* for an audition and was chosen to be a circus roustabout. At the time I was a driving instructor and thought it'd be a good way of earning a bit of extra money in between lessons."

Like John Atkins, Steve was reluctant to have his hair cut short.

"I had permed black hair and a moustache at the time and I refused to have it cut short. When I started, the main cast had gone but I was involved in two scenes. The first when the Mercedes drives through and we had to move out of the way. I was running across with an elephant stand and they did a couple of takes with a camera coming towards us, then again from a different angle with a camera in the car. Then I was a passenger on the train when they fired the Mercedes into the river. It was pretty spectacular and it's incredible to think I was part of it. Some days there was nothing for you to do, but like everyone else has said, the food was fantastic! I don't think I've ever had better bacon butties."

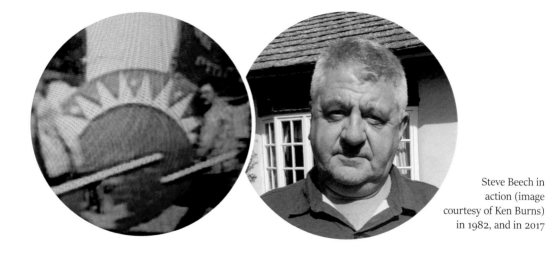

Steve Beech in action (image courtesy of Ken Burns) in 1982, and in 2017

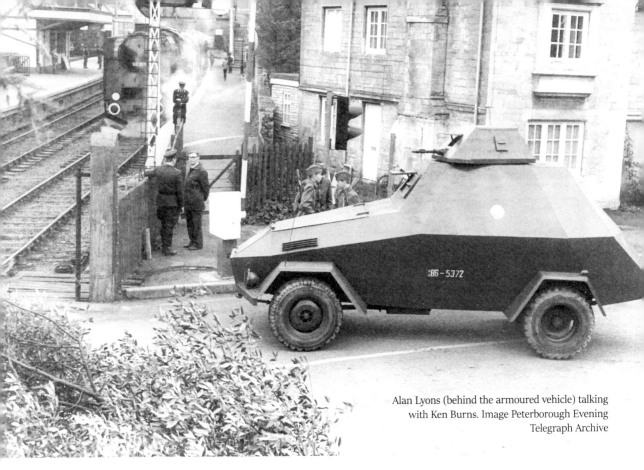

Alan Lyons (behind the armoured vehicle) talking with Ken Burns. Image Peterborough Evening Telegraph Archive

Alan Lyons was another who heard the announcement on Hereward Radio that some extra 'extras' were needed for the second week of 2nd Unit filming.

"I had just finished college, was 22 at that time and looking around for a job. I phoned the Job Centre. They took down my details and at 6pm the casting assistant rang me back saying I'd need to be at the NVR at 7.30am. When I explained we had no car in the family she said if I could get to The Bull Hotel where the crew were staying, there would be some mini-buses going down that I could get a lift with. On the first day I was up at 5.45am, biked into town, locked my bike up in Park Road and walked to *The Bull*, where I got a lift with the film's construction crew in their minibus. After much hanging about I was made into a soldier. This involved queuing up with other extras to enter a small caravan where I was given a very swift short back and sides! The uniform was a little on the large side although authentic, apart from the boots which were basically rubber wellies. I met some of the other extras and practiced jumping out of an armoured car for a future take."

The scene Alan featured in was filmed on the second day.

"I was with some other extras in a jeep in the station yard chasing after Bond's car. In the afternoon I jumped out of an armoured car...again....again and again! The car was completely enclosed with someone on top driving. As soon as it screeched to a halt we had to come out. I was in the dark recesses of the vehicle with another extra. We took it in turns to jump out first as it screeched to a halt but I had problems; the magazine in my machine gun kept falling out and on another take, my foot got caught in the gun strap. This is the scene when Bond drives the Mercedes on to the track. There's an armoured car blocking the road and where he swerves onto the rails you very briefly see a soldier getting out; I'm pretty sure that's me, or at least my legs that you see."

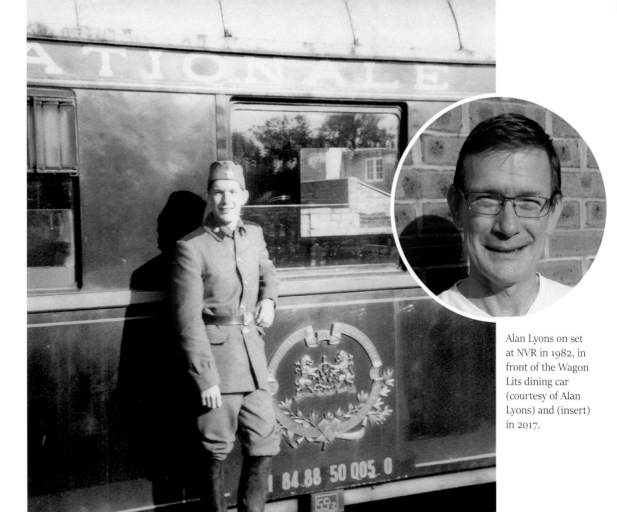

Alan Lyons on set at NVR in 1982, in front of the Wagon Lits dining car (courtesy of Alan Lyons) and (insert) in 2017.

Alan now works for a graphic design company in Peterborough producing the artwork used on food packaging for a leading supermarket chain.

"I'd trained at art college as an illustrator and I went freelance for a couple years, but then one of my friends started a printing firm and because it was a steady income I carried on in the industry."

One of the recruits in 'Orlov's Army' who gave Alan a lift to the railway most days was Martin Allpress. He played the soldier that walks into shot with his back to camera, a rifle over his arm and follows the CCT wagon as it's shunted into the tunnel with 007 underneath. We met at Martin's house. He'd paused the film at the exact moment and, in order to verify it was him, he turned to show me the back of his head!

"That's definitely my ears and the back of my head; a little greyer now. It was Arthur Wooster who picked me out to walk in front. He also said that if I'd like to come to India, he could get me extra work. But you had to pay for your own flight and early 1980s India wasn't somewhere you could fly to as easily as you can these days."

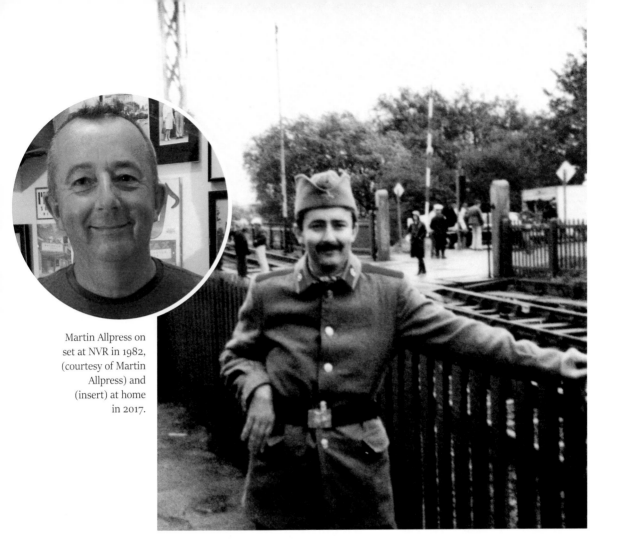

Martin Allpress on set at NVR in 1982, (courtesy of Martin Allpress) and (insert) at home in 2017.

The distant figure of Martin can also be seen as one of the fishermen that rushes out from under the bridge after the Mercedes lands in the river.

"As the car hit the water, I'm one of the guys fishing on the other side of the bridge. I wore a grey woolly sweater and dark jacket. You can just see me running towards the camera underneath the bridge."

Martin now runs his own building firm based in Peterborough, so for any Bond fans who'd like a replica of an East German watchtower built in their back garden, look up *MJ Builders* online.

Something that Orlov's army and the hidden extras won't be aware of is that during the first week of filming, Steven Berkoff stayed at a hotel in my hometown of Oundle. This only came to light when I noticed it mentioned on one of the call sheets. The *Talbot Hotel* in Oundle was one of a number in the vicinity of Peterborough that was used for cast and crew. The hotel that I would later go to parties and weddings at, played host in 1982 to not only Steven Berkoff, but Walter Gotell, Dermot Crowley (Kamp), David & Tony Meyer and Suzanne Jerome (Gwendoline), and Cherry Gillespie (Midge).

# 15  EAST MEETS WEST

In 70s and early 80s, Martin Allpress was heavily into the Northern Soul music scene and, along with Stuart Stocks, a regular at the *Phoenix Soul Club* at *The Wirrina*. In Stuart's back garden, I heard from the only extra in Octopussy to play a German who in real life, had German heritage.

"I spent a lot of my childhood in Germany in my mum's hometown. I wasn't born there, but I've been back and forth my whole life so I'm probably as German as a Brit could get. It's difficult to explain because I'm not a typical Brit, but I'm not a typical German either; there's too much English culture in me."

It was a conversation with one of his work colleagues that alerted Stuart to the news that extras were wanted in a Bond film and so he went for an audition at The Wirrina. "I'd come out the British army and was working as a postman at the time. I didn't really know much about the Nene Valley Railway, but I used to love James Bond and being an adventurous type of person, I thought I'd give it a go. I was living with my parents at the time, carried on being a postman and then another guy I knew, Keith Evans, heard he'd got a job as an extra and I thought 'You lucky bugger!', because I'd heard nothing."

Despite not hearing back, Stuart decided to go to the set at Wansford on the first day of filming.

"They had a look through their list of names and said 'You were chosen, but we couldn't get in touch with you'. This was in the days before mobile phones, and my parents had been away on holiday, so someone had tried to phone, but there was no answer. They told me to turn up on the second day of filming and they dressed me in a dark olive-green uniform of the East German border police. The local Bond girls were all there and because I was a new face, everybody thought I was a proper actor, so I was lapping it up and I must admit I did play on it for the rest of the day. Well, I was single then and there were a lot of beautiful women about!"

East meets West: Stuart Stocks and Keith Evans guarding the armoured lug at NVR in 1982. Image courtesy of Keith Evans

Stuart Stocks in 2017
Photo by Marc Hernandez

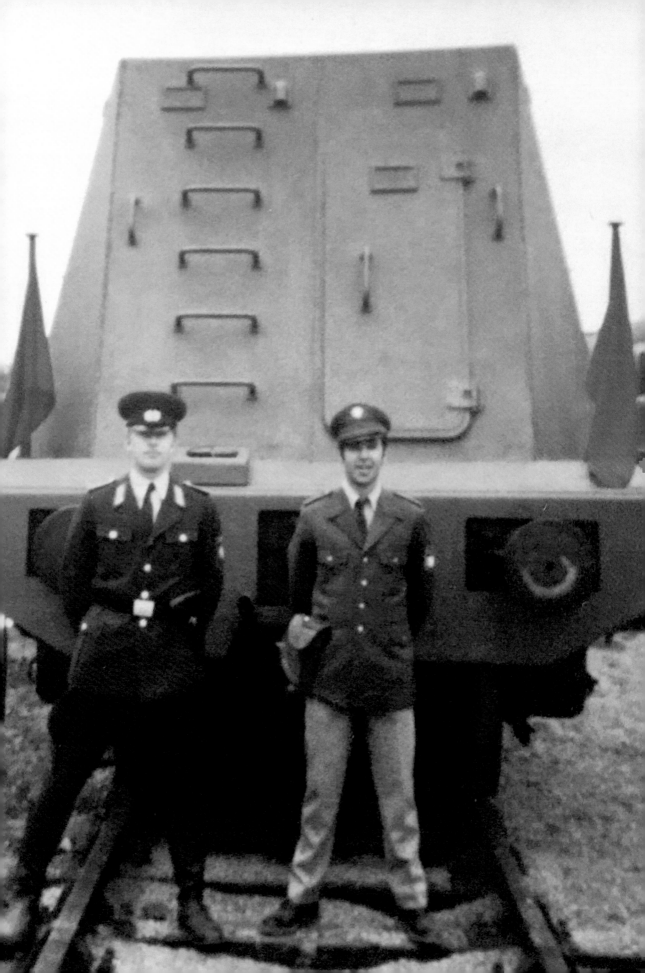

As an extra, Stuart was mainly in background shots, but depending on what was being filmed, in a variety of roles,.

"Every day we'd meet up at Wansford, and we'd either be around there or go by train down to Ferry Meadows where they were also filming. I was a border guard to begin with and that scene where they all look up to see the helicopter, I should have been the border guard that saw the helicopter, to get his gun up and ready.  But you have to imagine all around me, there were hundreds of people watching it and I just couldn't stop laughing! They tried it a couple of times, but I didn't get it quite the way they wanted it, so someone else did that scene. My one chance of being in shot – gone! All the other shots of me I was about a couple of hundred metres in the background and when you saw where the camera was, you thought 'Well I'm just in here to make the numbers up', but it was interesting."

Stuart also found it wasn't just James Bond that had to sneak around the station. With a big smile on his face, he told me;

"Originally, I had a week's holidays from the Post Office, but I was needed on set for about six weeks. I rang in work feigning illness! Every day when the postman came to the station, I'd hide. I couldn't risk him spotting me and reporting back because it was a chance of a lifetime to be in a Bond film."

Stuart talked me through some of the other scenes he was involved in.

"I was one of the roustabouts that had to look shocked and get out the way when the Mercedes rolls by on two wheels. But they didn't tell you what was going to happen.  They just said, 'There's a guy that's going to come through in a minute', but they didn't say it would be on two

wheels. We were just milling around and all of a sudden, this car appeared and we're thinking, 'What's going on here!?' Of course we got out the way really quickly, which is obviously what they wanted. I was also a Russian soldier and given an AK47. We were in the back of the Jeep as it drove around the corner really quickly and we had to jump out and run along shooting at the car. The first time we did it, I fell over! We were wearing these big boots and it wasn't easy to run along tarmac, so 'whoosh' I went flying, grazed all my hands, made a hole in the trousers, cut my leg and all I heard was 'KEEP ROLLING, KEEP ROLLING!' and I thought 'Do they mean me, or the cameras!?' "

From speaking to Stuart, I was able to get in touch with his old friend, Keith Evans. Keith had a fantastic photo of the two of them together; Stuart in the East German Border police uniform and Keith in the West German border guard uniform.

"I got involved through a friend's sister who was at college doing drama and I heard they wanted some extras. I ended up being there for about a fortnight I think. It was great seeing all the famous people, a lot of them were very friendly including the camera crew who got me drunk most nights in The Bull or Red Lion!"

Keith can be seen twice in the film. The first occasion on the station platform as equipment is loaded onto the train. He's the circus roustabout wearing a base-ball cap with dark sideburns.

"I was meant to be one of the circus workers moving things around, but spent plenty of time looking at the Bond girls which I won't forget!

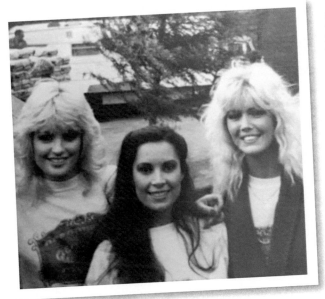

Carole Ashby, Joni Flynn and Janine Andrews posing for Keith Evans' camera

Keith Evans in 2017

I found it quite funny when they told you not to look at the girls and just act normal, because I couldn't keep my eyes off them. I was also a soldier in the Jeep which was very interesting, flying around pretending to be shooting from the back of it."

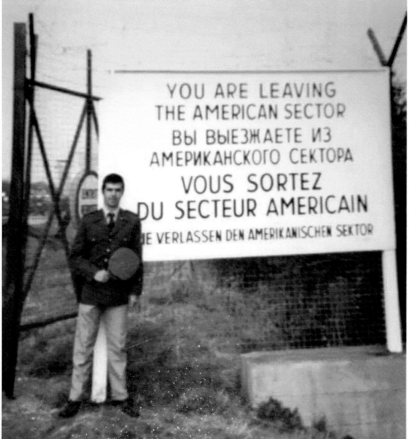

Keith at the border gate at NVR in 1982. Photo courtesy of Keith Evans

YOU ARE LEAVING THE AMERICAN SECTOR
ВЫ ВЫЕЗЖАЕТЕ ИЗ АМЕРИКАНСКОГО СЕКТОРА
VOUS SORTEZ DU SECTEUR AMERICAIN
SIE VERLASSEN DEN AMERIKANISCHEN SEKTOR

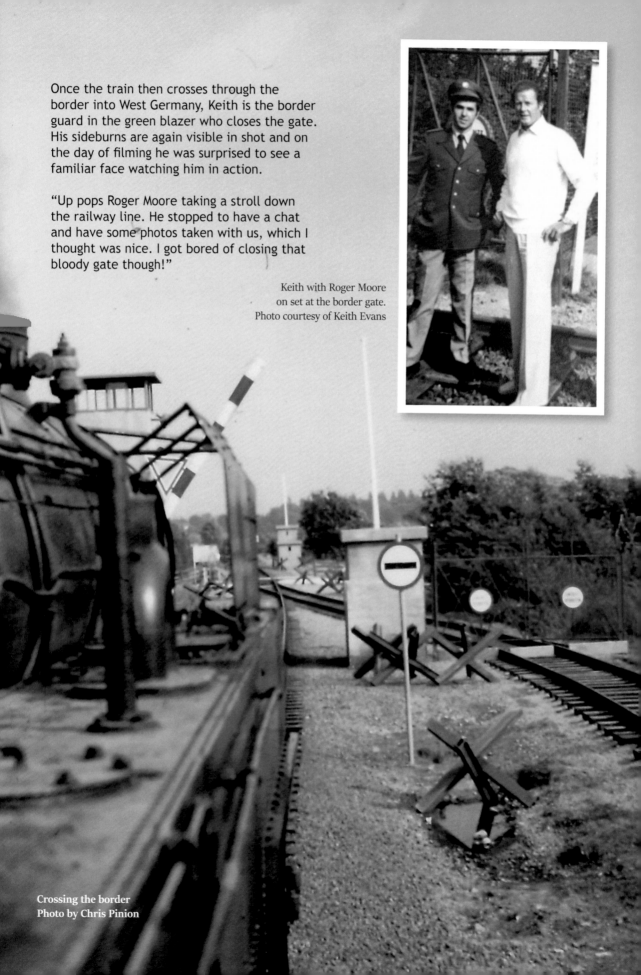

Once the train then crosses through the border into West Germany, Keith is the border guard in the green blazer who closes the gate. His sideburns are again visible in shot and on the day of filming he was surprised to see a familiar face watching him in action.

"Up pops Roger Moore taking a stroll down the railway line. He stopped to have a chat and have some photos taken with us, which I thought was nice. I got bored of closing that bloody gate though!"

Keith with Roger Moore
on set at the border gate.
Photo courtesy of Keith Evans

**Crossing the border**
**Photo by Chris Pinion**

# 16    I WAS GOGOL'S AIDE

Another person Stuart remembered very well is a guy whose moustache was a thing of local legend...

Every mid-July, all across Britain you'll find football clubs preparing for the new season. There are pre-season friendlies to be played, season tickets to be sold and the familiar sight of a club's latest signing and manager standing by the side of the pitch holding the club's football scarf or shirt aloft. In Peterborough it's no different and one lunchtime I found myself at Peterborough United's stadium on London Road walking through the tunnel and out by the side of the pitch to meet someone heavily associated with the club. In August 1982, just before *Octopussy* began filming, Peterborough United's big summer signing was a 19-year-old goalkeeper called David Seaman. The future Arsenal, England and Dancing on Ice Series 1 star arrived from Leeds United in a £4,000 transfer. He went on to make 91 appearances for 'The Posh' before Birmingham City splashed out £100,000 for his 'Safe hands' in October 1984. Following his long career, the moustachioed shot-stopper had his association with Peterborough United immortalised, when they named one of the club's function rooms after him.

As I turned and walked past the 'The David Seaman Suite' towards the London Road terrace, I saw a smiling face walking towards me, minus his infamous moustache. I shook David's hand. But it wasn't David Seaman. I was there to meet another David; David Stent, Peterborough United Safety officer who, at the age of 19 and along with his moustache, became a local extra in *Octopussy*. Up in the control room that overlooks the pitch, David told me how it all started.

David Stent pitchside at Peterborough United FC

"I was working as a building planning officer at Peterborough City Council and saw the advert in the Evening Telegraph. It was just the sort of thing that appealed to me because I've always been involved in acting, and still am. I'm now the producer of the Westwood Musical Society and have been involved with that for 22 years. 90% of people who went for auditions were to be Russian or German soldiers. I had very blonde hair then and a really rubbish moustache. I went to *The Wirrina*, some photographs were taken and a few days later there was a phone call from a lady at Eon productions, all OTT and flamboyant. My wife took the call as I was out, and she asked her some questions "Has he still got his moustache?' 'Yes', 'Does he mind flying in helicopters? 'Of course he doesn't'.

Now I'd never been in a helicopter in my life, but she said 'Is there any chance he can come down again?' So I went to *The Wirrina* again, they took some more photos, which lasted about 10 or 15 minutes and they again asked if I minded flying in helicopters. I said 'No' and within 48 hours they rang and said 'We'd like you to be an 'Extra' and to be this character called 'Gogol's Aide'."

The role was to be the on-screen assistant to 'General Gogol', head of the KGB, played by Walter Gotell.

"When I found out I'd be his sidekick, his Russian counterpart, it felt great as I'd seen him in Bond films before. Then some weeks later they said 'We'd like to measure you up for a suit'. I went to Wansford and I was getting quite excited. I met John Glen with this casting person, they measured me up and over the course of a week produced a really nice suit, a lovely pair of shoes, a beige gabardine mac and if you watch the film, you'll see Walter Gotell wearing a mac. Mine was exactly the same kind he was wearing. The mac never came off me once in filming, but there was this made to measure suit underneath with a shirt and tie. I also had one of the dark green border police uniforms which I wore as, after they'd finished with me as Gogol's aide, I did a few days as one of the extras, but just for background shots."

Throughout the first week of filming, David was in a somewhat privileged position compared to the other extras.

"Basically, I spent six hours a day for nearly a week flying around in the helicopter with Walter Gotell. They had film cameras in the helicopter and on the ground and it was quite exhilarating, but in the finished film there's no footage from within the helicopter. There's film of the helicopter taking off and when it lands you can see us getting out and running down the line and that's a minute at most. It all took four or five days to film. One of the pilots' biggest concerns was that, when they were flying up and down the railway line, there were quite a few fir trees they'd planted with stakes just to fill out the scenery. Due to the height the helicopter was flying at, the up force or the downforce was bringing lots of bits of the trees up into the blades, so the pilot was seriously concerned about the safety. It changed their thinking because of it. All I remember thinking was, 'Well that's good, because I'll get another day of doing this!'"

Despite playing a character that's referenced on the call sheets as 'Gogol's Aide', David was very much in the background of shots, but I was interested to find out if there was any discussion of him being given any lines.

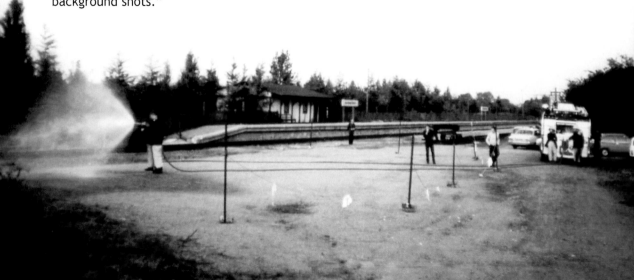

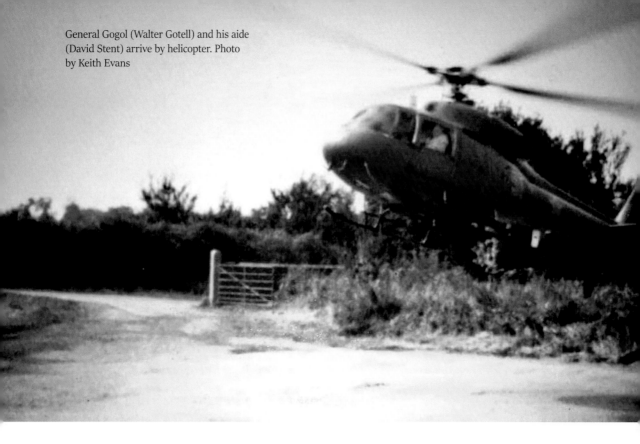

General Gogol (Walter Gotell) and his aide (David Stent) arrive by helicopter. Photo by Keith Evans

"It was mentioned at one time but then there was talk about equity cards which were a requirement then. At one point I was going to be put on the credits because it was an actual character 'Gogol's Aide, but nothing ever came of that. Without being egotistical, because I was with Steven Berkoff and Walter Gotell primarily, there were people who'd come to the location to watch, but who didn't know me from Adam. As far as they were concerned I was another 'Bond' actor, so people were asking for my autograph too; and as much as I would feel like a complete and utter fraud now, then I was completely up for it. It was brilliant really; you'd be eating the best food in the world for breakfast, lunch and dinner, and in between, doing scenes for a Bond movie."

Working in a principal scene with Steven Berkoff provided David with some enduring memories of his acting style.

"I used to share cigarettes with Steven Berkoff and it was surprising just how much of a method actor he was. In the scene where he needed to be all hot and out of breath he went off for a run to get himself like that. And because I was part of that specific scene, I used to get taken from Wansford to Ferry Meadows in a car with him and the others. At lunch time, they had their own dining tents, so I went in with them and I'd look around and there'd be Mary Stavin. She had been Miss World a few years earlier. There was also Cherry out of *Pans People*, and together we'd go into a nice area and all have lunch, which was good fun. I don't think Roger Moore was around those scenes I was in, but he was such a down to earth person and a great guy when I did see him."

Being part of the filming gave David an insight into the level of detail required behind the scenes to make everything look as good as possible on screen.

Peterborough Volunteer Fire Brigade helping to dampen down the helicopter landing area. Photo by Kevin McElhone

"One of the biggest things for me was the continuity; again you just don't think about it, but because we're flying in this helicopter, they had to have all the continuity to make sure if your tie was skeewiff, it's skeewiff when you go back out again. The make-up girls would have all these photographs of you from the day before and it was just little things like that that I found so fascinating, because they did go to a great deal of effort with the detail. I got paid for the work, there was plenty of food and it was bloody good fun to be fair."

Following on from the filming, David did a couple of training videos for *Thomas Cook* and *Midland Bank* around pickpocketing and fraud; these were filmed at East Midlands airport.

"I thought it might have been the start of me in films and television, but basically that was the start and finish of it! Since then, I've been involved with *Westwood Musical Society*, which are a big company. We have professional directors, an orchestra and spend £30-40,000 on a show, so it's a big business."

David walks me back down the Peterborough United players tunnel telling me about how he's preparing for the start of the new football season. "I've been the safety officer for nine years and the deputy safety officer prior to that, but I've been associated with the club since 1991 and basically following the Hillsborough disaster and the enquiries which changed the way clubs worked with the Police."

It is, I suppose, a strange twist of fate that an extra who played a KGB agent in a Bond film at the height of the cold war in the 1980s is now in charge of the safety of football supporters on a weekly basis at an English football ground. It's a shame that Marco Sciarra's plan in the pre-titles of *SPECTRE* to blow up a football stadium in Mexico were thwarted before it reached the stadium; I know just the man who could've grown back his moustache to play the Stadium safety officer.

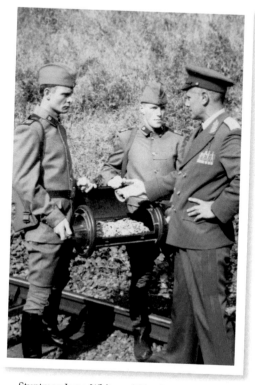

Stuntmen Jason White and Tip Tipping with Steven Berkoff at NVR in 1982. Photo by Chris Pinion

Roger Moore at NVR in 1982. Photo by Chris Pinion

# 17 THE TALE OF THE LEFT-HANDED SOLDIER

Any story about soldiers chosen for a daring mission isn't complete without a tale involving somebody lying about their age. In the case of 'Orlov's Army', there was a very persistent 15-year-old school boy who was determined to be an extra. Ken Burns is a name that James Bond fans may have already heard of. On the *Octopussy: Ultimate Edition* DVD/Blu-ray there is '*Ken Burns on-set movie*'; a seven-minute behind the scenes home movie that Ken made at the NVR during the filming of *Octopussy*. We arranged to meet up on one of his returns to Peterborough to visit family over an August Bank holiday.

"I wasn't 16 until October, so I was still only 15 that summer, but when I rang I told them I was 16. The voice on the other end of the phone went 'Ahhh' as if to say 'Ah, you've now failed to get any further, because you've told me you're 16 and we need soldiers and border guards for a Bond film. A 16-year-old, spotty Herbert is not going to be mean enough'. So when they went 'Ahh', I can still hear it in my head. It was the telephonist, but I phoned back the next day and said 'I know that you don't think I'm what you're looking for, but I'm 6ft tall, I'm a Royal marine cadet, I know how to fire weapons of all descriptions; just give me the chance!' Again, it didn't go any further but I continued ringing until eventually the phone was handed to somebody else. 'Hang on....' I could hear the woman sigh and say 'It's him again', and then I heard 'Oh put him through.' It was the casting director who said 'Ok, we're going to give you a chance, the audition's actually tonight at *The Wirrina*. What's your name?'

I got a call back about three days later saying, 'You're one of the lucky ones', and it did feel that way because there were only 20 of us picked to be soldiers, but hundreds had applied. I met the other soldiers, had a costume fitting and a haircut and then obviously it was just a lot of standing around. But I can remember having an absolute hoot, because from my point of view it was a film and I was watching how it was all done. My hobby was making home movies on my cine camera, so it was all great experience."

The chance to be an extra in a Bond film is something most 15/16-year-olds can only dream about and Ken was definitely living the dream.

"There were so many people everywhere; those involved with the film, and those there to watch, and those who were trying to get autographs. I was walking with one of the other extras when I jokingly said, 'Do you think Roger Moore would like our autograph?' and quick as a flash this familiar voice came out from one of the nearby caravan trailers. 'He most certainly would not!'"

Having got the part from hassling the casting team, Ken wasn't going to lose it by upsetting the film's main star and at the end of the first day's filming, he went to phone his Mum to come and collect him from the station.

"They'd put an East German looking telephone box outside on the main road at Wansford and one of the other extras had said there was a working phone inside, so I'm looking around for where the phone is and of course there wasn't one. It was just an empty box! I turned around and everyone was outside wetting themselves laughing, but it was a double whammy for me getting the part because a) It was Bond and b) It was also in an environment I knew at the Nene Valley Railway. My dad was the housing manager for the development corporation. They were the ones who gave the railway to the NVR so in those early days of it being set up, there's cine film footage of me at the sugar beet factory getting on and off the very first days of what became the NVR, which was then, shunting up and down on Jacks Green. So when *Octopussy* came along, I was going to play soldiers on my favourite little railway just up the road from where I lived."

The cine film that Ken took on-set of *Octopussy* was compiled over the first few weeks of filming and eventually used in the *Ultimate Edition* DVD/Blu-Ray as one of the special features.

"They licensed the footage from me and the commentary I provided and recorded separately. John Cork, who produced the DVD, rang and asked me to talk through what I'd filmed. There are a few shots of Roger in my footage, but even at that stage I didn't want to impose as I was very reluctant to be in his face. I wanted to film him naturally in the carriage, but he was being bombarded with people. Otherwise, there would've been more of Roger in it."

During the opening weeks filming, Ken took part in the scene where General Orlov runs to try and stop the train leaving *Gutenfürst* station. Ken is the soldier on the right who Orlov pushes past. Ken then turns and raises his rifle behind the Border guard who shouts at Orlov through the loud hailer to stop.

"I still cringe thinking about what I said to Steven Berkoff, because I just thought he was one of the extras; he never let on that he was one of the stars of the film! At the time, one of the directors came up to us and said 'The scenario is, this general is your superior officer and he's going to be running towards you. But your job is to not let anyone through. So in your mind, what do you do when your commanding officer is running towards you, wanting to get past you, but you're guarding the border?' He left us with this to ponder and there was Steven Berkoff sort of pacing up and down, so I went up to him and said, 'How do you think we should play this then?' And he just sort of humoured me and said 'I don't know, what do you think?' and he was just letting me go. 'Well, what I'll do, because I'll be really confused about whether to let you through or not, is that I'll sort of stand to try and stop you, but then kind of move back'."

There was further embarrassment for Ken during the rehearsal of that scene.

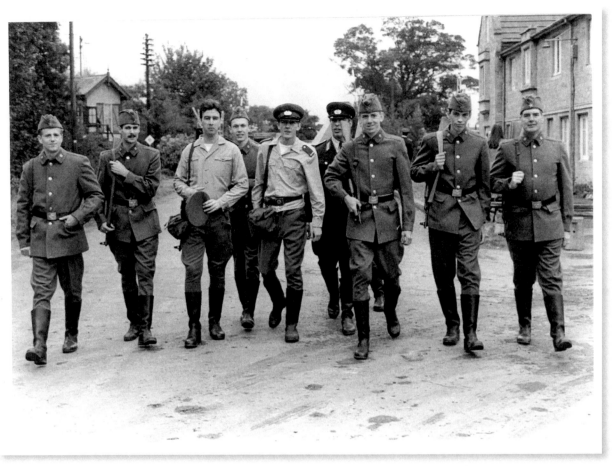

Ken Burns (third on the right) and his friends stroll through the street, all dressed up and ready to appear on set.
Image Peterborough Evening Telegraph Archive

"I stopped production at one point, because I put my foot through what was meant to be a concrete block but was just wet canvas paper. It was during the run through and as Steven Berkoff barges through, I stepped back and put my foot to steady myself. But I actually trod on the side of this massive border post and my foot went through; so I've got that as a memory too. It stopped filming for a little while so they could quickly replaster and paint it down at foot level, but most of the pain from that scene is the memory of me talking to Steven. He's such a brilliant actor and there's me, a spotty little Herbert trying to tell him how to act."

It wasn't until nearly a year later and seeing the film on its release that the penny dropped for Ken.

"One of the first scenes of him as General Orlov is him giving his big speech in the Kremlin War room. I just sank into my seat thinking, 'Oh my god, I was telling one of the main cast how to play it'."
Once pushed out the way by Berkoff, Ken then emerges standing behind the border guard with the loud hailer who eventually shoots Berkoff.

"Unfortunately it's his megaphone that blocks my face. It's more comical now because Ricky Gervais highlighted that kind of thing in his TV show Extras. There was a scene where Ricky is dressed as a soldier and every time he comes into shot, somebody stands in front of him and it's, 'Cut...just before the fat bloke comes in'.

That was like me in *Octopussy.*"

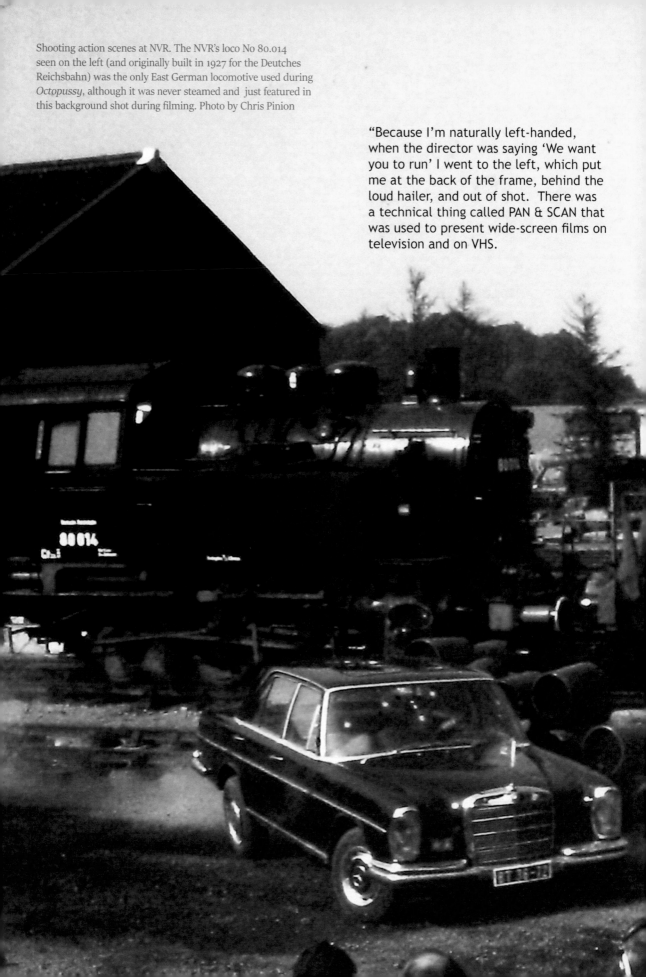

Shooting action scenes at NVR. The NVR's loco No 80.014 seen on the left (and originally built in 1927 for the Deutches Reichsbahn) was the only East German locomotive used during *Octopussy*, although it was never steamed and just featured in this background shot during filming. Photo by Chris Pinion

"Because I'm naturally left-handed, when the director was saying 'We want you to run' I went to the left, which put me at the back of the frame, behind the loud hailer, and out of shot. There was a technical thing called PAN & SCAN that was used to present wide-screen films on television and on VHS.

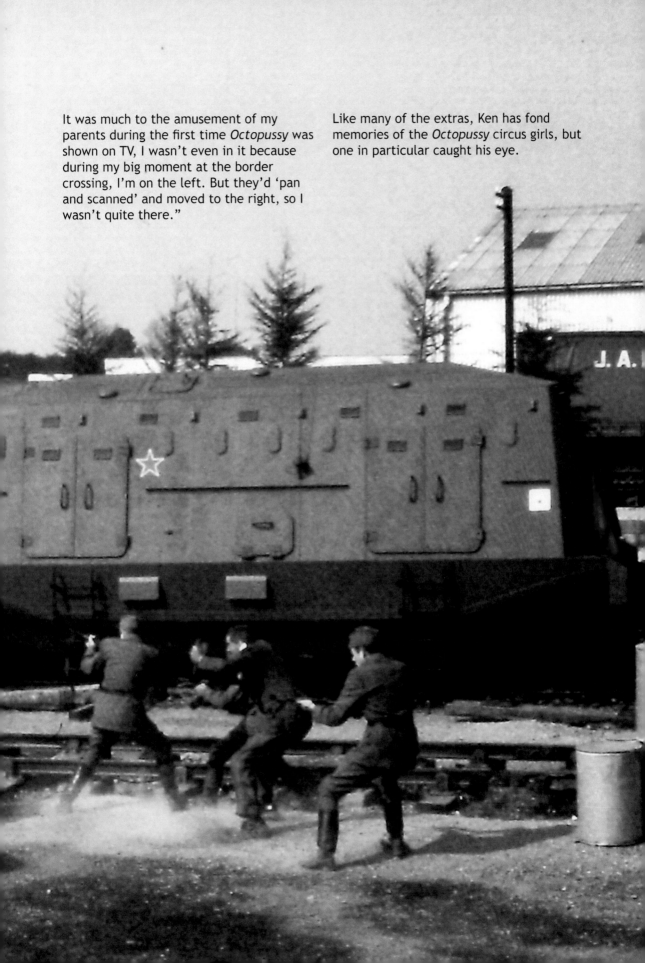

It was much to the amusement of my parents during the first time *Octopussy* was shown on TV, I wasn't even in it because during my big moment at the border crossing, I'm on the left. But they'd 'pan and scanned' and moved to the right, so I wasn't quite there."

Like many of the extras, Ken has fond memories of the *Octopussy* circus girls, but one in particular caught his eye.

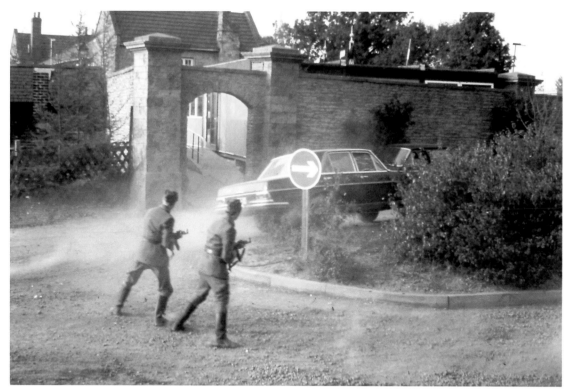

Soldiers shoot at the Mercedes as it leaves the car-park. Note the false wall that was built in order to obscure the NVR portacabin office. Photo: Chris Pinion

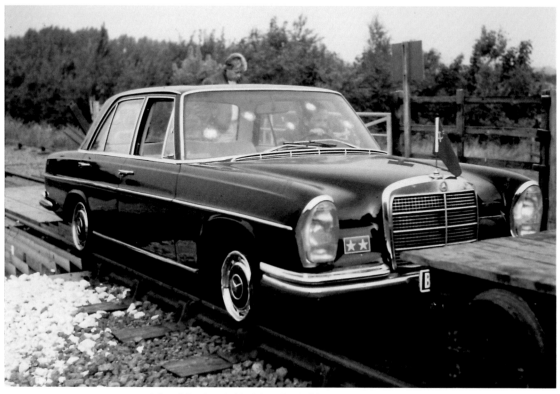

John Richardson behind the wheel of the Mercedes on the railway tracks. Photo: Chris Pinion

"A lot of the girls were just too precious; they'd be on the train saying, 'Oh it's too hot', 'Ooh my make-up'. But Kristina Wayborn! She was like carved out of pure loveliness. She should be cloned! When I met her she was in this tailored suit outfit and I just thought she wasn't real. Her dimensions were just impossible; you can't have a chest and a waist like that, it's not possible. But as you can see, I've now managed to get that shape!!"

Ken laughs, patting his stomach before adding, "And here's a story for you. My Dad is Scottish through and through, and the guy who provided all the Mercedes from mint to smashed up condition had a stack of them. He was a Londoner, salt-of-the earth type, and he was great because he gave me access to the behind-the-scenes riggers that were coming in and setting up all the stunts. He said at the end of filming, 'Look, three of these Mercs are fully operational, but left-hand drive. I don't want to take them all back to London, so I can flog you one of the Mercs for £100'. So I went back to my Dad saying 'Look! It's Bond, it's the car that's gonna be in the film, I could drive it when I pass my test and then you could sell it again after!' And he said to me 'I'm not having a car dripping with oil on the drive'. He just couldn't see it as an investment and to this day, even if he'd kept it in storage, that particular Merc could have been sold for thousands to a collector."

Life for Ken after the Bond circus had left town meant starting a search for a job, but bitten by the film bug he set his sights on a full-time career in the industry.

"I went to work in a local shopping centre, Queensgate, for a while but it was when I got a job in London which was monitoring news 24 hours a day in 1987 that I found my way in. All I did was edit news but it led to work at a post-production house that made *The Crystal Maze* and *Interceptor*. Then I went to Pinewood. I produced for ITV the 40th anniversary of the *Carry On* films. We later did the DVD releases and their 50th anniversary at Pinewood. My connection with Bond and *Octopussy* returned with the Director of Photography, Alan Hume. He'd done all the *Carry On*s, so I interviewed him at his house. He was a lovely bloke, really laid back, a top, top guy. His sons are still in the business."

Ken also had a reunion of sorts with *Octopussy* director John Glen at Pinewood Studios.

"I met John at the Pinewood 70th anniversary in 2007 and I felt like a child again because he remembered me! My office at Pinewood for when we were doing the *Carry On* stuff was next door to Roger Moore's agent, Gareth Owen, and John was having a canape out in the grounds of Pinewood. He was the one who all those years ago said 'Right, you can film, but you've got to stay out of the way'. So I introduced myself again and John immediately referred to the footage and said 'You're Ken Burns. Well, wasn't that a wise thing I did'."

Continuing the search for local people involved in the filming, Ken told me about two Sikh brothers called 'Singh' who at the time of filming, ran discos by night, and by day tied the turban for Kabir Bedi and his stunt double.

# 18 TURBAN TIER FOR HIRE

At first, I thought Ken was getting his own back for when I'd laughed at some of his misfortune during *Octopussy*. Two Sikh brothers called 'Singh' who ran a disco and were paid to tie turbans? Nice one Ken, I'm not falling for that; but then I tracked down Del Singh who'd run *The Park Nightclub* in Peterborough I'd frequented in the late 90s. He confirmed the story was true. It was him and his brother Dave who had been turban tiers at the NVR for *Octopussy*! Del still lived locally and shared his story.

"It was bizarre how it came about because at the time, we were fly-posting for our discos. Somebody phoned us up and we honestly thought it was a wind-up. When someone booked a disco, they don't usually start asking 'Is your name Singh?' 'Yes, it is'. 'Are you a Sikh?' 'Yes I am' 'Do you wear a turban? 'Er, yes'. So I was thinking, 'Where's this going?' because in those days there was the National Front and quite a lot of racism around. We'd encountered some of it running a disco, so you think to yourself 'Is somebody phoning up because they want to be abusive or do we take our disco equipment somewhere and end up getting attacked?'"

Del soon realised that the phone call was genuine when the voice on the other end told them he was calling on behalf of Eon Productions.

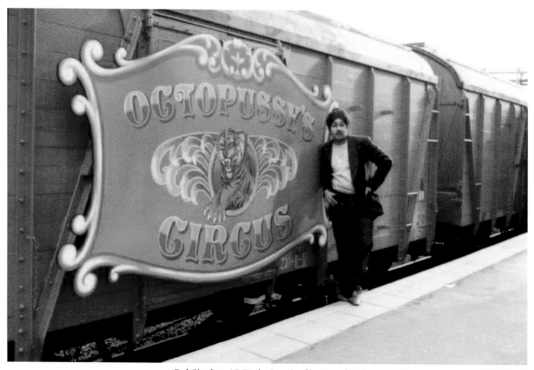

Del Singh at NVR during the filming of *Octopussy*. Image courtesy of Del Singh

"They had taken the entire top floor of The Saxon hotel, later the Moat House, and asked us to come to meet them. They showed us upstairs and they were quite stricken. They had put this stuntman on top of the train to start some of the pre-shots with the stunt crew, and the turban he was wearing would just fall off. They were asking us, 'Why's this happening?' We asked, 'Can you show it to us?' It was about the length of a large bath towel and we said, 'Hang on a second, this isn't a turban! A real turban is probably twice if not three times that in length and that's because it goes on in layers; the more layers that go on, the more it compresses and tightens up.'"

Del and his brother Dave then ended negotiating to be paid £50 a day to supply and fit the turbans that were used in the train scenes for Kabir Bedi and his stunt double.

"The problem had been, when they got on top of the train and it started moving, it didn't seem like the train was going fast but the wind would blow the stuntman's head back and that's when the turban would come off. Once we'd put them on, there was no way the turban was going to come off. And the one that was used was in fact my old school turban! That's the grey style you see Kabir wearing in the film with the red flash underneath it. He had a little bit of light reflecting off his forehead, so what I suggested was we should get a thing called a 'Fifty' and it's basically a piece of cloth that goes around underneath and it just shows a little triangle of red that looked really smart. I said to Kabir 'You're a tall guy, so to really set your turban off you need this little bit there that sets off the rest of it'. And when we did that, all the costume people were saying it looked really smart because it went with his size.

Second unit director Arthur Wooster (middle of photos in the blue jacket) looks on as Martin Grace rehearses a fight sequence on top of the train. Photos by Chris Pinion

ACTION VEHICLES:     Comma

SFX:                 Spare
                     Stea
                     Cape

PROPS:               To ir
                     Bond
                     Tackl

RAPTYS:              On Location at 8.00 with Bonds Gun, Kamals
                     Gun and Guns for Soldiers.

PRODUCTION:          Turban Expert on location for 7.45am.

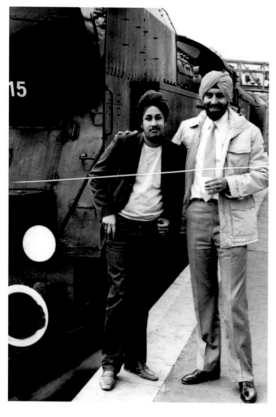

Del with Kabir Bedi
Photo courtesy of Del Singh

He was really polite, very modest and he admitted this was probably the biggest film he'd got. It obviously worked for him as it gave him a springboard into America with Dynasty. And although he didn't become a huge star, he's had a good career and is still working."

Del and Dave also managed to juggle the demands of working on Octopussy with their other summer jobs.

"We were both working at Christian Salveson, a vegetable processing factory, earning a few pounds before we went off to our respective colleges in London and Hatfield. For the filming, we'd do it in turns. We would go in the morning, fit the turban and then we'd literally just sit around in the trailers and have a wander about. We were a bit fortunate compared to the rest of the extras as we had access to all areas so we could go where most people weren't allowed to."

Being part of the backstage crew on set also meant Del got to spend some time with Roger Moore during breaks in filming.

"With Roger it was interesting because he had a fantastic sense of humour, very dry. But he also never took himself seriously and was very self-deprecating. I remember some of the reporters allowed on set tried their best to goad him about the Connery vs Moore Bond rivalry since Connery was coming back to do Never Say Never Say Again. But Roger never rose to the bait. He simply commented that both he and Sean interpreted Bond in their own way and that some would like his version and others Sean's version."

Also, for an Indian guy, Kabir was quite unique, because he had piercing blue eyes and quite light features, so with a grey turban he looked really, really good."

Working with the main henchman in a Bond film was a memorable experience for Del.

"Kabir was lovely, a real down to earth guy. He'd started off life in Bollywood, but had made that transition across. He'd made an Italian series called Sandokan Pirate where he'd come to prominence, but I only found out about his career after he'd told me. We had some nice chats and he even gave me his address and phone number in Beverly Hills, which of course I lost! And funnily enough, when I started scanning all my old photos a few years ago, I opened up a box and out fell this pink bit of paper and on the back was his home address and phone number. I rang it up, but of course it didn't work anymore.

Del on set at NVR in
conversation with Roger Moore.
Images courtesy of Del Singh

Del Singh

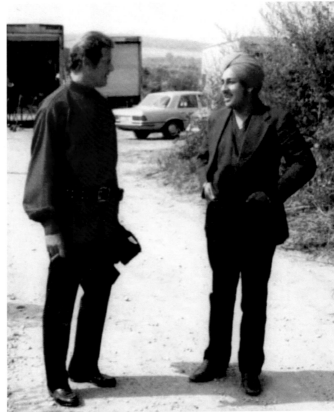

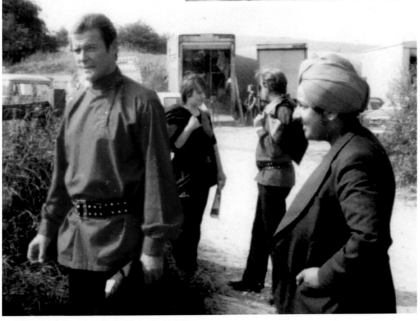

The money Del and Dave earnt from Octopussy helped put them through college and university, with Del getting a degree in Genetic engineering.

"I remember it as just an amazing summer and having an absolute blast. You know one minute I'm hobnobbing with Roger Moore and then I'm hiking it up to a factory and freezing peas! It was quite a contrast. They'd normally wrap up filming at 4 or 5 o'clock, so I'd hightail it out of there and start a night shift. 6pm – 6am. That was one of the reasons my brother was there. If when I was tired in the morning, he'd do a session tying the turban. Then he'd go

off and I'd turn up, so there was always one of us around. But it was a charmed life, because once we'd tied the turban it wasn't going anywhere."

Del also went to see the film at the Odeon cinema for the charity premiere which I'm pleased to hear.

"I came away from it really excited. There's bits where it doesn't quite float my boat, like Roger Moore dressed as a clown, but the story makes you think, and there's some interesting stuff in there. Steven Berkoff as one of the Russian Generals is rather brilliant."

These days Del works for a large IT software vendor in London, but still lives in his hometown of Peterborough with his wife Jas. At the time of going to print Del was preparing to take part in his latest marathon and over the last five years has raised thousands of pounds for local charities.

In 2017, 35 years after losing Kabir Bedi's contact details, Del was reunited with Kabir over Skype. He introduced a screening of *Octopussy* that had been organised by a London based cinema club called *Supakino*, who also ran 'Turbans Seen On Screen (TSOS); films notably featuring characters wearing Turbans.

Ranjit from *Supakino* with Del reuniting with Kabit Bedi on a Skype call in 2017.
Photo courtesy of Del Singh

# 19  ERNIE & CLEO

In the early 1980s, one of the biggest questions in popular entertainment was, 'Who Shot JR?' This was a storyline in the popular TV soap opera, *Dallas*, when JR Ewing was shot by an unknown assailant in the cliff-hanger episode of the 1980s series. Television audiences were gripped across the world and over 80 million viewers in the United States tuned in that November to watch the 'Who done it?' episode.

In the UK, audiences had to wait until early 1981 for it to be shown, but a year later in 1982 there was another whodunit. Who Shot General Orlov? Because unusually for a Bond villain, he meets his end after being shot by an extra.

Ernie Morris was that extra, and the only one during the NVR filming to be given a line in the film as the VOPO (*Volkspolizei*) German border guard, who stops General Orlov dead in his tracks on the railway line.

One of the other extras remembered Ernie had ran the security firm that provided on-site security at the NVR whilst filming took place. After a lot of searching I eventually tracked him down. Retired, still living in Peterborough, and happy to put the kettle on, as he reminisced;

"I'd formed Central Security in 1974 after I'd come out of the Police force, so we were an established company. We had national contracts with the gas board and a lot of businesses across Peterborough. Originally for *Octopussy* I was in charge of looking after all the filming equipment there, day and night, but then the location manager asked if I had a dog they could use on set. The only dog we had in the company was my own personal dog – Cleo, a German Shepherd. So they then asked me to be an extra, as a German Border guard walking up and down with her, under structures, behind the train, and in between the border. I wore the grey VOPO uniform including the boots, which looked very smart."

It wasn't long before Ernie came face to face with Roger Moore on set over the first few days of filming and also his daughter Deborah, who was an on-looker during the filming and later made a cameo in 2002's *Die Another Day* as an air hostess.

"I was only with Roger for one scene at the Yarwell tunnel. We had to follow the train down the track, stop, come back, do it again and during one of the delays in between, he'd tell us jokes. Roger was a real character and his daughter was lovely. Everyday she'd come over, stroke my dog Cleo and make a big fuss of her."

It was around this point that Ernie was summoned over to see John Glen sitting in his director's chair. Ernie recreates the look of panic that went across his face when one of the assistants came up and said, 'John would like a word with you'.

"'What's gone wrong with security?!' That was my first thought because I was meant to be in charge of it all. I'd had to semi-promote one of my senior security guards into my job, but when I went up to John he said, 'Have you ever had any acting experience, Ernie?' I said "Well I was one of the Three wise men at school!" I immediately thought 'I wish I hadn't said that', but he just said "Well I've got a

little job for you. I've been watching you walk around and think I've got a part for you'. So I was marched off with a woman to learn a line in German."

Ernie wasn't able to recall the exact phrase, but Benjamin Lind of the *Bond Bulletin* was able to identify it as *'Hey, Stehen bleiben!'*, which means, Stand still, don't move.

Cleo, the guard dog, was then handed over to one of the other extras who had got used to her, allowing Ernie to concentrate on his new role.

"I was now one of the border guards for the shooting scene with Steven Berkoff. Obviously they wanted to make sure I could get the line right, although I think it was later dubbed in post-production. I also had to learn how to use an AK47. I'd done my National Service with the SLRs, which weren't much different as a semi-automatic rifle. So I was given a bit of training practice by the armourer until I was ok with it."

Unlike the majority of the extras who were given prop rifles that didn't fire, Ernie's was a fully working rifle.

"They were usable weapons, so the security was very tight. It used blank bullets, but they gave you a real kick when they were fired. I had to sign for them every day with the on-set armourer. We then rehearsed how I was going to come out of the sentry box. The idea was, Steven Berkoff runs past me as the train leaves from East to West Germany and I run out with a megaphone, telling him to stop, and of course he doesn't. He carries on after the train and then the scene should be that the helicopter lands behind me and Walter Gotell runs up, knocking my gun down as I'm shooting. But of course it all went wrong. I fired a couple of shots

off, Steve Berkoff did his scene being shot and falling, but Walter Gotell didn't arrive to knock my gun down. He was lying behind me! He'd tripped over a railway sleeper on the line and cut his cheek and left eye quite badly. The scene was stopped and I thought, 'Well that's the end of my career as a border guard!'"

Fortunately, the accident to Walter Gotell wasn't serious and a few days later he was able to resume filming with Ernie once again back in action.

"They put the scene on ice until his swelling went down and we then shot it again on the Sunday before the main unit left. When Walter came back after tripping on the sleeper, he said to me, 'Do you know, that's never happened to me in all my years of acting'. I said 'Well, you've never acted with me before!' That did make him laugh. But it went well the second time; they got the shots they wanted. Steven Berkoff is a marvellous actor; he really practiced his dying scene and did his last line at least five times. He really, really got into the part and when he was working up to run down the track he actually ran around, so he got hot and sweaty. He's a really top actor, a serious man, but a proper actor can I say."

Following the completion of that scene, the 1st unit under John Glen left for location filming in India and the 2nd unit took over at the NVR under the direction of Arthur Wooster, Gerry Gavigan and Michael Zimbrich.

"On the final Sunday after they'd finished, John Glen called me over and said, 'Have you thought about an acting career? You've got the ability and I think you should take it further'. There was talk of having to have more experience to be signed up by Equity, so I was sent along to meet Jill Freud in Chatteris, a stage actress at the

time. She made a few phone calls and said, 'I can get you into a London play as a uniformed police officer with a couple of lines'. It all sounded very interesting, but I was married with three children, in my early 40s, my own business was doing quite well, so I just had to say no and I let it go for all these years."

Not content with running his own security business at the time, Ernie was also an officer in the RAF Training Corps in March, on the outskirts of Peterborough.

"I was born during the Second World War and grew up in the East End of London. We were all rough kids playing in bombed out areas, but my history teacher was a real hero, a bomber pilot. I left school just before I was 15 and he said, 'What do you want to be Morris?' I replied 'I want to be a pilot sir'. 'An RAF pilot?' he asked and I said, 'Yes Sir'. Then he just looked at me and said. 'You've got no chance. You, son, are factory fodder'. And those words have always stuck in my mind. '*You son, are factory fodder.*' I thought 'One day I am going to fly'. So, when I got my security business going, that's when I learnt. I got my commission in the Royal Airforce training cadets, became an officer in the RAF and a pilot, so I did it. I was a uniformed flying officer in the air training corps in March, Cambridgeshire. I got the Queen's commission and I've flown light aircraft for 30 years, but my son went on to do what I always wanted. He was Squadron Leader in the RAF for 18 years and flew Hercules in the first Gulf War. That's his Herc on the wall there behind me. My son's led the life I dreamt."

Ernie Morris - Now and then in the photo with his Alsatian, Cleo. Photo by Marc Hernandez

After a distinguished career in the RAF, Ernie's son now works as a commercial pilot, but when Ernie retired from the security business in 2008, his wife made a suggestion of how he could keep himself busy.

"She said, 'Why don't you do some acting?' She'd heard the story enough times about *Octopussy*, so I joined various agencies and started doing what's now called 'supporting artist work', and in the end I got my equity card! All those years after *Octopussy* and I got it!! They wanted proof of five films so I did a lot of low paid budget films and then I got into two features: Moral Conflict, which had Linda Robson in, and Field of Corpses, where I played the male lead opposite Catherine Manford, Jason Manford's wife at the time. So yeah, I've been very fortunate to have some good work in my later years of life."

That 'good work' also included a few weeks as an extra/supporting artist on *Nine* (2009), filmed at Shepperton Studios, and a scene with Dame Judi Dench. "We were sat around tables in a nightclub and she comes around singing a song in English with a French accent (Folies Bergère). She stopped at the tables where we were sitting, and she says something like, 'Last week there was a priest, and there (looking at me) was a, er...I forget the next effing word!' Her mind must've gone blank, so it can happen to the best of them! But she was a lovely person, so down to earth. At the end of this particular scene, tinsel was released from the ceiling. And to prepare for the next take, out came the commercial vacuum cleaners. Judi Dench was sitting on a piano, got off and grabbed a vacuum cleaner. People were looking at her, a bit surprised, and she just laughed saying, 'I've done this before, you know!'"

Another Hollywood A-lister to share a tea with Ern was Russell Crowe on the set of *Les Misérables* (2012) at Pinewood studios. Crowe played the part of 'Javert', the ruthless Police inspector. Ernie again found it an enjoyable experience.

"I played a citizen in a scene with him and when they said 'CUT' he had this big posh caravan to go back to, but he said, 'No, I'll stay with the boys'. He stayed all afternoon chatting, joking and he was great with us, a really nice guy."

Perhaps Ernie's biggest on-screen role as an extra in recent years came in *The Muppets Most Wanted* (2014).

"I was at Miss Piggy's wedding at the Tower of London. They filmed at Pinewood, so one minute you see Ricky Gervais and then you see me marching with my wife to the wedding on a big red carpet at the Tower of London. I'm there up the front going into the wedding of Kermit the Frog and Miss Piggy. My grandkids couldn't believe it!"

It's clear to see that Ernie has found a new lease of life, particularly with some of the independent filming jobs he does.

"I do like doing a lot of the University film work because they go out of the norm with the storylines and they're just so diverse. I got a copy of the film so my family can see it and I've done things I've really enjoyed. I've been a gangster, a vampire, I've been in musicals and it's all because of *Octopussy*!"

Not only is Ernie involved in budding film makers' work, he's also an extra in one of the most critically acclaimed TV shows currently in production; *The Crown* on Netflix.

Ernie in action, twice! In black & white as border guard in *Octopussy*, shooting at General Orlov. The insert shows Ernie all dressed up as an Archbishop for a scene in *The Crown*. Images courtesy of Ernie Morris

"I was in the scene at the Queen's Coronation where I carry a banner; a big standard. We filmed at Ely Cathedral which was meant to be Westminster Abbey. I was an Archbishop. I had another part which they filmed at Pinewood Studios where I held the crown; one of the actors takes the crown from me to crown Her Majesty in the film. I play two archbishops; I'm a Catholic in one scene and a Protestant in the other!"

Before I left, Ernie casually told me of another link he has to the Bond films.

"I was in *Skyfall* as well. It was only a crowd scene, walking up the street. It's when Daniel Craig comes out the tube station and he runs behind the cars, near the Houses of Parliament. I had two days on that one; not a speaking part. I was just at the end of that tube station, outside in the background. I was in the crowd of people where the Police are outside with the ambulances all lined up on the curb. There was a 100-yard spot where I was a bystander strolling in the background. The funny thing was, nobody knew I'd been in *Octopussy*; none of the other extras or even the casting manager."

Hearing this made me watch that particular scene of *Skyfall* on slow motion straight after my tea with Ern. As he said, you can't spot him in the crowd as it's quite a quick scene. But I guarantee the next time you make a cup of tea, you'll be thinking of Ern: The man who shot General Orlov at the East German border, and the man who cóuld have shot Raoul Silva in *Skyfall*, had there been a spare AK47 lying around.

# 20 DOG DAYS

Ernie had lost touch with all the other extras he'd worked with on *Octopussy*, until a recent experience with a guy who recognised him in the *Burghley Square Club* in Peterborough.

This was how I met the next 'missing' extra, Andy Moore, current chairman of the Peterborough Lions Rugby Club, and to hear how he had his moment of fame snatched from him, all because of Cleo, Ernie's guard dog.

"I'd just turned 21 and was coming out of my apprenticeship at *Baker Perkins*. Me and David Fitch, another apprentice, went to the old *Wirrina* for the auditions. At first, I was going to be a roustabout, but when I got there, I was seconded to the East Germans straight away. Prior to that, my Uncle got a contract to provide drivers and cars for the actors, which I would have done if I hadn't been an extra."

Once on set, Andy soon found that having the same surname as the film's leading actor had its perks.

"They gave us stickers to put in our cars for when we reported to the railway. They said *Octopussy*, but the *OCT* was done to look like *007*. You had to write your name on it, so I had 'Andy Moore' and of course, with Roger Moore being the star, everyone would stand outside trying to get autographs. When I pulled up and they saw it had 'Andy Moore', they all thought I was something to do with Roger as some of his family were there, including his son who was found bombing about on a little 4x4 quad bike."

After being fitted out as an East German VOPO, Andy began work around the *Karl-Marx-Stadt* station set.

"I was involved in various bits, but as you were moved around, you could be in two or three different places depending on what they were doing. I was also there the night they filmed at Orton Mere, with the knife throwers and the stuntman falling into the river. But the best thing was having dinner with all the Bond girls. They had their big tent and we were all young blokes, full of testosterone, so we'd hang around with the crew and it was brilliant. I can't remember how much we were paid, but I didn't really care; I would've done it for nothing!"

There were a couple of scenes that Andy remembers that didn't make it into the final film.

"One where the car pulled up at the front of the station and Steven Berkoff got out. We were border guards standing by the car. What was amazing, they went to a lot of detail that wasn't really shown. To start with, I was up the watchtower and they had a massive prop gun up there to make it look like a gun tower. They never showed it in any of the scenes. I remember when the train was leaving the station and the girls were all waving out of the train windows, I was up the tower just taking it all in."

Whilst he was taking it all in, one particular lunch break saw Andy and some of his fellow extras including Paul Carrington and David Stent nearly cause widespread panic. Dressed as they were in Russian and East German uniform outside of the railway, they looked like part of a real-life cold war invasion force.

"One dinner time we did sort of 'escape', because you weren't allowed out with your uniforms on. On this particular day there were about four Russians, two VOPOs, and a few roustabouts; we made our escape. We all went to *The Haycock* hotel and there was a little old lady in the foyer who went nuts at us; she thought we were real Russian soldiers! We got into a lot of trouble for that, going out in our uniforms."

Andy helped make amends with the crew by suggesting one of his *Baker Perkins* pals, Dave Fitch, to them for something they needed.

"Fitchy was originally there to be a soldier. One day, someone from the crew asked, 'Has anyone done any silver service waiting?' 'Dave Fitch has!' He had a part-time job at a local restaurant and that's how he got the part of the waiter you see on the train. He was the guy that walks through the carriage as one of the Bond girls juggles a tea cup; he catches it from her."

Andy's own chance to appear in a scene on screen is one he tells me he's told many times over the years, normally at the bar after Rugby matches.

"When they came to the part where Ernie shot Orlov, Ernie handed me his dog. I was only nine stone dripping wet then, with his eight stone German shepherd wrapped to my arm. So, what happened was, the barrier would go up, the train would go through, the helicopter would land and out they'd run chasing Orlov. As they came through the barrier, I was standing in the way and Ernie shoots him. I was thinking, 'They're not going to have this big dog and not have it on camera!' So we practiced and then the helicopter started coming in and then it was for real and Ernie was going to shoot.
The barrier goes up, the train comes through, the helicopter lands, they come out running, I'm holding the dog, Ernie comes out with his machine gun, and because of the sound of the gun, the dog went apes\*\*t; yanked me straight off my feet and down into the ditch at the side of the railway!

'CUT, CUT, CUT!' went the call and we had to do it again. I scrambled out from this ditch, a little bit dishevelled and they said, 'Right, can you move slightly across?' So the train comes through, out they come running, and I've got this massive chain holding the dog that I'd got wrapped

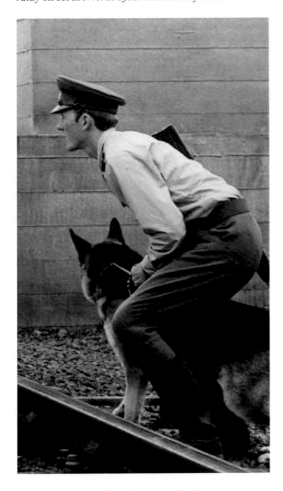

around my hands, they brushed past me this time, off goes Orlov, out comes Ernie, he shoots, the dog starts barking and again, I couldn't hold it. I'm off my legs and the dog's dragged me back into the ditch.

'CUT, CUT, CUT!' I come back up, and I'm even more dishevelled now. 'Right, can you just stand a little bit more to the side?' So now I'm digging my feet into the ground whilst holding the dog. The barrier goes up, train comes through, the helicopter lands, out they come running and this time they run by me. I'm holding the dog, trying to look mean, out comes Ernie, shoots the gun, and the dog's off again! I just cannot hold on to it. It weighs eight stone and is dragging me head first down the ditch.

'CUT, CUT, CUT! I get up and this time my uniform's a little bit ripped, and I'm thinking, 'The dog's screwing this up for me'. But they said 'Can you stand right over the side?' And then someone else said, 'Hang on a minute'. There was a bit of a kerfuffle, whispering and talking and then someone suggested putting cotton wool in the dog's ears! So, they stuffed cotton wool in the dog's ears, it is poking out the sides, and they say, 'Can you stand just a little bit more to the right?' I'm thinking, 'I might as well stand behind the camera if I move any more to the right'. So, I'm there, Ernie comes out, shoots the gun, and the dog just looks at me, because she can't hear anything. The only trouble was by now, I was right on the very edge of the shot, so I knew I'd hardly be seen!"

Andy's on-screen moment was lost for over 20 years due to the pan and scan cropping techniques used in television broadcast and VHS releases, but there was one place he could be seen. On the inside cover of the official *Octopussy* film programme there's a black and white photograph that shows him holding 'Cleo' amongst Ernie and Steven Berkoff running towards the train.

"When I went to the first showing of Octopussy in Peterborough at the Odeon, we were all sitting there not knowing what had gone in and what hadn't. I watched it and I was a bit disappointed because Fitchy was on the train and you could see him clearly, but then another guy comes up to me after as he'd bought a programme and he said, 'Look, you're in here!' And that made it ok for me because at least there was proof and I didn't feel too bad. But then of course, when I used to tell people I was in the film, they'd go 'Nah, we can't see you!' They would think I was making it all up.

It wasn't until I watched it on a widescreen TV years later and on DVD that I thought, 'Flipping hell I am in it!' My kids were young, so I was able to say, 'Look, there I am.' Then all the people who didn't believe me, I got them around just to prove I was in it and to stop them taking the mickey! The other thing I did was buy a copy of the *Octopussy* programme in different languages whenever I saw one for sale on eBay, so I've got it in about three or four different languages. It makes me laugh to think millions of people have seen my photo around the world but have no idea what I went through with that dog! I still see Ernie around from time to time and whenever I do, I get on to him that his dog stole my stardom!"

In the years since his dog day afternoon, Andy went back to his day job at Baker Perkins before setting up his own steel construction business in the 1990's. It has now become one of the top bridge building companies in the UK, specialising in heavy fabrication and bridge work all over the country, including contracts with Network Rail.

"We work a lot on the railways and in fact we've done quite a lot at the Nene Valley Railway, renovating some of their old bridgeworks. I know Roger Manns quite well."

The next day Andy told me that he'd be seeing David Stent, the Peterborough United safety officer and General Gogol's Aide, as Andy's company were sponsoring the match. I then made sure to check the match report and can confirm that at no point was the game stopped due to Andy being dragged onto the pitch by an excitable police dog.

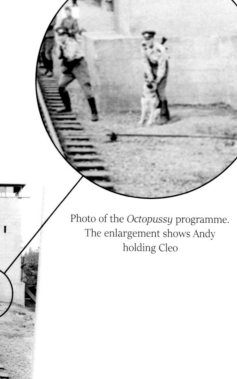

Photo of the *Octopussy* programme. The enlargement shows Andy holding Cleo

# 21  THE CUP CATCHING WAITER

The moment a waiter catches a teacup being juggled on the train by one of the Octopussy circus girls played by Vera Fossett, occurs when he's barged aside by Gobinda chasing Bond in the carriage, while Bond is making his escape on the carriage roof. I remember travelling in the exact carriage, the Wagon Lits 2975 dining car, when it was in service on the NVR and hoping that one day I might see a waiter catch a cup being juggled in front of his face! Of course it never happened and I forgot all about it. Until Andy Moore mentioned it. His friend, David Fitch, had been the waiter, in shot for 10 seconds, to catch the teacup and with the Wagon Lits 2975 dining car still at the NVR, there was really only one place I could meet him. Over an August bank holiday weekend in the carriage at Ferry Meadows station, I heard his story.

"I was an apprentice at *Baker Perkins* at the time and my dad picked up on seeing in the newspaper that there were auditions being held at *The Wirrina*. I went into work, told Andy and we went to the auditions. We were both in our apprenticeships so after we'd been picked, we took two weeks holiday and then went to Wansford. I was first fitted out to be a Russian soldier and Andy was a border guard."

Dave as a Russian soldier. Image courtesy of David Fitch

As one of the Russian soldiers, David remembers one scene particularly well.

"One afternoon they said 'Can any of you stay late? There's a scene that needs to be done at night in the tunnel with Roger Moore'. I was one who said 'Yes!' and I remember sitting on the ballast in the tunnel waiting for ages. We were all thinking 'Roger Moore's coming, we've got this big scene to do!' And when he arrived, he said some very nice things and was lovely to us. What he had to do for the scene was stand in the 'man safe' in the wall and what he did was just turns his eyes; he looked left and right in the alcove and then he walked out saying to us, 'That's it lads, see you tomorrow!' I thought he was joking because it was like 'Look Left, look right, Goodnight'. But that was it, a few seconds worth of filming and off he went."

It was during the train scenes where David then played the waiter on the train.

"It was Andy who said, 'Fitchy's a waiter. He's trained at it!' At first I thought I was being asked to help with the catering for the cast and crew. I was thinking, 'Either I've got to serve food or lay the tables for their lunch.' But then they explained the scene and kitted me out in a maroon jacket, cummerbund, trousers and bow-tie."

David Fitch back in the Wagon Lits dining car in 2017. Photo by Marc Hernandez

The scene of Kabir Bedi coming up the train and pushing past David was practised, and then the cameras rolled.

"On the first take I got my feet tangled in the cables, fell over and of course the train's still going and they're running out of track. They must have been thinking, 'Oh here we go'. But then on the next take, one of the crew pushed the back of my shoulder, so I was in shot as I walked. I turn, catch the cup and that was it. Simple. But as Andy's probably told you, they really looked after you. It was top class; you could have any food you wanted and I think we got about £160 for the week, which was a lot of money back then. I was earning £14 a week as an apprentice and one of the reasons I got an evening job as a waiter was because I'd just got married that July and was saving up to buy our own house."

David was also present when Cubby Broccoli arrived with daughter Barbara, whose first official credit on the Bond films was as an assistant director on Octopussy.

"How I remember it is they turned up in a silver Ferrari and everything was set out. He pulled up and they got him one of those big director's chairs, because he wanted to see this final scene where Steven Berkoff's character gets shot. There were a lot of people there, all talking because it was so exciting, nice weather and then one of the crew quietened everyone down. Cubby Broccoli pressed this digital watch on his wrist and it played the Bond theme. So of course everyone cheered and I just thought, 'That has made my day!' Even now it's one of the things I've never forgotten, because back then you didn't have ringtones on phones or watches or anything like that. It was quite something. Seeing Cubby Broccoli with a watch that played the Bond theme was just brilliant."

The last day of the Odeon, Peterborough Nov 1991.
Photo by Mike Jackson

"I'm the Senior Agent for *Amco Rail*, which means, on behalf of *Network Rail*, I put all the bridges in on the M4 corridor from Paddington to Cardiff. I'm predominantly working at Reading, Newbury and then along all the way through to Wales. It's funny, because I was in the hotel gym a few months ago and overheard two guys talking about James Bond. One of them said to the other, 'Do you know, I think *Octopussy*'s my favourite Bond film' and so of course I had to lean over and say 'I hope you don't mind me interrupting, but I was an extra in that film!'"

Once filming had wrapped, David went back to his day-job, saw the film at the Peterborough *Odeon*, and later started his own business which brought him back into the *Odeon* cinema building. Founder of the *Pizza Express* chain, Peter Boizot, bought the building.

"Shortly after the *Odeon* closed, I worked for Peter because I had set up a laundry business in Peterborough and was then involved in his hotels in London. He said to me, 'I'm going to buy the *Odeon* and put it back to how it was'. He was a very wealthy man in those days through *Pizza Express* and spent something like £9million on it, bless his heart; he turned it into the *Broadway Theatre*."

With his engineering experience it's no surprise that Dave returned to this as a career and on the day we meet, he has to race off on a call to Swindon.

The majority of the local extras still live here in the UK, and there is one I made contact with who is living a little further away from the Nene Valley than the others. Now living in New Zealand, Tony Lock told me over email.

"I was in several scenes either as a soldier or an officer. I was in the scene on the river bank as the car was pulled out of the river. I was in the centre of the group of soldiers holding a gun as the two men talked at the back of the car when it came out of the river. The main scene I was in was at Ferry Meadows, as the officer who came from behind the train to inspect it, and then walked alongside the train in the station as it left. I was alone in that shot, so you can see me quite clearly wearing the dark olive green East German police uniform. It was great fun, kids were asking for autographs, I was paid £12 a day, I had lunch and I was there two weeks."

# 22 FOR CINEMA EYES ONLY

The Royal World Charity Premiere of *Octopussy* took place on Monday 6 June 1983 at London's *Odeon Cinema*, Leicester Square. It was held in aid of the Stars Organisation for Spastics. As with all James Bond premieres, it was a star-studded affair and given the Royal seal of approval with the future King of England, Prince Charles and Princess Diana being in attendance.

Meanwhile in the Nene Valley, a handful of the NVR steam team had seen the film a day earlier at the crew screening which was also at the Odeon, Leicester Square. For the majority of those involved in the filming the previous summer, they had to wait a few more weeks to see it and two men were planning to make it a memorable night.

The Odeon Cinema on Peterborough's Broadway Street was the setting and where I first saw the film when it opened. By pure coincidence, the local charity premiere took place at midnight on 17 July, my 10th birthday. It was attended by almost all the railway personnel and extras involved, together with a few special guests. I have a vague memory of the evening and my Grandad taking me to it, but to explain how it all came about I need to introduce you to Mike Turner, the Odeon's manager.

"I started at the Odeon in Peterborough during June 1976. I'd started in my home town of Liverpool with the Odeon in 1969 as assistant manager. Learning my trade and from there, I went up to work in Scotland at Odeons in Rutherglen, Ayrshire, Glasgow and Edinburgh and then in 1974 I went to Leeds."

Moving to Peterborough with his wife and two young children in 1976, he found a city undergoing redevelopment and the cinema industry about to witness the birth of the modern Hollywood blockbuster.

"I went on to have my best times of my career in Peterborough. It was a great place to be; both my children went to Jack Hunt School and we had a great family life there."

We soon got onto the biggest, the best and beyond a shadow of a doubt, the film that changed the fortunes of his own cinema.

"For *The Spy Who Loved Me*, we had over 25,000 people see it during its run;

a record at the time for the cinema. I got Bernard Lee who played 'M' to come to the East of England Showground for Expo, the steam, transport and county fair, and he started a car rally we organised to raise money for charity. But 1978 was when regular business really started to pick up. We had *Star Wars* and *Close Encounters Of The Third Kind*. What *Star Wars* did for the movies, well, you can't complain about, can you!"

Over the seven weeks it was first shown in 1978 at the *Odeon Peterborough*, more than 30,000 people saw it setting a new attendance record and one that stood until the cinema closed in 1991. In February 1978, Mike was the recipient of the 'Thunderball Trophy' which was presented to him by the general manager of the *Peterborough Evening Telegraph* with an accompanying article.

Mike Turner (sitting in the middle) in 1978 surrounded by members of his Odeon staff as he's presented with the latest award for his cinema showmanship.
Archive Peterborough Evening Telegraph

## THUNDERBALL MIKE

*Top showman... that's the new title for Odeon manager Mike Turner... for Mike has been awarded the Thunderball Trophy, which means he is one of the five Top Showmen in the country. The award is for outstanding management and includes publicity, press coverage and a continuous public relations exercise.*

*"Thunderball" taken from one of the Bond films, is the name of one of five leagues and represents some fifty cinemas in the Rank organisation.*

*A delighted Mike told the ET "This is the highest accolade that Rank can pay one of its managers and naturally I am delighted to have won, but I didn't do it alone. I have a great team of people working for me and they must share the honour with me."*

*The handsome trophy was presented by Evening Telegraph's General Manager, Lionel Coles and carries with it a prize of £100.*

"Receiving the award was a lot to do with the great relationship I had with the local press. Every time they ran a story connected with the Odeon, I kept a copy and then sent it all at the end of each month to head office. The award encompassed various elements of what was then called 'showmanship' and I remember the trophy well. When I left Peterborough to go to the Ipswich Odeon in 1989, I had it up on the wall there... until some bastard nicked it!"

His own memories of James Bond began with first watching Dr No at his local Odeon cinema, Liverpool in 1962, and continued when he entered the cinema industry.

137

"They'd all done tremendous business at all the cinemas I worked at. I loved the movies; the whole environment was something I absolutely took to and because of my flair for the marketing and publicity side, that was something I embraced. So when it came to *Octopussy*, the fact it was having scenes filmed locally generated a lot of excitement. It had the knock-on effect of bringing a lot of people in to see the film. I don't know the exact numbers, but it certainly did very good business and outsold other *Odeons* of similar size around the country."

On hearing the news that the NVR was going to be used for *Octopussy*, Mike arranged for a double bill of the two previous Bond films, *Moonraker* and *For Your Eyes Only*, to be shown for a week during July 1982. Once filming commenced at the NVR, Mike remembers being invited to have lunch there by Geoff Freeman, Eon's marketing manager. Mike had first met him at Pinewood during a visit to the 007 stage in 1977, kept in touch, and met him again at the NVR.

"I was greeted by Geoff and we dined at a large luncheon table with him, Roger Moore and other cast members, before travelling on the train when it pulled out of the station." He then adds, "It was only for one scene and you don't see me in the film, so I wasn't an extra as such, not like the people you've tracked down anyway."

In the lead-up to the film's release the following year, Mike saw an opportunity to arrange a regional charity premiere of the film after organising ones for the previous four Bond films.

"I'd been to and worked at some of the Royal Premieres held for the Bonds at the Leicester Square Odeon, so had tried to replicate a bit of that, but obviously on a smaller scale when the films came to

Double Double-O-Seven ad for the July '82 double bill at *Odeon Peterborough*

**Opposite page:**
Press cutting from the *Peterborough Evening Telegraph* of the opening night of *Octopussy* at the *Odeon*

Courtesy of Marc Hernandez

my own cinema. As you know, one of the film's cast who hadn't filmed at the NVR, but everyone already associated with the Bonds at that point, was Desmond Llewellyn who played Q. I'd last met him at a press screening of *The Spy Who Loved Me* where some photos were taken of me with him and his box of tricks, the briefcase from *From Russia With Love* with a selection of Bond gadgets from a number of the films. The *Odeon* had a lot of really good marketing people at head office in London so I was able to get him to attend the opening night of *Octopussy*. I booked him in at *The Bull* hotel and remember picking him up with his 'box of tricks' which he then brought along and gave a little short demonstration to the audience before the lights went down and we showed the film."

# OCTOPUSS

**EXTRA SPECIAL** **EXTRA SPECIAL**

---

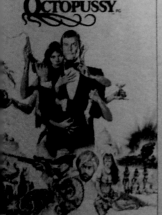
---

# Lucky 13 — latest Bond film provides local thrills

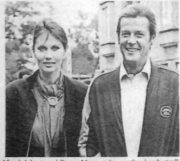

Maud Adams and Roger Moore take an after-lunch stroll at Wansford station during location work for "Octopussy".

THE latest 007 movie "Octopussy" holds an extra thrill for the Peterborough area, where some of the action-packed scenes were shot.

The charity premiere of the film at the city's Odeon was a sell-out on Saturday night. It opens to the public tomorrow and looks set to be a local hit.

Odeon manager, Mr Mike Turner, said: "It has created a terrific amount of interest. We are expecting a very good response."

"Octopussy" will be screened at the Odeon through the summer. From tomorrow, showings will be at 1.45 pm, 5.00 pm and 8.20 pm, Mondays to Saturdays, and 4.30 pm and 7.50 pm on Sundays.

And the Evening Telegraph is presenting a special serialisation of the full story for readers. The serial will appear in the ET from next Monday, July 25 to Friday, July 29, and will combine a competition.

### Explode

"Octopussy", starring Roger Moore, is the 13th Bond epic, and sees the super smooth secret agent 007 uncovering a disastrous plot to explode a nuclear device.

As the story unfolds, Bond meets Octopussy — (played by Maud Adams) — a mysterious and lovely circus owner who has close connections with the evil Kamal (Louis Jourdan).

The film, produced by Albert R. Broccoli, promises plenty of excitement and spectacular stunts, and a dramatic, unexpected conclusion.

Scenes shot in the area last year were mostly on and around Nene Valley Railway and feature in about 20 minutes of the movie.

Local filmgoers may recognise some of the local extras who took part, and should also identify the NVR Wansford station, Orton Mere and Ferry Meadows station, which was converted into a German border post.

Rail enthusiasts can watch for four of the engines based at the NVR — the Danish S No 740 locomotive, a Swedish B engine, a Swedish S class engine No 1178 and a diesel shunting engine called "Horsa".

Nene Valley Railway manager Mr John Pentlow said. "The atmosphere was very exciting during the filming, but at the same time it was hard work for everyone involved."

The film team was in the area for about eight weeks, and stars who came for part of that time included Roger Moore and Maud Adams.

---

---

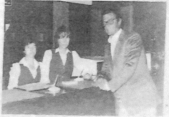

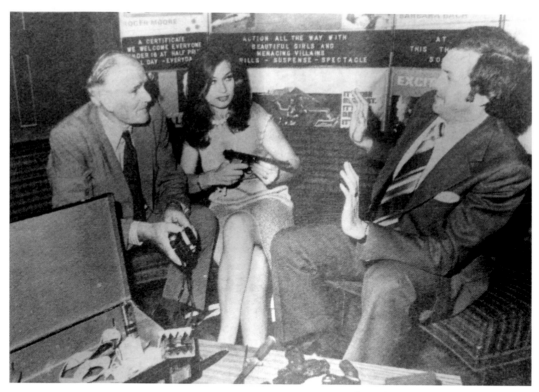

Mike with Desmond Llewellyn and Valerie
Leon in London 1977 during a press event
for 'The Spy Who Loved Me'.. Clipping
courtesy of Marc Hernandez

The next day, the following article
appeared in the local press:

### LUCKY 13 – LATEST BOND FILM PROVIDES LOCAL THRILL

The latest 007 movie 'Octopussy' holds an unexpected thrill for the Peterborough area where some of the action-packed scenes were shot. The charity premiere of the film at the city's Odeon was a sell-out on Saturday night.

It opens to the public tomorrow and looks set to be a local hit. Odeon manager, Mr Mike Turner said, "It has created a terrific amount of interest. We are expecting a very good response." 'Octopussy' starring Roger Moore is the 13th Bond epic and sees the super smooth secret agent 007 uncovering a disastrous plot to explode a nuclear device. As the story unfolds, Bond meets Octopussy – played by Maud Adams – a mysterious and lovely circus owner, who has close connections with the evil Kamal (Louis Jourdan).

The film produced by Albert R Broccoli promises plenty of excitement, spectacular stunts and a dramatic unexpected conclusion. Scenes shot in the area last year were mostly on and around the Nene Valley Railway and features in about 20 minutes of the movie. Local film goers may recognize some of the local extras who took part and should also identify the NVR Wansford Station, Orton Mere and Ferry Meadows station which was converted into a German border post.

Rail enthusiasts can watch out for four of the engines based at the NVR – The Danish S No. 740 locomotive, a Swedish B engine, Swedish S Class engine 1178 and a diesel shunting engine called 'Horsa'. The film team were in the area for around eight weeks and stars who came for part of that time were Roger Moore and Maud Adams.

Nene Valley Railway manager Mr John Pentlow said, "The atmosphere was very exciting during the filming but at the same time it was hard work for everyone involved."

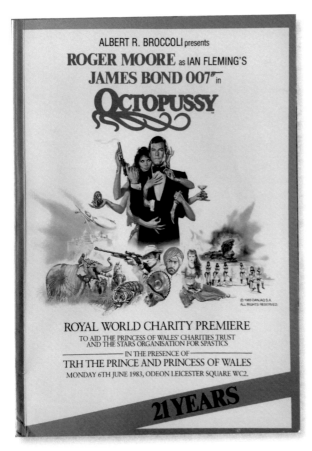

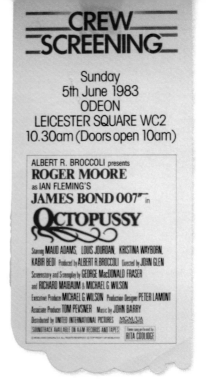

Octopussy Premiere programme (left) and ticket for the crew screening (right).

Mike Turner back on the steps of the old *Odeon* cinema in 2017 for the buildings re-opening as the *Broadway Theatre*. Images courtesy of Marc Hernandez

The other person who helped organise the night was Stewart Francis from the city radio station, *Hereward Radio*. He helped with ticket sales from the evening going towards the Hereward Radio Charity appeal. Mike elaborates:

"The first showing of all the previous Bonds I'd arranged had all benefited a chosen local charity and I was a regular guest on Hereward to talk about what was showing at the *Odeon*. This is how they got involved with *Octopussy*."

Mike had lost touch with Stewart over the years, but fortunately I knew a few people who'd worked at Hereward Radio that hadn't.

# 23 ONE OF EVERYTHING

In 1983, Stewart Francis was the *Hereward Radio* station programme controller and DJ. He also oversaw the stations fundraising, but chatting to him over the phone I realised our paths had first crossed in 1982. A year before the charity premiere, I'd played for my school team at the Nene Valley Football tournament at Prince William School, Oundle. Stewart was the local 'celebrity' who handed out the trophies that year and as soon as he mentioned it, it all came flooding back. Stewart laughed, telling me he recalled that a teacher at the school was married to one of his fellow Radio DJs, hence why he was there to present trophies.

He then mentioned that he'd started his career in broadcasting at *LBC Radio* in 1973 and had grown up in Purley, a small town in South London bordering into Surrey.

I was keen to meet up in person to see what he remembered about that charity premiere at the *Odeon* and he invited me to the first of a series of talks he was giving "In Conversation With'. This one was with David Lowndes, a *Peterborough Evening Telegraph* photographer for 44 years and someone I knew as well from events at the NVR. The talk was to raise funds for Stewart's local church St Kyndeburgha, Castor and the Jaki Francis Fund for Haematology Research at Peterborough City Hospital (set up in memory of his late wife). It was nice to be back at St Kyndeburgha's. Two of my friends got married there in 2014, and in between all the official photographs, I never tired of telling people the church had been in a Bond film! The church spire is briefly back projected into *Octopussy* when Gobinda, Kabir Bedi, is walking from one carriage to another during the train chase.

The first half of the talk saw Stewart showing a selection of David's photographs as he talked through them. Before the interval Stewart commented how powerful a photograph can be, transporting you back to a particular moment in time or a part of your life you'd forgotten about.

I spoke to him briefly during the interval, just to say hello, and at the start of the second half, he opened with a charity auction of various donated items. He put up some photos on the big screen of his late wife Jaki, who had passed away from leukaemia in September 1997. He talked passionately about the reasons funds were needed for haematology research at Peterborough Hospital and showed all the press coverage in the *Peterborough Evening Telegraph* following Jaki's death.... and then something happened....

I looked at their wedding day photo displayed on the portable projector screen that had been on the front page of the newspaper after she died, and I thought, 'I've seen that woman before'. Perhaps it was because I'd remembered seeing the front-page newspaper coverage in 1997, but then I leaned in for a closer look, saw her age at the time (34), the spelling of her first name (Jaki) and then it clicked into place. As Stewart conducted the auction, I discreetly scrolled through the 'Camera Roll' on my iPhone and found the photo I was looking for. The press clipping from September 1982 entitled 'The Harsh Reality of an Extra's lot'. There in the photo with Rachel Bratley was Jaki Fox (19) who looked an awful lot like Stewart's wife, Jaki Francis and, in 1997, would have been the same age as her (34). Could this be the same 'Jaki', and if it was, how exactly should I ask Stewart?

Jaki Fox

I couldn't exactly stand up and say, 'Sorry Stewart, can you stop the auction? I think I've got a photo of your late wife on my phone from 1982!' No, this required the upmost sensitivity and so the following day I sent him a carefully worded email. He replied later that day, saying I was correct - It was the same Jaki.

We met up for a coffee at his home and he started explaining the background to the *Hereward Radio* appeal for the disabled, and how it became associated with the local charity premiere of *Octopussy* at the *Odeon* in July 1983.

"At the time I was the radio station programme controller and became managing director the following year. I also did a morning show between 9-12pm

and the year earlier, had read out the card asking for extras and the telephone number to ring saying, 'Here's your opportunity to be in a James Bond movie!' I remember the city getting very excited about it. The Radio appeal was started when the radio station began in 1980 as a Christmas appeal with an on-air auction and it had two facets. One, was to raise money to buy things, in this case to really enhance mobility, and the second was to take as many people with disabilities as we could to the East of England show for a day out. So by 1983 it had become very successful. The business community were involved in donating items, we had radio staff and volunteers all behind it and the East of England Society believed in the project and knew they had to make the showground more accessible. We ended up taking 6,000 people to the East of England show every year, but it was at this point, 1982 to 1983, that we said 'Ok, if we can do it at Christmas, why don't we actually do fundraising throughout the year as well?' And that's how the opportunity came along for a local Bond premiere. Mike Turner spoke to me and said 'We want to make this big, can the radio station get involved?' I agreed and it then became a joint venture between ourselves and the *Odeon*, with our charity being the beneficiary."

"I remember I helped introduce and did the meeting and greeting with Mike. I don't remember how much that night raised for the appeal but the appeal ran through to 1994, the annual on-air appeal, three of four Royal Philharmonic orchestra performances in the Cathedral and a whole range of fundraising events, so basically whenever the radio station went out, we were raising funds.

---

**HEREWARD RADIO APPEAL**
**MIDNIGHT CHARITY PREMIER**

# OCTOPUSSY

ODEON FILM CENTRE, PETERBOROUGH
SATURDAY, 16th JULY, 1983
at 12.00 Midnight (Doors open at 11.30pm)
PROCEEDS IN AID OF
HEREWARD RADIO APPEAL FOR THE DISABLED

Admission Price based on Seat Price
(inc. VAT)                                    £2.10
Plus Optional Donation to Hereward
Radio Appeal for Local Disabled   £1.90           A28

TOTAL ————————   £4.00      NON-
                                         SMOKING AREA

Opening night ticket

In just over 10 years we raised a million pounds, bought 16 mini-buses for local disabled groups and they were presented by various dignitaries who included Prince Edward, Princess Anne and the Duke of Edinburgh. They were always presented at the East of England show at our stand, an outside broadcast unit with many other personalities and visiting celebrities, so it was quite a big thing in the city. A million pounds between 1980-1990 was an awful lot of money, so we did pretty well."

With Mike using his contacts to bring Desmond Llewellyn to the premiere, Stewart was able to use his and bring a future Prime Minister to the evening!

"The radio station had opened in 1980 and in 1979 there had been a general election in which Brian Mawhinney, who became Lord Mawhinney, was elected MP for Peterborough and a young John Major was elected MP for Huntingdon. It meant we had five or six MPs covering the area we broadcasted to and got to know them, but without knowing at that time that John Major was going to go on to become Chancellor of the Exchequer and then Prime Minster."

**Opposite page:**
Press cutting from the Peterborough Advertiser

**Below**: Stewart Francis looks on as Desmond Llewellyn shows a watch prop to future British Prime Minister John Major, the then Conservative MP for Huntingdon

# Octopussy premiere

## A NEW CLASSIFIED SPECIAL FEATURE

# Charity showing will raise money for radio appeal

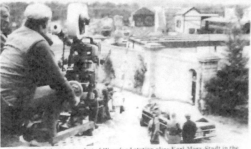

● A behind the scenes shot of Wansford station alias Karl-Marx-Stadt in the film. Picture by Chris Goodwin.

HAIR-raising stunts and glamourous girls are important ingredients of any Bond film, but the chances are it will be the familiar places and faces which most people will be looking out for when Octopussy gets its first screening at the Odeon in Peterborough on Saturday.

Seats have been selling well for the Hereward Radio sponsored charity premiere, in aid of their appeal for the disabled.

To make the event a very special occasion, one of the leading characters from the film, 'Q' alias actor Desmond Llewelyn will be the guest of honour. He has appeared in every James Bond film with the exception of two, as the British Secret Service gadget inventor responsible for 007's highly effective and usually deadly gimmicks. It is hoped he will be bringing a few of his more recent inventions along, hopefully the less devastating ones.

Several local dignitries will b be in attendance, among them Peterborough mayor and mayoress Coun Ken and Ellen Winfield, and MP for Huntingdon John Major. It is hoped that various other invited celebrities will also come along, most with local connections, like Geoffrey Hughes better known as Coronation Street's Eddie Yates, World strong-man Geoff Capes, and actor Robin Nedwell who owns a home in the area.

Before the film begins at midnight, there are lots of surprises in store, in particular a ticket draw, with six months free admission for two at the Odeon Cinema at stake.

Hereward Radio's head of news, Paul Needle will be there interviewing the special guests and speaking to members of the audience. This will be broadcast live as part of the Saturday Night Late Show.

"We are hoping to raise several hundred pounds for the disabled", said Paul. "Most of the seats have been sold so it should fulfil both its aims, to do some good for charity and be a fun event."

The total raised from the evening should be known at the end of the film, and it will be added to the fund, which currently stands at £22,000.

● Don't worry if you haven't been able to attend the premiere, Octopussy opens on Screen One at the Odeon from July 21st.

● THE long-awaited arrival of the latest James Bond film in Peterborough and by now everyone should know why

it can hardly have escaped anyone's notice that various scenes from the film were shot locally, mainly on and around the Nene Valley Railway between Wansford and Peterborough.

What many people might not have realised is the extent to which our locality features in the film.

Originally the Octopussy film crew was going to stay in the area a maximum of four weeks, they ended up staying for nearly eight.

"They used the location much more than they intended to," said NVR press officer John Jeffery "They were so impressed with what was on offer have that they kept adding new ideas".

As a result about 20 minutes of the film was based locally, as opposed to the few short sequences first planned. That still means that a lot of the filming around this area has not been seen, particularly when you consider that the spectacular crash between a car and a NVR train takes up 90 seconds on the screen but took three weeks to film.

## More films being shot

JUST like the Midas Touch, everything associated with a James Bond film seems to turn to gold, and not surprisingly Nene Valley Railway are hoping that some of the legendary fame and fortune will rub off on them.

The Railway was already established as a popular location with various television companies, but for their 'bigscreen' production they could hardly have secured a better catch.

Already they have two more film contracts 'in the bag' one with EON Productions who did Octopussy. The BBC will also be there later this year filming for a new second World War spy story 'Diana'. In the meantime NVR has played host to a pop group, Big Country, who recorded a video on the railway, the makers of an Imperial Leather soap commerical and Thames Television who are also making a spy drama, called 'Reilley' which will be shown in September.

Of course Octopussy helped the railway more directly by boosting its income last year

"Let's just say our turnover doubled last year from £100,000 to £200,000," said NVR press officer John Jeffery.

In addition to that the Bond film crew left behind one other memento of their visit, a new-look station at Ferry Meadows. Heavily disguised post with the odd sounding name of 'Gutenfurst', the NVR decided that the alterations were an improvement and so the new pitched roof, chimney and wood supports have been left in place.

Of course one of the main attractions connected with the film is the Danish locomotive 2-6-4 T (No 740) which pulled the Octopussy Circus Train, that can be seen as usual at the NVR headquarters in Wansford, along with the two other engines used in the film the Swedish 4-6-0 built in 1934 and the 2-6-2 T built in 1914.

Brian Mawhinney would later go on to become Northern Ireland minister, health minister and then chairman of the Conservative party.

Stewart took me through into his study and on a wall of framed photographs from his career, there's one of him at the *Octopussy* *Odeon* premiere standing in Mike Turner's office next to John Mayor, who's holding a watch which he's being shown by Desmond Llewellyn.

"Quite a lot of people were suited and booted with their dinner jackets and everything else and we tried to make it like a proper West End premiere, so it was an event and obviously Mike knew how to do that. I remember how charming Desmond was when I had to interview him. 'What's in the briefcase?' It was one of the guns from the movie, a watch, one of the Faberge eggs, so I remember him going through a routine in front of a full house. So yes, that happened and it wasn't something you just imagined!"

Stewart's broadcasting career had begun in 1973 when he joined *LBC* and led to many memorable on-air interviews, including one from 1974.

"*LBC* started in 1973 and I was the youngest presenter on the station, which was the first legal commercial radio station on air in Britain, followed a week later by the next legal commercial radio station, Capital. By 1974 I'd moved to afternoons and occasionally the show would go out to events and for this particular occasion we had a stand at the Motor Show in Earls Court. I was then asked if we could do a one hour, live, lunchtime special from there all about *The Man With The Golden Gun*, as they had the latest Bond car at the Motor Show. The programme consisted of me interviewing Roger Moore, Christopher Lee and Britt Ekland. What I remember of it, was that Roger Moore was clearly a world superstar, instantly recognisable and I was only 21-22, but he was so helpful and charming. Christopher Lee likewise, which was strange, because all I knew of him was

**Opposite page:**
Desmond Llewelly, Judy Beba and Stewart Francis at the
Odeon. Image courtesy of Stewart Francis

from all the Hammer House films and I was thinking 'Wow, this guy was Dracula, but he's really, really nice!'"

Also being interviewed was Britt Ekland, who had been married to Peter Sellers, a topic of conversation that Stewart was told to steer clear of.

"I think she thought I was going to be like a tabloid reporter who was going to go straight for the jugular and ask her about it, but all I wanted to do was talk about the film and how they made it. But like so many things during my time at *LBC* I've not got a photograph of it, but I remember crowds of people around the stand as I interviewed them in front of the car that was going to be in the film, the red AMC Hornet. Had it been now, everyone would have been taking pictures on their phones, but of course then nobody had a camera or bothered with things like that."

I then thought this would be a good point to show Stewart the press cutting and a photograph of Jaki on set at the NVR, standing on the platform in the distance next to Rachel Bratley. Stewart looked

closely and without hesitating said.. "Yes, that's definitely Jaki and what's extraordinary is, although she told me about it, I'd never seen any photos of her from it. We didn't know each other until a long time after this."

Stewart and Jaki started dating in 1996 and were married shortly after. Six months into their new life together, tragedy struck when Jaki was diagnosed with leukaemia and despite a brave battle she tragically passed away before their first wedding anniversary.

"It's one of those things that I can look back now and see that we had one of everything. One Christmas, one birthday, one summer holiday and one anniversary of our first date. Jaki was diagnosed with a particularly viral form of leukaemia and it had a devastating effect on me. I'm not quite sure how I continued to do things. I understand now I had fantastic people around me who held me up and after a period of extensive counselling and that sort of thing I went into fundraising mode."

the local Bond girls line up for a different sort of camera. Pictured below are Jaki Fox, Althea Meredith, Alison Coleman, Susan Turner and Rachel Bratly.

Press cutting, featuring Jaki Francis (Fox) on the left. See photo on page 89.

Stewart Francis, Revd David Rideway and Jo Morris from St Kyneburgha Church, Castor and Peterborough
Telegraph photographer David Lowndes present a cheque to Dr. Siva Kumaran at the Haematology Unit at
the City Hospital after an evening talk at the church.
Image courtesy of Stewart Francis

'The Jaki Francis Fund for Haematology Research' was set up in 1997 and went on to raise £70,000 to purchase a flow cytometer for leukaemia diagnosis at Peterborough Hospital. It meant the hospital have been able to detect leukaemia earlier amongst patients and Stewart is still involved with the fund.

"Jaki was an extremely wonderful, beautiful person. She had this extraordinary effect on everyone she met. I'm not just saying that because she was my wife, but if she was standing here now, you'd walk away feeling just that little bit happier from having talked to her."

It's testament to Stewart's strength of character that he was eventually able to rebuild his life both personally and professionally. A career change saw him become chairman of the Rail Passengers Council in the late 90s, championing consumer rights and helping to lobby for improvements in services provided by Network Rail. After remarrying in 2004, Stewart became the Deputy Chairman of Vivacity, managing Peterborough's leisure and cultural facilities on behalf of the City council. His wife and their daughter were both at the fundraising event I attended to support a cause close to his heart.

A week later, Stewart contacted me to say he'd forwarded on the press cutting and photograph of Jaki I'd found to her parents, who now live in Sri Lanka. He'd also found another interesting photograph from the Octopussy Odeon premiere. Desmond Llewellyn and Stewart, both in their dinner jackets, standing either side of a chic looking woman in a flowing white dress.

# 24 SATURDAY NIGHT BEBA

S & M Entertainments came from the surnames of Tony Scibelli and Stef Malajny - Two enterprising Peterborians, who set it up to run various events in the city in the late 70s and early 80s before starting *Papa Luigi* - the UK's first dial-a-pizza business. Their pizza delivery business is still going strong and I have bumped into Stef a number of times over the years.

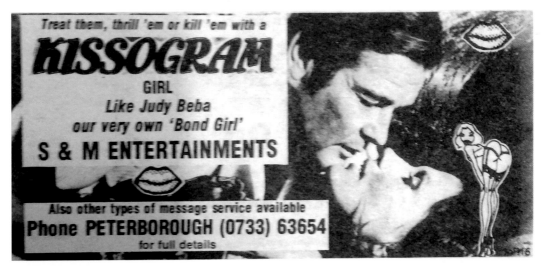

Judy Beba was the lady in the white dress in the photo on page 146, alongside Stewart and Desmond at the Odeon, but she hadn't been sent there as a kissogram. Stef had lost touch with Judy sometime ago, but I managed to track her down and - over the course of a telephone conversation from her home in South-East Wales - heard how she was working as a model when she applied for a role as an Octopussy circus girl 'extra'.

"It was my Mum who saw the advert for extras in the local paper and I remember going for an audition and showing them my portfolio of work. I was 24 at the time so had been modelling for around two years; mainly photoshoots, I had some good examples of what I'd done. I was just known by my surname then, Beba."

'Peterborough's Bond girl', in fact came from the nearby village of Whaplode.

"My father ran an arable farm and like many farmers in the area also grew flowers. Have you heard of the Spalding Flower Parade? Well, I was crowned Flower Queen and that's what started my interest in becoming a model."

The Spalding Flower Parade was an annual event that took place in the town every May from 1959 to 2013 with a procession of floats decorated in tulip petals. The surrounding area, 20 miles north of Peterborough, had become an important part of the flower industry and the parade regularly attracted up 40,000 visitors. In 1982, actor Lewis Collins presented that year's Flower Queen with the award, but in 1977, the year Mary Stavin, one of the main *Octopussy* circus girls, was crowned Miss World, Judy Beba was crowned Miss Tulipland at the Spalding Flower Parade. That year's theme, 'A celebration of the Queen's Silver Jubilee', was an occasion Judy has never forgotten.

**Top:** Judy Beba in 1977 as 'Miss Tulipland'. Peterborough Standard

**Right & Opposite page:** Judy Beba's 1983 photos for her modelling porfolio

"I was at college in Lincoln at the time on a 9-month secretarial course, but what a year to win it! 1977, The Queen's Jubilee! I had a crown, a sash and a gown and for the whole year was treated like local royalty! I went to so many events, gala nights, presentations, it was just wonderful and so much fun. I remember I won £250, which bought me a whole wardrobe of clothes. Just wonderful! After college I signed up with the Julia Hunt modelling agency in London and started to do a lot of fashion shows, photoshoots and adverts for bridal magazines."

One of her favourites took place at the Royal Albert Hall in 1978.

"It was for the National Hairdressers convention and I was part of the show. I wore a lovely black dress with diamante straps and on my head, I had a silver-coloured branch which they wound my long hair around. But what really stood out was that Clayton Howard did my make-up. He did my whole face in these wonderful silvery colours. I looked absolutely amazing and as part of the shoot they had a huge prop of a wedding cake. It had models on each of the tiers and I was the model on the top, surrounded by all the best hairdressers in the world looking on!"

Responsible for what I'm retrospectively calling the 'Eager Beba Look', Clayton Howard was one of the world's leading make-up artists. In 1981 he worked with Lady Diana, creating her classic look in the first official photographs after her engagement to Prince Charles.

A year later, Beba was having her hair and make-up done; she was sat next to another glamorous woman.

"I sat next to Maud Adams a few times when we had our make-up done at Wansford and she was very nice. I was surprised, because although I was only an extra, they sat us in alphabetical order and because I was 'B' I got to know Carole Ashby and also Safira Afzal who I sat with a lot. Safira was lovely and recommended to me the agency in London on Archer's Street that she was signed with; they took me on after the film. It was an exciting time, lots of fun and although I didn't appear in any other films, I got a lot of work, wedding photoshoots, some advertising videos and Top of the Pops! I was one of the girls in the audience a few times dancing around the presenters."

For the *Octopussy* train scenes it's interesting to note that out of all the credited *Octopussy* circus girls, it was a former Miss Tulipland, and not Miss World or Miss England that people see on screen for the first time during the railway scenes.

"I had blondish-red hair, slightly curled that came down to my shoulders. I wore one of the white sweatshirts with the circus logo on the front, jeans and black boots and for that first scene I just had to walk up and down the platform."

Like many of the male extras' experiences it's a blink and you'll miss it moment, but she's definitely there on the right-hand side on the screen with a circus sign on the left on a roustabout's shoulder - the opening scene at *Karl-Marx-Stadt*/NVR.

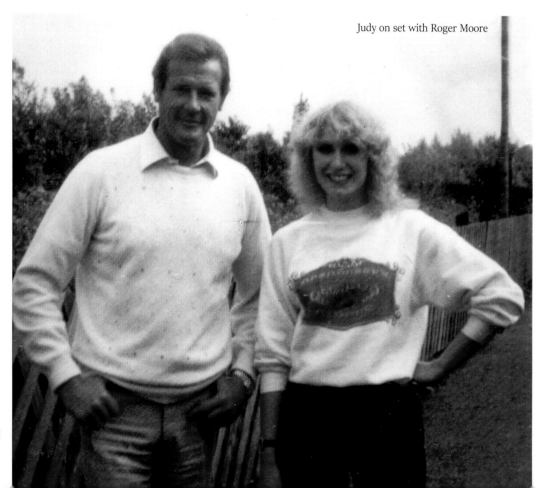

Judy on set with Roger Moore

"On the platform in between takes, Roger pulled up a wicker basket to sit on. Because it was my first bit of film work, I said to him 'What do you think about during all the waiting around?'. Roger smiled and said 'The money'."

Unlike the male extras who passed the time playing cards, Beba laughs remembering what the girls did to alleviate the boredom.

"We just gossiped! When you're with that number of girls there's always something to talk about and even though I wasn't in Equity like the others, they all treated me the same. If you look carefully you can see me later as the train's leaving the station. At that stage I didn't know if I'd be in another scene. I remember as we're all leaning out the carriage window waving, I stood on a table so I could lean out! If you pause the film and look, you'll notice I'm just a little bit taller than the other girls and that's the reason why."

Beba was on set for around two weeks and once the film was released attended the local charity premiere at the Odeon.

"I wore a big flowing white dress and had lots of photographs taken with Desmond Llewellyn and some of the dignitaries there, but I never saw any of the photographs afterwards. The only real memento I have from the event are two photos of me; one in a Bond girl pose that went into my modelling portfolio, and the other taken during filming with Roger. I've got that up in a picture frame on the wall in my living room."

Judy Beba (with her hands on the back of her jeans) as John Glen discusses the shot with Roger Moore.. Photo by Del Singh

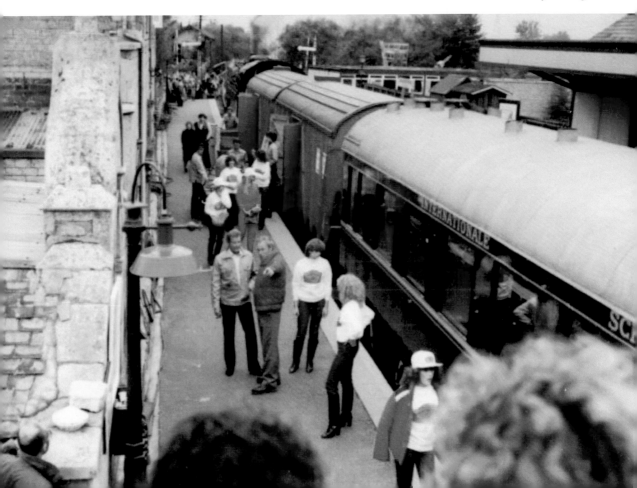

When I then emailed her the photo of her with Desmond and Stewart, she almost shrieked with delight.

"Oh my goodness, how wonderful to see this again. I've never seen it before, but remember it being taken; it really brought it all back. I'm thrilled you've found it. Please thank Stewart and thank you so much, I might have known it'd be a Bond fan that would find it. I'm so excited to see it!"

Following the charity premiere at the Odeon, Beba continued modelling until her late 20s. She then began a career as a bridal make-up artist utilising the experience of countless wedding magazine shoots. After she was married, she returned to her flowering heritage

"When I lived in Derby, I opened my garden to the public and on Gardeners World it was voted one of the Top Ten gardens in the country. And yes, I had lots of tulips!"

Judy also told me that her and husband Paul celebrated in a suitable way the 40th anniversary of the year she became Miss Tulipland; she wore a flower Queen themed fancy dress outfit for her party with her friends.

Judy Beba in 2017 at a party.
Image courtesy of Juda Beba

**Below:** Article in the *Peterborough Standard*

# Full house for Bond premiere

It was a case of 'full house' at the charity premiere of the Bond movie Octopussy at Peterborough's Odeon Cinema on Saturday night.

Cinema Manager, Mr Mike Turner, who said he was very pleased with the turn-out, expected the premiere to have raised several hundred pounds for Hereward Radio's appeal for the disabled.

The star guest for the evening was Desmond Llewelyn who plays the inventor 'Q' in the film. Peterborough's Bond girl Judy Beba was also present.

At a VIP reception before the showing Hereward Radio made a live broadcast and prizes of LPs, T shirts and a year's worth of cinema tickets were given to some lucky ticket holders.

# 25 DRINKING ON THE ORIENT EXPRESS

The exposure that the Nene Valley Railway gained from their role in Octopussy saw a steady stream of film and TV companies utilise the location for the rest of the 1980s. Following closely on the tracks of 007, another spy came out to the cold Nene Valley landscape.

In 1983, the TV mini-series *Reilly: Ace of Spies* starring Sam Neil used the railway for a scene in the episode '*The Last Journey*'. This time the NVR doubled for a railway line on the Russian frontier with Finland in 1925. On a steam train bound for Moscow, Reilly jumped into the open side door of one of the grey painted circus wagons used in Octopussy. The NVR Swedish 1178 was used and can be seen silhouetted in a long shot as it crosses over the Lynch Bridge river crossing. Sam Neill's performance as ace spy Sidney Reilly, brought him to the attention of the James Bond producers and he screen-tested for the role of Bond in 1986 as a potential replacement for Roger Moore. Timothy Dalton would ultimately get the role, but Neill's screen test showed he certainly looked the part.

Also, in the same year as *Reilly: Ace of Spies*, one of the forgotten bands of the 80s, *Big Country* came to the railway to shoot the music video for their hit song *Fields Of Fire*. It became the band's first Top 10 hit in the UK charts in April 1983. The rip-roaring anthem to returning heroes and those left behind had the 'City of Peterborough' 73050 locomotive feature in the video. The engine that had sparked the NVR into life was now running in perfect harmony to the pulsating beat of the drums that underpinned the song. The rhythmic and driven sound a steam locomotive makes has always given it a compelling musical quality and it was used to great effect in the video. The steam loco gallops into action like an iron war-horse, all pistons firing and leading the song's swirling twin-guitar cavalry charge.

The video featured the four band members on board the train before jumping off as they approach Yarwell tunnel. As foot soldiers, frontman Stuart Adamson led his rock band of brothers, fellow guitarist Bruce Watson, drummer Mark 'Unpronounceable' Brzezicki and bass player Tony Butler, up the embankment, scrambled to the top to witness a WW1 battle unfolding.

In fact, before we go any further, look up the video online. You'll notice that as the band follow a Scots piper into the tunnel at the end of the video, the wooden stairs that were put in for *Octopussy* for James Bond to run up are visible.

1983 also saw the NVRs next role with Paramount film company, and arguably the best non-Bond film to use the railway as a location; *Top Secret!* (1984), a spoof cold war spy movie by the makers of *Airplane!* Val Kilmer played Nick Rivers, an American singer caught up in a plot to rescue a scientist imprisoned in an East German prison. The scientist, Dr Flammond, played by Michael Gough, is being forced to work on a Polaris mine designed to destroy the entire NATO submarine fleet on their imminent manoeuvres through the strait of Gibraltar. *Top Secret!* begins almost where *Octopussy* had left off at the NVR, except for a night time train steaming out of the Yarwell tunnel with a fight taking place on the roof between allied agent Cedric, as played by Omar Sharif, and a German soldier.

NVR's Neil McGregor recalls the filming.

"For *Top Secret!* I was on the 1697/101 loco during the filming of an actor on a roof who was demolishing a polystyrene prop bridge on the remains of the original Lynch Farm Bridge."

This was the same location where the pipeline was put across in *Octopussy* that stuntman Paul Weston leapt over whilst doubling for Roger Moore. In the opening sequence of *Top Secret!*, stuntman Dougie Robinson carries out another memorable stunt. Dressed as a German soldier on the roof of the Berlin Express travelling through East Germany, he crashes backwards through the prop bridge, destroying it in the process; one of a number of clever sight gags throughout the film.

Later in the film, Nick Rivers, Val Kilmer, is due to perform at an East German cultural festival. He arrives at a train station in East Germany, the same NVR Ferry Meadows station that doubled for *Gutenfürst* in *Octopussy*, but in an unusual visual twist. Rather than the train leaving the station, the station leaves the train as the construction is pushed away in the opposite direction.

The film also saw production designer Peter Lamont back at the NVR after being involved in *Octopussy*, and with a number of the Bond stuntman from the year before including Martin Grace, Paul Weston and Jim Dowdall.

The Lynch Farm Bridge stanchions prepared for the *Octopussy* filming.
Photo Kevin McElhone

A year later and the railway was once again on a war footing. This time being prepared for use in *The Dirty Dozen: Next Mission* (1985), a TV movie sequel to the 60s classic. Oscar winner Lee Marvin and Ernest Borgnine reprised their roles as Major Reisman and General Worden, as Marvin led a mission into Germany to storm a train and assassinate a Nazi General played by Andrew V. McLagen; the same Andrew who directed three Roger Moore films, *The Wild Geese* (1978), *North Sea Hijack* (1979) and *The Sea Wolves* (1980). Some of the *Octopussy* crew who'd been at the NVR were also involved, including Michael Zimbrich as first assistant director and stuntmen Paul Weston and Jim Dowdall. Although not nearly as well regarded as the original, *The Dirty Dozen: Next Mission* featured an impressive battle around the NVR Ferry Meadows station site. Playing Adolf Hitler, actor Michael Sheard also made a cameo appearance as he arrives at the railway.

Another time I remember seeing the remnants of a crumbling house at NVR Wansford with 'Tod dem Varrater' ('Death to the traitor') scrawled on a prop wall in white paint. It was part of the backdrop to *The Last Days of Patton* (1986) made by CBS, with George C Scott returning to the role of United States Army General George S Patton; a role that he'd first played in *Patton* (1970), and a performance that had won him an *Oscar* for best actor. In the sequel, the NVR signal box crossing at Wansford, also seen in *Octopussy*, was used to recreate a car accident in December 1945 that led to General Patton's death. Driving past bomb-damaged houses and roadside rubble, his car stops at the railway level crossing to allow a train through. Patton says to his chief-of-staff, General Hobart, "Trains do something to me, make me sad...wandering forever at the earth again."

Once the train passes and the barriers lift, an American army truck pulls out

and collides with the staff car. At Patton's bedside for his last days are his wife, played by Eva Marie Saint, and General Hobart, as played by Murray Hamilton. The next main piece of filming links back to a story Gary Foster told me. After driving the Octopussy Circus Train, he later drove the 'Orient Express' at the NVR.

It happened in September1987 for a *Diet Coke* commercial starring Pierce Brosnan. Having missed out on playing James Bond in *The Living Daylights* (1987) due to a contractual obligation to NBC series *Remington Steele*, he played a similar man of action in the *Diet Coke* commercial.

It had a very familiar feel to Bond; starting with his character in a car at a railway level crossing, being chased and trying to evade capture by clinging to the side of a train. It ends with him on board the 'Orient Express' carriage and sharing a drink with a beautiful woman. Among those capturing the action? Some of the *Octopussy* crew who'd filmed at the NVR, including cameraman Alec Mills and key grip 'Chunky' Huse. The commercial was directed by Howard Guard, who had made his name in the world of TV commercials in the late 70s through to the 00s for brands such as *Yves St Laurent*, *Smirnoff* and *Euro Disney*. The one he's perhaps most closely associated with is for *Fry's Turkish Delight*, which he directed in 1984. It ran for 14 years, an industry record, and still regularly features on lists of 'The Best Adverts of all time'. Since retirement, he's served as the High Sheriff of Hertfordshire, Deputy Lieutenant of Hertfordshire and runs a livery yard with his wife at their farm. It was from here that Howard spoke to me.

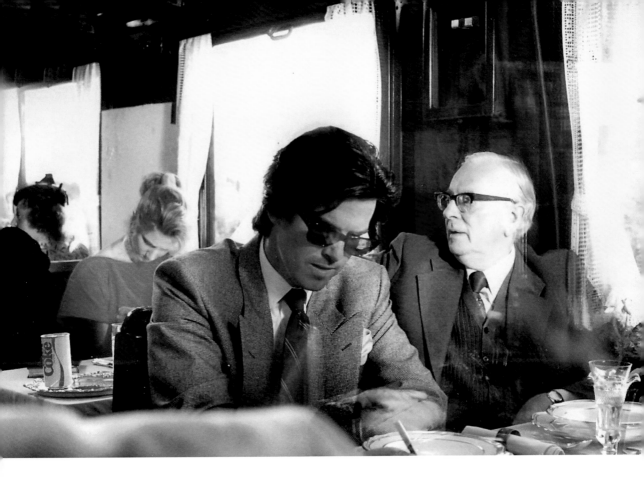

"At that time, I did a lot of work for both *Pepsi* and *Coca Cola*, which was unusual, but I think I did some of my best work for *Coca-Cola*. They produced very good scripts and I rode that wave when I directed for them. I didn't cast Pierce for the ad I did with him, he was already signed with them and had made one the year before that featured ninjas. But that was all a studio-shoot in America which I didn't direct. They wanted to make another that would give it a bigger canvas, better production values, greater excitement and the Nene Valley Railway offered us everything we needed really."

Due to the monetary exchange rate, a lot of American made ads were shot in the UK throughout the 1980s and Howard has fond memories of his Diet Coke break.

"I remember it being a very enjoyable shoot because in 1987, my eldest son was 15. He came with me to set and found it particularly exciting."

Howard then told me he hadn't watched the commercial for a number of years. After pointing him to it on YouTube, he watched it in order to give me his own 'director's commentary' on the 30 second ad.

"I'm just putting it on now, to remind myself and, oh yes, here we are, there's Pierce in the Ferrari at the start and the train, then the Ninjas, and what I remember is that it took a long time to do the opening shots, a large part of three days was taken up just with that. And it was quite a large crew, so a lot of rigging was required."

Howard is still full of praise for how Pierce conducted himself throughout the 'Orient-Express' ad, despite the obvious blow of not getting the role as James Bond.

"He'd been blocked from playing Bond due to his contract with *Remington Steele*, and I think he saw this advert as a wonderful way of showing he could be really good in an action film role. He was very professional,

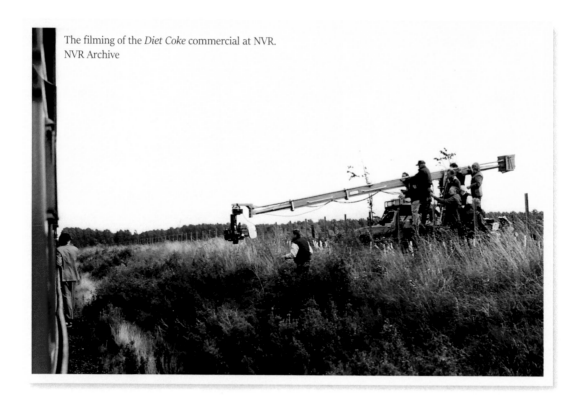

The filming of the *Diet Coke* commercial at NVR.
NVR Archive

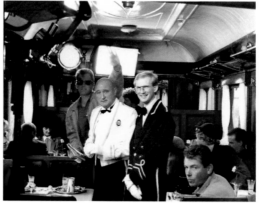

The filming of the *Diet Coke* commercial at NVR.
NVR Archive

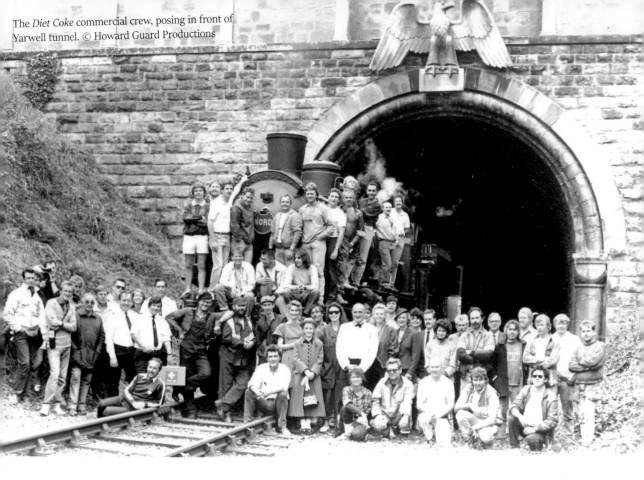

very relaxed and the whole thing was seamless. Communication between us was good, and what can I say, he just got it!"

Howard laughed and then joked, "Seeing the ad again, I think it still looks good. I'm surprised I wasn't asked to direct a Bond film on the strength of it!" he laughs.

Brosnan's co-star in the *Diet Coke* advert was Joely Richardson, someone Howard has known all her life. "Joely was 22 when we did the *Diet Coke* ad, but someone I'm still very friendly with. I last saw her at a David Hockney exhibition, but have known her ever since I worked on a film in 1973. Called *Dead Cert*, it was directed by her father Tony Richardson who gave her a small role in it when she was three or four."

The advert certainly did Brosnan's career no harm and after the disappointment of missing out on playing Bond, he was soon cast in *The Fourth Protocol*, a cold war thriller by Frederick Forsyth, starring opposite Michael Caine. He then starred in *Taffin* as a debt collector out to stop a gang of ruthless property developers. Howard went on to direct two more commercials for *Coca-Cola* in 1988, both of which can be found on YouTube: '*Tomorrow's People*' shot in St George's Hall, Liverpool and then '*The Rockefeller Center Christmas Tree*', shot in New York and starring Oscar winning actor Art Carney.

Howard did keep a memento of filming at the Nene Valley and it still occupies a prominent place in his home.

"I had the photograph framed that was taken after filming wrapped and I still have it. It's in one of my farmhouse buildings hanging above the loo."

It's the same photo Gary Foster had shown me and although Pierce wasn't in the photo, Howard can be seen in the centre of the photo in a white shirt sitting on the rails, and just behind him is Gary is his loco crew overalls.

*Queen* on board the Wagon Lits dining car used in *Octopussy* whilst filming the music video for '*Breakthru*' at NVR in 1989.
NVR Archive

In the pages of *Nene Steam* Issue No. 26, the editor Jim Wade included a photograph from the *Diet Coke* filming that showed the train emerging from the tunnel and wrote;

"The phrase, Right away driver, may now have to be eradicated from the rule book after the making of the 'Coke' advert during which Gary Foster, who was driver for the occasion, was repeatedly informed by the director to 'Go Gary Go!' This was much to the amusement of the rest of the NVR staff who are more familiar with 'Right away driver!' For those of us more concerned with passenger safety, a blind eye had to be turned as stuntmen leapt from carriage to carriage and fell backwards onto the specially prepared embankment. The numerous breaks in filming were much appreciated by staff as large quantities of freely distributed *Coke* was consumed."

Pierce would eventually get the opportunity to play James Bond when he was cast as Timothy Dalton's replacement in 1994, and returned to the NVR to shoot scenes for *GoldenEye* (1995) in April of that year. Filming at NVR in the 1980s came to an end in 1989 with a brilliant music video for rock band *Queen*, and their hit song '*Breakthru*'. The video had the band board the *Miracle Express* to fly up and down the tracks. There followed an actor called Connery, Jason Connery, who came to the railway after taking the lead role of the man who created James Bond in a TV movie called *Spymaker: The Secret Life Of Ian Fleming* (1990).

# 26 THE FLEMING CONNECTION

The train scenes for *Spymaker: The Secret Life of Ian Fleming* were shot at the NVR towards the end of 1989. The made-for-television film was a dramatised and somewhat fictionalised account of Ian Fleming's life before he sat down to write the spy story to end all spy stories.

This time the NVR's station at Wansford stood in for Moscow's *Belorussky Railway* for a scene loosely based on Ian Fleming's work for Reuters. As a journalist, Fleming had travelled to Mother Russia in 1933 to cover the trial of six British *Metro-Vickers* engineers accused of espionage. This real-life event was hinted at in Spymaker during the aftermath of the trial, as Jason Connery's 'Fleming' makes a daring escape from the secret police by smuggling himself underneath a departing train. This concealed way of evading capture was not too dissimilar to the sequence filmed at the NVR for *Octopussy* with Roger Moore hiding under the circus train. But the way 'Fleming' left Moscow in Spymaker was pure fiction and embellished for dramatic effect.

Despite this, Ian Fleming's *Spymaker* train journey did have some basis in reality. Ian Fleming had travelled from Berlin to Moscow on board the Nord Express in 1933. This was a train operated by the *Compagnie Internationale des Wagons-Lits*, who also ran the world famous Orient Express across Europe that had launched in 1888. After its success, CIWL founder, George Nagelmackers, turned his attention to an even longer distance. He planned to link St Petersburg to Paris and Lisbon before passengers were transported to the USA by ship. The train was split into two parts: The Nord Express, running St Petersburg to Paris and the Sud Express for the Paris to Lisbon service.

With similarities to 1983 when two rival James Bond films were released in months of each other, 1989 going into 1990 saw screened two rival TV films about Ian Fleming. *Goldeneye: The Secret Life of Ian Fleming* was shown in August 1989 with Charles Dance portraying Fleming during the time he'd created James Bond, and then *Spymaker: The Secret Life of Ian Fleming* shown in March 1990.

Both films took a slightly different approach to 'The Secret life of' angle, but are interesting to watch when comparing the contrasting ways they explore different periods of Fleming's life. Of the two, the decision to cast Jason Connery as 'Ian Fleming' ensured his version received a lot of media interest and some favourable reviews on both sides of the Atlantic. Ray Loynd reviewing it for The Los Angeles Times on 5 March 1990 described it as...

"glossy entertainment, full of knowing winks to the 007 movies and even to '40s-style film making. The production, full of Bentley roadsters, smoky train stations and high-stakes casino games, is classic Bond on the one hand, and on the other a revealing look, up to a point, of Fleming's personal life."

The knowing winks to the Bond films included Connery's Fleming introducing himself at one point as "Fleming. Ian Fleming". It also had a richly written atmospheric score by an award-winning composer, Carl Davis, who in 1989 was already a maestro of TV and film music scores. He was perhaps best known for writing the theme to *The World At War* (1973-74), the landmark TV documentary series narrated by Sir Laurence Olivier.

The year before the Fleming film, Davis had composed the film score for *Scandal* (1989) based on the 1963 Profumo affair. Amassing over 200 notable TV and film score credits throughout his career Davis also conducted a number of James Bond music concerts, including the James Bond 50th Anniversary concert with the Royal Philharmonic orchestra broadcast on BBC Four in 2012, and the CD 'Bond for Orchestra'.

*Spymaker: The Secret Life Of Ian Fleming* was produced by Turner Home Entertainment from a script by American screenwriter Robert J Avrech, and directed by Ferdinand Fairfax. The late British film and TV director was BAFTA nominated for two TV Series; *Winston Churchill: The Wilderness Years* (1982), for which Carl Davis also wrote the score, and *Jeeves & Wooster* (1993).

Not surprisingly, the train stunts at NVR for *The Secret Life Of Ian Fleming* were devised and performed by some highly talented people. Greg Powell, the stunt co-ordinator, had already been involved in a number of Bond films at that point including *The Spy Who Loved Me* and *For Your Eyes Only*. The honour of being 'Ian Fleming's stuntman' went to Lee Sheward, who, like Powell, went on to become one of the most sought after stunt co-ordinators in the industry and who also worked on numerous Bond films.

Another master of his craft who'd also worked on numerous Bond films was matte artist, Cliff Culley (1928-2016). He provided the scenic background for long shots of the train journey 'Fleming' makes. Culley had previously worked inhouse at Pinewood Studios and provided a variety of matte paintings and optical effects that featured in all the 1960s Bond films from *Dr No* to *On Her Majesty's Secret Service*. In the 1970s some of his optical effects also appeared in *The Man With The Golden Gun* and *The Spy Who Loved Me* however, he also provided a memorable piece of work for *Octopussy* which I was amazed to learn about from his son, Neil Culley who worked on it alongside him and told me.

Filming *Spymaker: The Secret Life Of Ian Fleming* at Wansford. Image by Angi Beckett

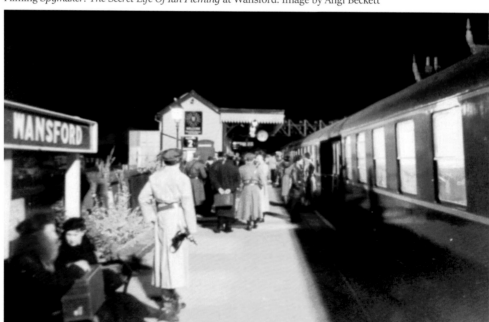

"In the war room scene for *Octopussy* we did the map that appears on screen when General Orlov's showing his plans to invade Europe. This was pre-digital, so it was all optical effects that were used. We spent about a day making the map on a 5ft by 10ft piece of glass and then cut out the tank shapes which we printed on rubber. We then used stop/frame to project them onto the screen as they appeared in the film. We also did the arrows for when Orlov shows where the tanks are going to invade across the map".

Digging out my copy of *Nene Steam* from Summer 1989, I saw it had a black and white photograph of Heather Beckett, the NVR office secretary at the time, with her daughter Angi, and Jason Connery. John Pentlow put me in touch with Heather who shared the story of her NVR involvement.

"I started in November 1982 on a Government scheme for a year and worked as the museum curator in the old Travelling Post Office carriage, so I didn't see any of the *Octopussy* filming, but was aware it had happened. I later became office secretary to John Pentlow and absolutely loved my job; the whole time there was wonderful. I'm not really into films or television, but I remember taking calls when they filmed the *Diet Coke* advert, and those that had helped were taken to the *Haycock Hotel* for a meal by the film crew as a thank you."

Heather then recalled her memories of *The Secret Life Of Ian Fleming*.

"It was a night-time shoot and I took Angi, as she was a big fan of Jason Connery; she was thrilled to meet him, she was in her element! He was very nice and came over during a break in filming, so she could meet him."

Angi and Heather Beckett with Jason Connery in 1989. Image courtesy of Angi Beckett

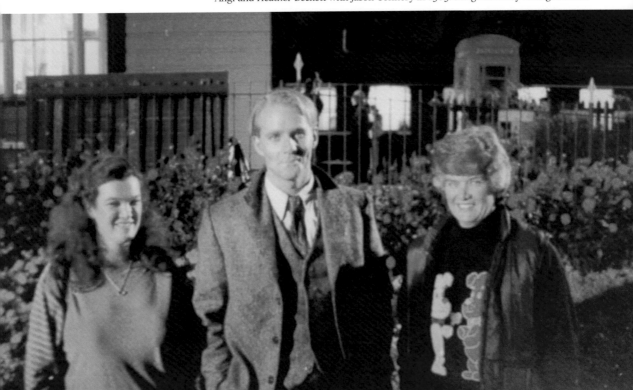

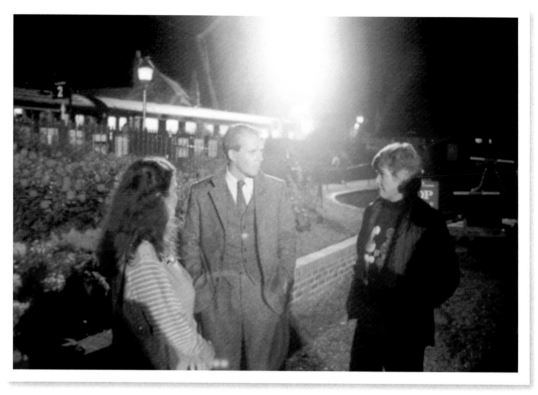

Angi and Heather Beckett with Jason Connery in 1989. Image courtesy of Angi Beckett

Angi now lives in Hull and remembers the night-shoot well.

"I'd always liked Jason in Robin of Sherwood, so when Mum said he was filming at the railway I got very excited. It was arranged that I would meet him in his break. He was as lovely and gentlemanly as he appeared on screen and just as I expected. However, like a stupid school girl I couldn't think of a thing to say, I just stood staring at him; I was besotted! He kindly offered for me to be in the film as an extra but I said no! It is something I regret to this day; I think I was dumbstruck as he was the one screen idol I wanted to meet. But it was still a dream come true for me."

Meanwhile, Stuart Stocks, who had also been an extra on Octopussy, was involved again for *Spymaker: The Secret Life of Ian Fleming* in 1989.

"I was an engineer by this time, but had been out of work for a few months when I saw an advert in the Job Centre window 'Extras Wanted'. The reason I liked doing this one was because it was a one-night thing, and set in Russia just before the Second World War. All the outfits we had looked like from those times. At one point, when we were all in a field, the kids who were extras had been given toys to play with, and if you forgot what you were doing, you would have thought it was the 1930s. There was nothing electrical or modern anywhere to be seen. I wore a Soviet uniform and just had to walk up and down the platform, checking passes and looking to see what was going on. There were maybe a 100 people or so, all in period costume.

Stuart on set at NVR for 'The Secret Life of Ian Fleming'.
Image courtesy of Stuart Stocks

Remembering his time on *Octopussy* and the amount of waiting around in between scenes, Stuart came up with a solution to stop himself from getting bored.

"As I'd been an extra before, I thought, 'This might go on a for a long time', so I took a small bottle of whiskey with me. By the time they came to filming, I'd drank the whole thing and I had a stinking headache. When I got home about 2 am, my wife didn't know what the hell I'd been up to. 'I've been filming', I said, but of course because I smelt of whiskey she didn't believe me!"

Stuart's post-postman's career has continued to have its fair share of drama and his German heritage would again play its part. After the fall of the Berlin Wall, his fluency in German provided him with the opportunity to work in the early 1990s as a translator in the building trade. "The interesting thing was, I'd been in the British army and had been a guard on the border of West Germany looking out into the East. A place called Goslar in the Harz area, a beautiful place, so I was always interested in knowing what was on the other side. When the wall came down, I went there to work and realised that for the 40 odd years it had been a Communist country, they hadn't done anything with it. They hadn't got the infrastructure to repair things. At one point I was roofing and we were taking tiles out and they were just crumbling in your fingers."

Stuart now runs his own courier business, transporting motorcycle parts across the UK and Europe.

"Being half English and half German I don't know what my parents were thinking giving me the initials SS, but anyway I called my business 'SS 59', my initials and year of birth. It got me some strange looks from people, especially in certain parts of Germany."

He showed me one of his old business cards; he now just goes under his full name to avoid any confusion.

# 27 REFLECTIONS ON A GOLDEN SPY

My first ever full-time job was in the head office of an insurance company based on the Peterborough Business Park at Lynch Wood. The surrounding area backed onto the Nene Valley Railway line and one lunchtime in the spring of 1995, I walked up the path and spotted work being done on a railway bridge at Castor Mill Lane. There were maybe a dozen workmen and as I got closer noticed a lot of scaffolding and some new frontage being added. I didn't think too much of it, until a month or so later when I picked up the *Peterborough Evening Telegraph* and saw the headline, 007 RETURNS TO THE CITY!

Suddenly it all clicked into place. I turned the page and saw an on-set report, and the first pictures of Pierce Brosnan as James Bond in *GoldenEye* and the converted railway bridge that now resembled a tunnel with a Soviet Red star above the entrance.

Of all the photos that sum up that mid-90s era of Cool Britannia, nothing felt cooler to me than seeing Pierce Brosnan, suited up as James Bond and holding a Kalashnikov rifle at the top of an army tank filmed at the NVR! He was only there a day to film his scene at the railway and instead of being stuck at school like I'd been for *Octopussy*, I was now stuck at work!

You'll never know how many times I've replayed that day in my mind, wishing I'd been tipped off so I could've taken a duvet day to watch Pierce with leading lady Izabella Scorupco. A week later, Don Gardner, one of the managers in my office, came back to work after a week off. He was a keen birdwatcher and told me that while he was out with his binoculars he'd seen the new lesser liver-spotted Bond, Pierce Brosnan was walking towards him with Keely Shaye Smith, Pierce's then girlfriend and now wife. Luckily Don had his camera and Keely took a photo.

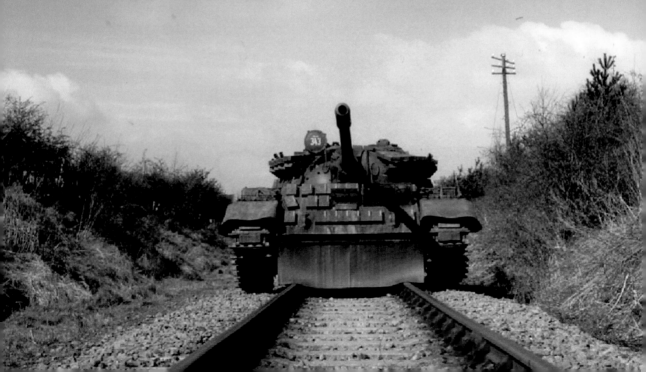

Castor Mill Road bridge being converted into a tunnel entrance for use in GoldenEye. Photo Don Gardener

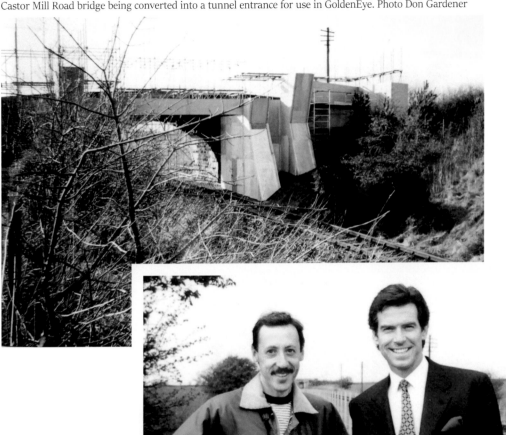

Bondwatching. Local birdwatcher Don Gardener spots Pierce Brosnan. Photo by Keely Shaye Smith, courtesy of Don Gardener

**Opposite page:**
GoldenEye filming at NVR at the Mill Road Bridge, Castor.. Photo Paul Bason

Recalling it years later, Don told me, "All I can say is that he was a genuinely nice person. We only had a chat for about a minute as I didn't want to intrude. But after he left, I thought I should have said to him 'You know, you haven't got exclusive rights on the name *Goldeneye* because it's the name of wild fowl, a type of duck they have in Ferry Meadows in the winter!'"

If I had been a regular reader of the local newspaper, I would have seen a few articles in the weeks earlier confirming that the NVR was about to feature in *GoldenEye*. But I'd semi-boycotted reading it after having my surname misspelt in the 'Local Sports' section on the rare occasion I scored on a Sunday morning for my football team. Fortunately, a small contingent of Bond fans had been

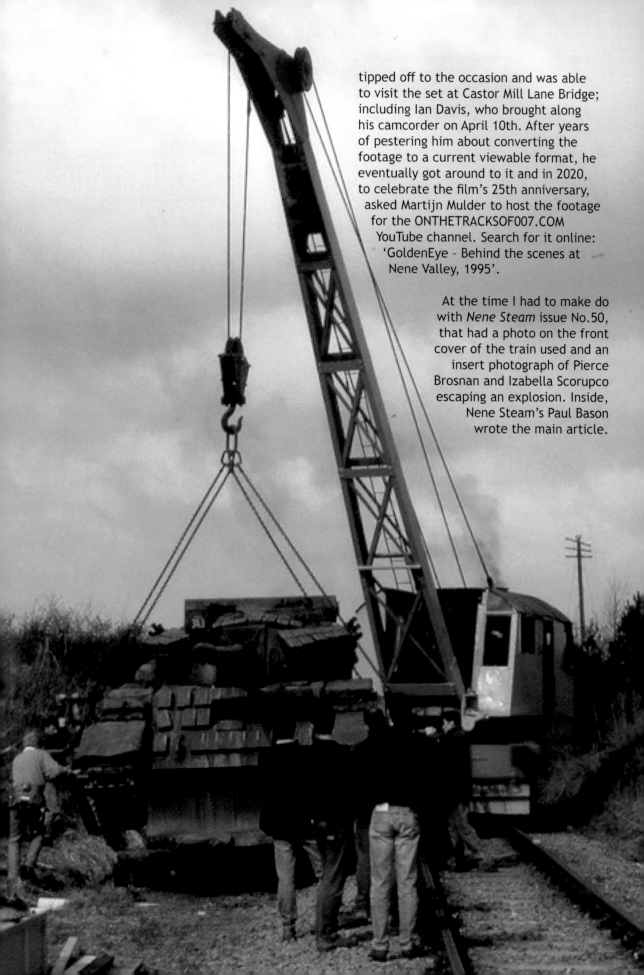

tipped off to the occasion and was able to visit the set at Castor Mill Lane Bridge; including Ian Davis, who brought along his camcorder on April 10th. After years of pestering him about converting the footage to a current viewable format, he eventually got around to it and in 2020, to celebrate the film's 25th anniversary, asked Martijn Mulder to host the footage for the ONTHETRACKSOF007.COM YouTube channel. Search for it online: 'GoldenEye – Behind the scenes at Nene Valley, 1995'.

At the time I had to make do with *Nene Steam* issue No.50, that had a photo on the front cover of the train used and an insert photograph of Pierce Brosnan and Izabella Scorupco escaping an explosion. Inside, Nene Steam's Paul Bason wrote the main article.

## GOLDENEYE FILMING SPECIAL

The NVR has, over the years, always prided itself on its impressive portfolio of filming contracts. Perhaps the most famous was "Octopussy", a James Bond spectacular shot in 1982 with Roger Moore in the leading role.

Since his early exploits on the railway James Bond has ventured to all corners of the globe, destroying enemies, charming the ladies and changing his physical appearance twice along the way. 007's return to Peterborough marked Pierce Brosnan's Bond debut in Eon Productions latest blockbuster "Goldeneye" which had its Royal European Charity Premiere on 21st November 1995.

Action on the NVR centred around Mill Lane Bridge at Castor which, heavily disguised as a concrete tunnel mouth, became the focal point of an enormous film set. Under the watchful eye of Eon Productions' location manager, Neil Raven, the impressive structure, constructed largely of plywood and plaster around a skeleton of scaffolding, quickly took shape in readiness for filming to start on 5th April 1995.

Transforming rural Cambridgeshire to the Russian countryside involved the "planting" of countless pine trees either side of the cutting and the repainting of Ferry Meadows' station building, even white rabbit guards around young trees were painted brown for the camera.

Alongside the lines a normally tranquil field was converted to the bustling headquarters of an international film crew. A temporary wooden road led down from Mill Lane to a host of vehicles carrying props, lighting, camera equipment, mobile dressing rooms and catering facilities.

Unlike Octopussy which made good use of the NVR's international steam fleet, diesel traction in the shape of Waterman Railways Class 20, 20.188 provided the motive power for a pair of superbly converted Mk1 coaches. Supporting an unusual nose and purpose-made armour plating, 20.188 created a lot of interest in Wansford Yard covered by a sheet of tarpaulin and escorted by a burly security guard.

Having arrived from another set built in the grounds of British Sugar Corporation's Peterborough factory, the production's second film unit began shooting at Mill Lane on April 5th. Working mainly without actors, the second unit's job was to shoot the action sequence along the line in readiness for the first unit, who filmed the artistes in action. Under the directions of Ian Sharp, the second unit spent three days on location shooting high speed run-pasts at Ferry Meadows, Mill Lane, Splash Dyke and, after dark, at the Yacht Club crossing*

The hallmarks of any James Bond film are the breathtaking stunts and spectacular special effects, for which "Goldeneye" appears to be no exception. With a firing tank confronting the speeding train and a helicopter landing on a carriage with meticulous accuracy, it is clear to see why James Bond's popularity has been maintained for over thirty years.

Having departed for a location somewhere in Russia, the second unit was replaced on 10th April by the main film crew, complete with James Bond and a hoard of onlookers. No stranger to the NVR, Pierce Brosnan, who previously starred in the Diet Coke commercial filmed on the railway, soon sprang into action, leaping gun in hand from the tank nestling beneath Mill Lane Bridge. Directed by Martin Campbell, one scene saw the Class 20 on fire. With flames raging around its nose, the blazing train was filmed rushing past Castor. Perhaps the most spectacular sequence of all was shot in the afternoon. As James Bond and Natalya fled alongside the train, the coaches behind were totally engulfed by a gigantic fireball, leaving the charred shells only fit for the scavenging of spare parts.

Finally, with the smell of burning still fresh in the air, true to form, Bond's thoughts turned to romance assisted by Bond beauty Izabella Scorupco. Pierce Brosnan's NVR finale was a love scene filmed in the cutting alongside the track on Castor Bank. To conclude I would like to thank Eon Productions for their permission to take photographs on the set and in particular Neil Raven and Ian Sharp, who made sure I was on location at the right times to capture the action (even if it did mean I had to stand under the whirling blades of a helicopter perched precariously on a railway carriage above my head).

**ACTION SPECTACULAR :** Pierce Brosnan, as Bond, filmed about to jump out of a tank on to the railway track in a scene from Goldeneye. The scenes shot at Nene Valley Railway formed part of the dramatic finale
(Photo: 9504293/23A)

# Premium Bond role

**TAKING A BREATHER:** Pierce Brosnan reads The Evening Telegraph (Photo: 9504291/13)

**by MARK SALT and NICK HOWELLS**

NEW James Bond, Pierce Brosnan has told The Evening Telegraph how he thought he had missed out on 007 for good.

Brosnan, who makes his debut in the super spy's latest blockbuster, Goldeneye, has been in Peterborough filming a series of explosive stunts for the new movie.

And during a break in shooting yesterday, the suave 41-year-old revealed how a contract wrangle almost denied him his starring role.

He was still tied to the television series, Remington Steele when his first chance to play 007 came up in 1986.

Timothy Dalton got the job and Brosnan thought another opportunity would never come along.

The Irish-born star said: "I was very, very frustrated about missing out on the role. I was powerless to do anything and there was a lot of anger.

"I never thought of it coming again – now it feels like unfinished business."

When the Bond rollercoaster set off again last year, Brosnan was at last allowed to get his hands on the cherished role, and is now midway through shooting his first 007 movie, which will hit the screens in December.

He added: "It was a relief to finally get the role, but I was terrified to start with, because I didn't want to screw up.

"It is great fun, this is what James Bond is all about. We have a great script, a good story, a wonderful director and I get to kiss the girls as well! Bond is a classic thing to do. It is a delicate balance, there is humour and action

– it is very silky and smooth."

Brosnan said he loves the role of the sophisticated charmer. When asked how much his Italian designer suit cost, he coolly replied: "Oh, a couple of grand, I think!"

Despite shooting action sequences at such glamorous locations as Monte Carlo, Puerto Rico and St Petersburg, Brosnan said he could not wait for the filming near Peterborough.

He joked: "I've looked forward to coming to Peterborough for the last five weeks and here I am – it's great. But it's not the first time I've been here – I did a Coca-Cola commercial here in 1986."

Brosnan is contracted for two more Bond outings following Goldeneye, but he is not looking any further ahead than that.

And after such an unconventional route to the top, he will Never Say Never Again.

## Chase under way at Nene Valley

THE Goldeneye crew and Pierce Brosnan took part in the filming of an exciting chase, for the new Bond blockbuster at Nene Valley Railway yesterday.

The scenes shot along the railway, at Castor, were part of the dramatic finale from one of the film's most spectacular action sequences.

Although movie bosses are remaining tight-lipped about the details of the plot, 007, played by Brosnan for the first time, is filmed jumping out of a tank on to the track and trying to clamber up a bank as another train heads straight for him.

And one of the Bond girls, played by Polish beauty, Izabella Scorupco, who escapes from the train, also took part in yesterday's scenes.

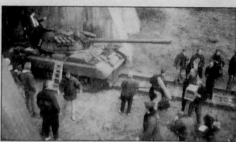

**FILMING:** On the set of Goldeneye

Other parts of the chase sequence were filmed on the railway by the movie's second unit last week.

Goldeneye's main unit was also

in Peterborough last Monday, where action from the start of the chase was filmed at the British Sugar factory, in Oundle Road, Woodston.

Castor Mill Road Bridge before it was blacked out with drapes at the back. Photo by Don Gardener

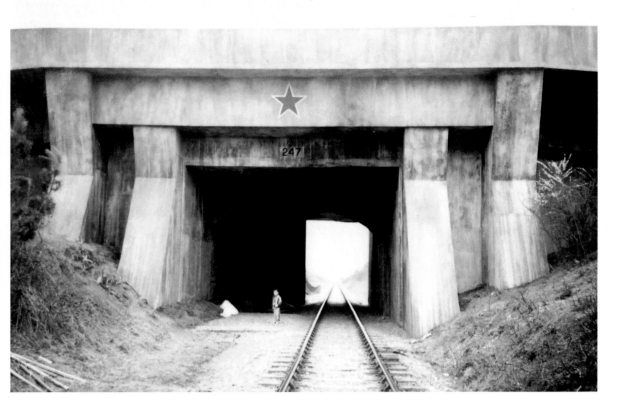

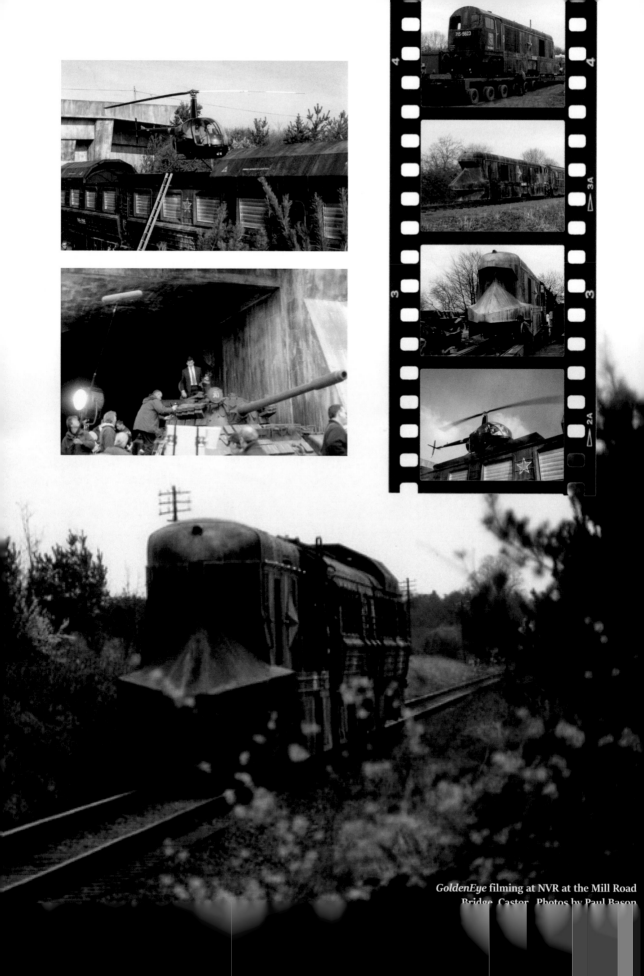

*GoldenEye* filming at NVR at the Mill Road Bridge, Castor. Photos by Paul Bason

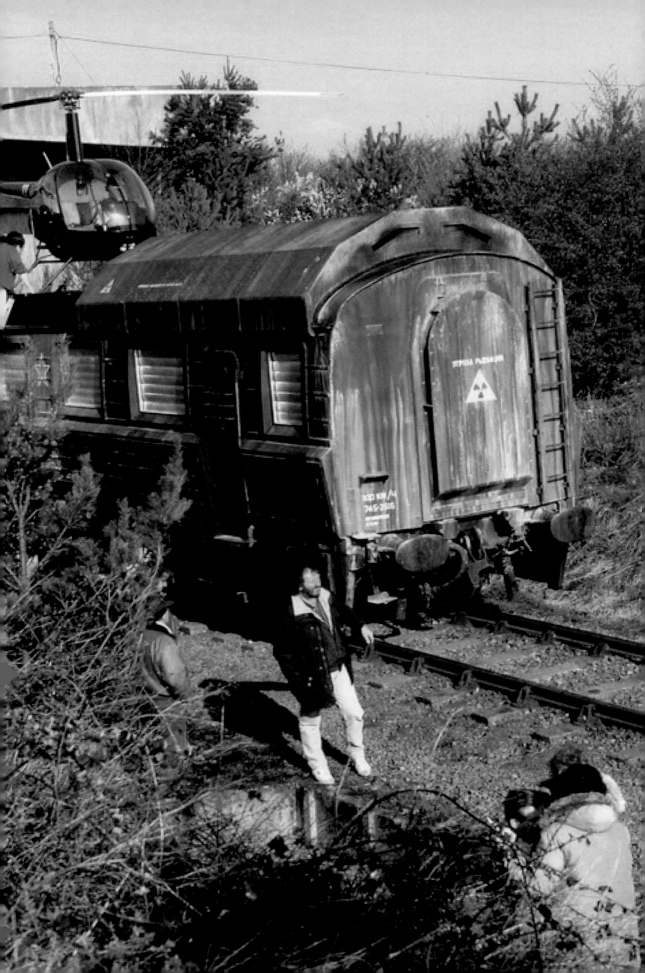

Only the filming at the Ferry Meadows and Mill Lane (Castor) parts of the railway were used in the final film and the rest of the train sequence, including the moment the train smashes into the tank, were filmed using scale models on the backlot at Leavesden Studios.

Someone else locally involved was ex-Policeman turned crime-fiction author Colin Campbell. In 1995 he had worked with one of my wife's old managers and emailed me half a dozen photographs he had taken on set at the NVR during *GoldenEye*. He told me how it all came about.

"Location managers have a good relationship with the police, so I phoned the production office and asked if I could visit the location; they said yes. I started on Bond with Phil Kohler on *A View To A Kill*. He then became production manager,

so continued with *The Living Daylights*, then with *GoldenEye*. I was privileged enough to be allowed on set to watch the filming at the railway."

The photographs show just how close Colin was allowed to get on set that he was present for the Tank vs Train climactic scene and to watch Pierce Brosnan, taking his first steps in the role of James Bond under the supervision of director Martin Campbell.

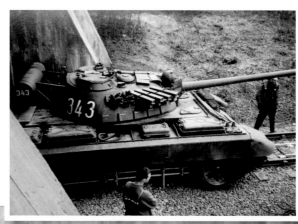

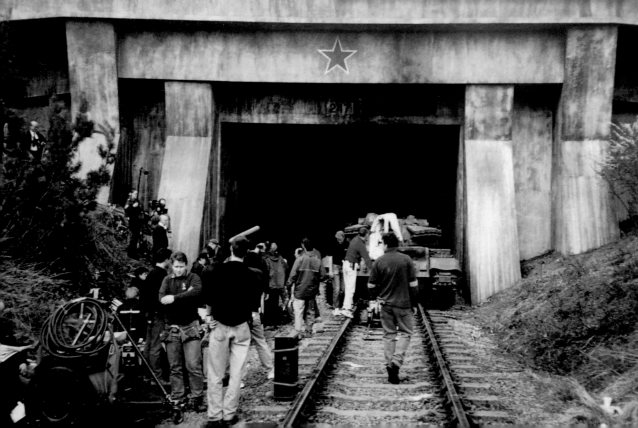

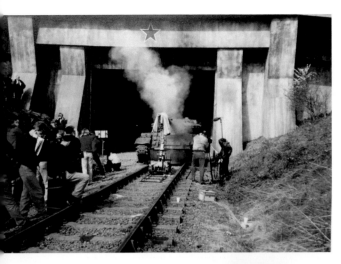

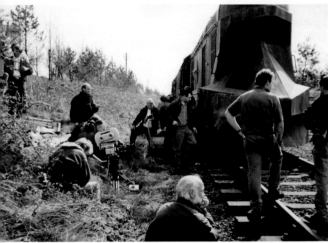

*GoldenEye* filming at NVR at the Mill Road Bridge.
Photos by Colin Campbell

"The final explosion was huge and caused my camera to shake; scared me to death. You can just about make out their silhouettes, but I was allowed to get some close-up shots of them on the crash mat. I was lucky enough to also visit Pierce Brosnan on the sets of *Tomorrow Never Dies*, *The World Is Not Enough* and *Die Another Day* at Pinewood Studios. By this time, as he'd seen me around before, he asked me, "Who are you?" When I explained I was a fan with connections, he admitted that he was a fan as well, first and foremost."

Unlike *Octopussy*, only a handful of extras were needed for the *GoldenEye* scenes at NVR, none of which appear to have been from the local area or NVR staff. The late Malcom Heugh was the NVR's loco superintendent and drove the train in shots used in filming with actor Trevor Byfield playing the engine driver on screen.

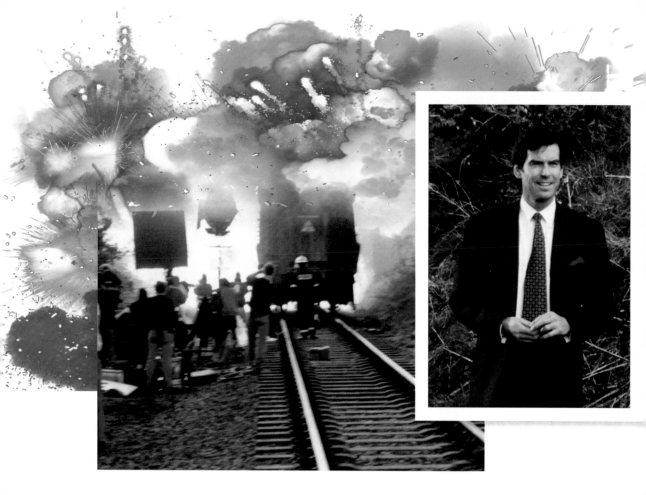

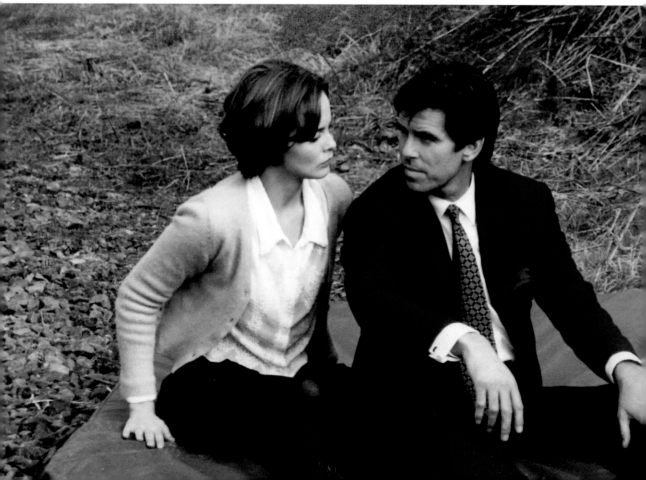

Action and romance at the NVR. Pierce Brosnan and
Izabella Scorupco blow up a train in GoldenEye.
Photos by Colin Campbell

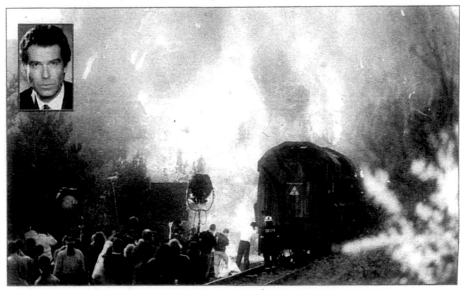

In the lead-up to *GoldenEye*, I'd heard
that the film was having a regional charity
premiere at the *Showcase Cinema*, the
new-ish multiplex at Boongate industrial
estate on the edge of Peterborough. I
quickly arranged to get tickets for me
and some of my football team mates from
The George Inn, Oundle. It wasn't quite
the art deco trappings of the Odeon, but
times had changed. My childhood was over
and this was the first new Bond film I was
going to see at the cinema as an adult; a
fact indicated by the ticket price, which
included VIP entry to an after party at
*L'Aristo*s nightclub. Over 21s only and just
around the corner from the cinema.

Our evening almost ended before the film
had started. We were nearly thrown out,
when I mistook the after-party tickets for
the VIP cinema seat tickets and sat on
the back row reserved for the Mayor of
Peterborough, other local dignitaries and
'a surprise guest'..

I had high hopes that it'd be Desmond
Llewellyn coming back to the city with
his 'box of tricks' briefcase and some
new gadgets. However, the *Showcase
cinema* manager, wearing a bright
blue blazer that made him look more
like an airplane steward, introduced
another actor, Geoff Hughes. Geoff
lived locally in Ashton, a village just
outside Oundle and was best known for
his role as 'Onslow', the slobbish lay-
about brother of Hyacinth Bucket in
BBC sitcom *Keeping Up Appearances*.
It meant I sat all the way through
*GoldenEye* waiting for him to pop up
either as Q's clueless assistant or being
crushed to death in between Xenia's
thighs. Of course he wasn't; he was
only there in the capacity of being a
'local celebrity' and to help support
the Mayor's charity.

On Boxing Day 1995, *ITV* screened *GoldenEye - The Secret Files*, a 'Making Of' documentary. It included footage of the armoured train used in the film being transported by road to the NVR and then a clip of the explosive scene from the film. It also confirmed that the diesel locomotive engine was owned by railway enthusiast/music producer Pete Waterman; something I was glad to find out after I'd seen the film otherwise I would have spent the entire time waiting for him to make a cameo as the train driver!

*GoldenEye* once again raised the NVR's profile as a filming location. A new film adaptation of the Joseph Conrad novel *The Secret Agent* (1996) with Bob Hoskins and Patricia Arquette soon followed, with a brief scene at the railway inside a carriage. Then followed a string of high-profile TV shows over the next 10 years. In 1996, the *British Sugar* factory site used in *GoldenEye* was utilised as the setting for an explosive two-part episode of *ITV*'s long-running drama series, *London's Burning*. They staged an electrical fire in the disused warehouses as one of the show's most popular characters, 'Sub Officer John Hallam', fell to his death from a dislodged gantry whilst saving teenagers trapped inside.

The hugely popular Sunday night show ran from 1988-2002 and had already filmed along the NVR in 1992 before it came back in 1997 to film at the NVR's Wansford station. The opening two episodes of the show's 10th series saw a huge fire break out on a train hired for an 18th birthday party. The stunt co-ordinator overseeing the action was Alf Joint. He had also worked on *Goldfinger* playing the assailant 'Capungo' that fights with Connery's Bond in the pre-title sequence. Ending up electrocuted in a bath, Bond utters the immortal line, "Shocking, positively shocking".

Other episodes of TV dramas to be filmed at NVR included *Into The Blue* with John Thaw, *Jack Of Hearts* with Keith Allen, and *The Bill*, all providing welcome income for the railway through location hire. Most were 'blink and you'll miss it' appearances, like the epic HBO 10-part mini-series *Band Of Brothers*, produced by Tom Hanks and Steven Spielberg which used the railway for some night scenes. *Band Of Brothers* was based on the international bestselling book by Stephen E Ambrose and told the story of the brave men of the US Army E Company, 506th Regiment, 101st airborne. By 2000, secrecy and security for high profile filming was getting a lot stricter, making it practically impossible to distinguish which parts were filmed where.

Slightly easier to spot is the NVR in episode 5 of the *Armando Iannucci* show. Broadcast on *Channel 4* in Sept 2001, the episode begins with a shot of the NVR Wansford platform. The whimsical sketch called 'Train Tracks' set in 1973, starts with a disabled child in a wheelchair at the NVR; the child grows up to become the boss of rail track and implements a highly improbable yet highly amusing track layout.

The NVR kept on gaining a flow of filming contracts in the years that followed, mainly for TV programmes. Episodes of popular BBC and ITV shows such as *Dalziel & Pascoe* (2005), two episodes of *Agatha Christie's Poirot - Mystery Of The Blue Train* (2005) and *Murder On The Orient Express* (2009), *Silent Witness* (2008), *Eastenders* (2010), *Casualty* (2011) and a scene for another feature film, *Nine* (2009), the musical drama that featured the characters played by Daniel Day-Lewis and Penelope Cruz meeting on a train station platform (NVR Wansford); the same platform used for the opening *Octopussy* sequence at NVR.

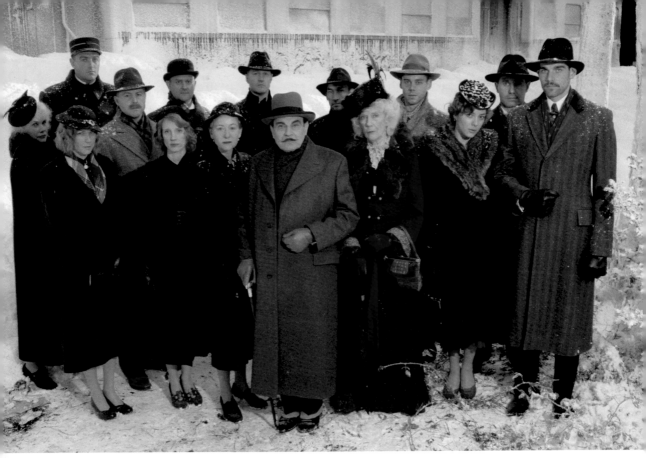

Cast of *Poirot: Murder on the Orient Express*
at NVR in 2010. NVR Archive

My favourite moment of all these was
either, spotting David Suchet as 'Hercule
Poirot' at Ferry Meadows station amongst
fake snow next to the Wagon-Lits carriages
used in *Octopussy*, or the surreal sight of
the signal box crossing point at Wansford/
*Karl-Marx-Stadt* that Bond had once
skidded his Mercedes on to the rails, which
was now featuring in *Eastenders*. Actress
Charlie Brooks, playing 'Janine Butcher',
stalled her car on the railway crossing in
front of the signal box and frantically tried
to rescue her baby strapped in the child
seat!

Unsurprisingly, I longed for something else
Bond-related at the railway, and 30 years
on from *Octopussy* it was about to happen.

# 28 PLAQUE TO THE FUTURE

In mid-September 2012, a week-long promotional event took place: The '007 Days of Bond'. A Blu-ray relay tour to mark the 50th anniversary of the James Bond films and release of the 'Bond 50' Blu-ray collection. Starting in London, Sir Roger Moore set the digital timer on a golden briefcase carrying the first copy before it travelled the length of Great Britain in an Aston Martin DBS; the same used in the pre-title sequence of *Quantum Of Solace*. The seven-day, 900-mile journey, saw other notable Bond cast and crew members visit key UK locations used in filming and on September 20th - 'Day 004' - it arrived at the Nene Valley Railway.

John Glen, director of *Octopussy* and stuntman Paul Weston, who'd doubled for Roger Moore in some of the train scenes, both arrived back at the NVR. Acknowledging the NVR's use as a key location in both *Octopussy* (1983) and *GoldenEye* (1995), John presented Hannah Forman, the NVR's General Manager, with a gold disc and a commemorative plaque that read: "Celebrating 50 years of 007".

The BBC's *One Show* presenter, Angelica Bell, was also on site at the NVR with a crew to film proceedings. Part of this saw John Glen back in the director's chair to oversee a quick fight sequence staged by Paul Weston, who demonstrated some of the techniques used by stunt co-ordinators. Also taking part in the stunt sequence, and returning to the NVR, was Lee Sheward, who'd doubled for 'Ian Fleming' at the railway back in 1989, and Marc Cass, who was a stuntman in *GoldenEye*.

The following day, I phoned Hannah at the NVR and popped down during my lunchbreak to see the '50 Years of 007' plaque. I have to admit, standing back at the NVR and holding the '007 days of Bond' plaque was quite a feeling. I felt a wave of nostalgia, and all the wonderful memories of times I had spent at the railway came flooding back. A visual montage of all my own days of Bond played through my mind, such as the warm afterglow of the London 2012 Olympics, John Glen and Paul Weston's visit, and the anticipation of *Skyfall*, a new Bond film to look forward to.

NVR's Hannah Forman presented with the commemorative plaque by director John Glen in 2012. NVR Archive

**Right:**
Paul Weston supervises a stunt sequence with
Lee Sheward and Marc Cass in front of the
steam loco 73050. Photos by Chris Johnson

**Below:** John Glen back in the director's chair

**Below:** An Aston Martin DBS from *Quantum Of Solace*
arrives at the NVR in Sept. 2012. Photo Chris Johnson

The **Insert** shows how a Mercedes 250SE  left
the NVR in the same spot 30 years earlier. Photo
by Kevin McElhone

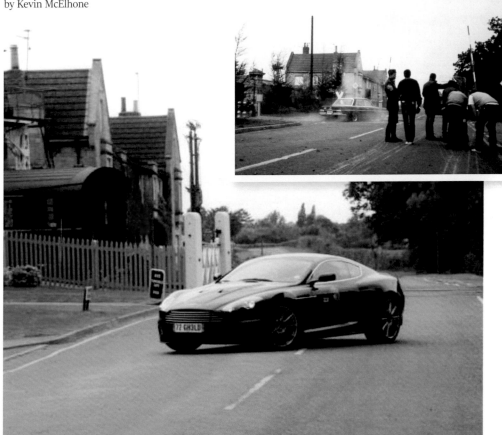

Gyles Brandreth at NVR to recreate an *Octopussy* train stunt in 2016. NVR Archive

**Left:** BBC One Show 'Stunt Troubles' feature involving NVR (top) and Details of filming at NVR by Icon films flyers. NVR Archive

The next piece of Bond related filming that took place at the NVR in 2016 was something I had a hand in helping to make happen. I was reminded of it on the evening of 23 May 2017 when I watched TV presenter, Gyles Brandreth, appear on the BBC *One Show* sofa to pay his tribute to Sir Roger Moore. The legendary Bond actor had sadly passed away earlier that day and Gyles recounted how the pair had become friends years earlier after Gyles had been taught Latin at his Kent prep school by the same Army Major who'd taught Roger during his National Service.

Gyles wrote a touching article that appeared in the next day's *Daily Telegraph* about their friendship and Roger's tireless work as a UNICEF ambassador. Although it wasn't mentioned, it occurred to me that one of Sir Roger's last interviews was for *The One Show* on BBC1 in November 2016 with Gyles Brandreth.

Each year they'd send Brandreth off to tell the story of a famous TV or film stunt and attempt to recreate it with a stunt team. In 2015 it had been the roller-skating scene from the sitcom *Some Mothers Do 'Ave 'Em*, and in 2016 they turned their attention to a train stunt from *Octopussy*, focusing on the one involving Martin Grace jumping from the Mercedes onto the side of the circus train. In July 2016 they'd visited NVR to film their recreation.

The NVR's marketing manager put me in touch with Icon Films who were making the item for the BBC. Over several phone calls and emails, I helped them with various pieces of information for post-production. As part of the *Octopussy* train stunt recreation, Brandreth interviewed Sir Roger interspersed with the train scenes. Roger recalled Martin's bravery and determination when he visited him in hospital and saw Martin doing pull-ups

in the hospital bed. Stunt co-ordinator Jamie Edgell oversaw the sequence for Icon Films; he was no stranger to the Bond series himself. He doubled for Pierce Brosnan in some scenes for *GoldenEye* and *Tomorrow Never Dies*. The stuntman who then performed the recreated stunts on top of and on the side of the train, was one of the new generation, Gordon Alexander, who'd doubled for Daniel Craig in *SPECTRE*.

The finished item aired on the BBC *One Show* that November and coincided with 'An Evening With Sir Roger Moore', his last theatre tour that month and what would be his last public appearance, on stage on 25th November at the *Royal Festival Hall*, London.

I had been at the opening date of the tour at the Theatre Royal, Norwich and Roger was on sparkling form. Humble and gracious, suave and sophisticated; always choosing his next witticism carefully and delivering it with effortless aplomb. There had been front page headlines that weekend about FIFA not allowing the England football team to wear poppies on their shirts. It hadn't escaped Roger's notice. He walked on stage, waited for the applause to subside and from behind his back produced a giant British Legion red plastic poppy, saying 'That's for FIFA!' It received huge laughter and more applause.

It was an afternoon performance, which meant I was able to take my son. Roger joked at one stage, the reason he'd started the tour with a Sunday afternoon performance was so he and his wife Kristina could get back to the hotel in time to watch the *Strictly Come Dancing* results!

I didn't think anything of it until the next day when a friend texted me to say his nephew worked in a hotel's restaurant

and had served Roger dinner and breakfast at the hotel before being driven up to Newcastle with his wife Kristina for the next date of the tour. The hotel wasn't in Norwich though; it was the *William Cecil*, Stamford, just up the A1 from the NVR; an eight minute car journey away. I like the fact that although Roger didn't stop at the NVR, he would have passed the road sign for it and crossed over the bridge that the *Octopussy* Circus Train went under in the film.

Not surprisingly my mind went into overdrive, imagining Roger, in the middle of the night, sneaking out of his room, commandeering a black Mercedes from the car park, taking it down the A1 and along the Nene Valley Railway, one last spin on the tracks of 007.

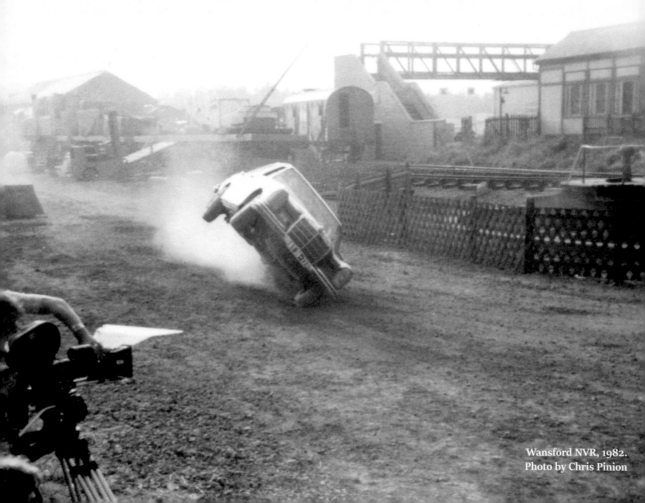

Wansford NVR, 1982.
Photo by Chris Pinion

# 29 AN OPEN RETURN

A few weeks later, on 1st June 2017, it was 40 years to the day since the Nene Valley Railway had officially opened. I was up before 6am to apply the finishing touches to a couple of James Bond photo displays I'd made. I dropped them off with Phil Marshall, the Station Master at Ferry Meadows, as they were forming part of a larger display celebrating the NVR's highlights. I then headed over to the NVR Wansford Station where the 40th Anniversary event was getting underway. I could see many of the founding members and volunteers that had helped build and run the railway already there, including many involved in the Bond Summer of '82.

Running trains in this forgotten valley was a way to preserve the past, whether it was steam, diesel or electric driven, but in keeping with tradition it was only right that the majestic power and magic of a steam train would be carrying the 40th anniversary passengers. Visiting locomotive 'The Royal Scot' class 6100 did the honours with a 'Nene Valley Railway' nameplate resplendent on the smokebox.

Sarah Piggott, the NVR's General Manager, walked towards me as I waited in the station building entrance and said, 'You haven't seen our special guests, have you?' With perfect timing, Peter Lamont appeared over my shoulder, and then the door opened in front and in walked John Glen, followed by Carole Ashby and Alison Worth!

John and Peter were both ushered off for quick interviews by the local BBC and ITV news crews for that evening's *BBC Look East*, and *ITV Anglia* programmes and the drinks reception on Wansford Station platform was in full flow. I took Carole and Alison off with me to get a drink and introduced them to Brian Pearce, the fireman on the footplate of the 1178 loco for some of the *Octopussy* train scenes. I had told him there might be a surprise for the long-serving volunteers, but the look on his face was a picture. 'These are two of the *Octopussy* girls - oh fantastic!' he said with a beaming smile.

Alison Worth, John Glen and
Carole Ashby back at NVR in 2017.
Photo by David Lowndes

I then introduced Peter Lamont to John Holdich, the Mayor of Peterborough in 1995, and recounted the story of how I nearly sat in John's VIP seat at the Peterborough Premiere of *GoldenEye*.

Over the next half an hour, it seemed like there was a red carpet beneath our feet on the station platform. John and Peter were warmly welcomed and remembered. With Carole and Alison posing for so many photographs I lost track of who had met them and who hadn't. Carole then noticed a vintage 'Brooke Bond tea' sign on the side of the station waiting room. It reminded her of the spoof James Bond TV advert for 'Brooke Bond' of the 1980s and she said as a youngster she'd always wanted a chimpanzee as a pet! At the NVR during the *Octopussy* shoot she'd had her photograph taken cuddling one of the chimps that had been on set, but the idea to use them in the train scenes was eventually discarded.

There was no doubt they both added a real touch of Bond-girl glamour to the day. Their effortlessly cool persona and engaging personalities gave them an instant rapport with everyone they spoke with; including Don Crick who back in 1982 had either been stuck in the tunnel or up in the signal box at Wansford so never got to meet them. In 2017 he was now the NVR station master at Wansford and over the years has told his story to lots of Bond location hunters who come to visit. Carole gave him another story to add to it, when she said, "C'mon Don. Let me have my photo taken with you. I do love a man in uniform!"

A hands on approach: NVR Station Master - Don Crick with the Bond girls and the Bond Wagon. Photo by Marc Hernandez

**Insert:** Don Crick (in jeans) getting his hands dirty in 1982 whilst helping to fit the Tunnel turn-out used in filming. Photo by Kevin McElhone

Meanwhile Doreen Foster, who ran Orton Mere station during 1982, jokingly told John Glen, "I still think you should have cast me as a Bond girl. My legs aren't what they were, but if you ever do another one, I'd be happy to help you out!"

Chairman Keith Parkinson gave a short speech to the 250 assembled guests saying "The main stars today are the people who in 1977, first having re-built the railway from the basic condition left by British Rail when the line was closed, set out to start to run the passenger services. Many of these people are with us today and I would like to see this as a sort of school reunion and affectionately call them 'the class of 77' and extend a special welcome to them. We are really here today to celebrate the last 40 years of this Railway and in particular the people who have worked tirelessly to keep it in operation, enabled its development and allowed this celebration to be possible."

Keith had started as a volunteer in the spring of 1982 and now as chairman led a minute's silence saying, "There are unfortunately some people who started the Railway in 1977 that cannot be with us today, having been called to 'a higher station'. It is entirely right and fitting that we remember them and many of the members of the railway will have special memories of our dear railway friends no longer alive. It is also appropriate, that as with so many gatherings of this type both in this country and all around the world, we remember the recent tragedy in Manchester and the 22 lives needlessly lost. And as well, a dear friend of Nene Valley Railway, Roger Moore, who passed away only a few days ago. Roger was closely associated with us through the James Bond films and especially *Octopussy*. In a few moments' time the locomotive's whistle will sound to start a minute's silence and I shall ask that you join me in remembering, and thinking of the people who cannot be here."

The minute's silence was impeccably observed with the sounding of a mournful whistle, followed up by former Chairman Roger Manns MBE, largely credited with coming up with the concept of a 'Nene Valley Railway', paying tribute to Rev. Richard Paten, founding father of the NVR.

Shortly after, I took Roger over to meet John and Peter. He'd been the NVR's civil engineer for 40 years and supervised the team who installed the track and point in the tunnel for *Octopussy*. I left them to catch up and around midday, passengers boarded the specially chartered train to travel the 7 ½ miles of railway whilst being served a buffet lunch from stylish picnic baskets. The sun shone brightly and happy memories shared as old friends met up to remember their part in the railway's many successes. Peter Lamont sat with his daughter Madeline, and John Glen with his wife Janine. The couple had met whilst she was working as Cubby Broccoli's secretary in the early 1980s and Janine told me a memory she had of visiting the NVR on one of the days Cubby came up to see filming. She recalled it was on a day where the Mercedes was fired into the river. There was also another member of the Glen family on the train too; their Yorkshire terrier Jesse, named after Jesse James, who sat on Janine's lap to observe proceedings.

Having missed out on travelling on the train with the *Octopussy* circus girls in 1982 as I had been at school, there was no chance of me missing out on sitting with Carole and Alison this time! They were both utterly charming and talked about their time working with Roger Moore. Carole said to me, "*Roger was such great fun to be with. I did two Bonds with him so he was my Bond, really. I shall miss him dearly, he was a true gentleman*".

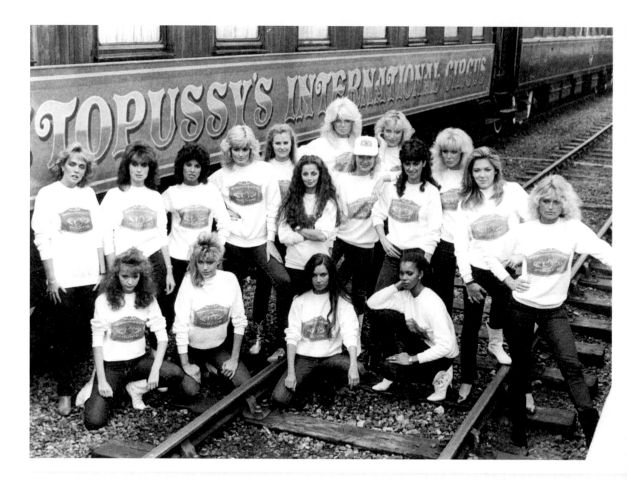

Just Seventeen: The *Octopussy* girls at the NVR in 1982. Back row: Tina Robinson, Alison Worth, Safira Afzal, Carole Ashby, Carolyn Seaward, Cherry Gillespie, Cheryl Ann, Helene Hunt, Suzanne Jerome, Jan Michelle, Janine Andrews, Marie-Elise, Mary Stavin. Front row: Louise King, Julie Martin, Joni Flynn and Camella Thomas. Image courtesy of Steve Woodbridge

Carole added that on the previous Sunday she'd been invited to a private screening of *Live And Let Die* in Roger's honour, hosted by David Walliams. It was also nice to hear that Carole and Alison are both still friends. Carole is Godmother to Alison's son, and they showed me some photographs on their phones of a recent holiday they'd all been on together to St. Lucia. In one photo, Carole was hurtling down a zip-wire; it was exactly the way I'd imagined an *Octopussy* circus girl would spend her holiday!

On the train's leisurely journey clickety-clacking over the rails, I pointed out some of the particular spots John and Peter both recognised from filming. I'd brought along my copy of Peter's autobiography

*The Man With The Goldeneye* and John started giving a running commentary on the photographs as he flicked through the book, going over the films they'd worked on together.

Brian Pearce had now joined us and was joking about how his scene with Micky Winter in the 1178 loco must have been left on the cutting room floor. Peter then said something which made both Brian and I sit bolt upright. He told us that one of the main reasons the NVR had been chosen and not The Severn Valley Railway, which had also been a considered location in 1982, was because the NVR had a turntable which Peter had noted would play a vital role in being able to turn around the carriages for quicker filming and allowing

The NVR's Roger Manns and Brian Pearce share a joke
with the Bond VIPs at the drinks reception.
Photo by Marc Hernandez

Alison Worth at NVR in 1982.
Photo by Frank Connor

the track to appear longer in the film than it actually was. This was Brian's cue to tell them both about the history of the turntable; that it came from the old Peterborough East station, and is still in full working use today at the NVR. At the Peterborough Nene Valley station, people were able to get off and stretch their legs. Brian took the chance to take Carole and Alison on a brief tour of Railworld, and once the 'Royal Scot' had turned around we set off for an hour long stop at Ferry Meadows station.

I then had a little surprise arranged for Carole. I was going to re-unite her with somebody who had his photograph taken with her in 1982.

191

Grabbing my arm as I walked up the platform with her, she said, "Oh my god, it's not the chimpanzee is it!?' But stepping out from underneath the station canopy just in front of us was Chris Goodwin, the man Carole had swept off his feet in September 1982. It had made for one of the most memorable behind the scenes photographs that I'd found and I knew it would make both their days. "OH MY GOD, CHRIS!!! FROM THE PHOTOGRAPH!"

"Hello Carole, fancy meeting you here!" I'd tipped Chris off the previous week that Carole might be coming back and Sarah had agreed I could invite him down to meet us at the station. Chris could hardly believe he was meeting Carole again and the pair of them caught up on 35 years of their lives in about three and a half minutes. I really wanted them to recreate the photo of Chris lying across Carole and the other circus girls, but let's face it, that was a one-off moment of spontaneity. When I got them to pose again together 35 years on, the resulting photo sparked something just as memorable. Chris put his arm around Carole, Carole picked up his leg and I realised that the two of them had decided between them to recreate a different photograph, the one of Carole hugging the chimp! The looks on their faces encapsulated the moment perfectly. Out of the corner of my eye I could even see Phil Seaton, who'd taken the original snap of Chris with Carole back in 1982. Phil was standing on the station, shaking his head and laughing to himself.

Carole Ashby cuddling a chimp at NVR in 1982. (NVR Archive) and re-creates that image with Chris Goodwin, 35 years later (Marc Hernandez)

For part of the 40th Anniversary Celebrations, Ferry Meadows Station was officially re-named Overton, with a nameplate unveiled by the Queen's representative, Deputy Lieutenant Penelope Walkinshaw. 'Overton' was the station's original name when it first opened in 1854 and in recent years has

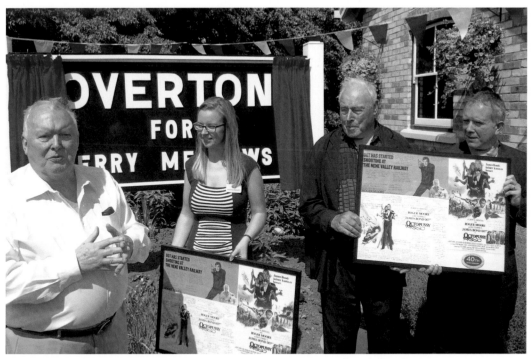

Peter Lamont, NVR GM, Sarah Piggott, John Glen and the author at the re-named Overton station.

been a hub of volunteer activity. Much of the construction and transformation work has been carried out by the NVR's youth group, aged between 13 and 18. Under the guidance of station master Phil Marshall and Joel Fletcher Hawkins, they showed the class of '77 how the class of 2017 will continue their work and keep their legacy alive. Straight after the renaming, NVR's General Manager, Sarah Piggott and myself made a short presentation to John and Peter. I'd put together two framed montages of *Octopussy* film posters and had got all the NVR volunteers involved in the film to sign with their brief claim to fame. John and Peter both seemed genuinely surprised by this, and Peter said a few short words on their behalf, thanking everyone for inviting them back for the anniversary and for all the help they'd been given in making *Octopussy* and *GoldenEye*.

The plaque John Glen had presented the NVR with in 2012 had started me off on my journey to track down the local people involved, and now I was reciprocating the gesture. It was an odd feeling, standing on the platform just metres from where I'd first seen the border guard tower constructed as a 9-year-old in 1982. The hypnotic sight of steam escaping from a vintage locomotive momentarily took me out of the moment before we boarded the train and returned to Wansford. I sent Brian Pearce down the carriages to find John Pentlow and looked out the window as the soft puffs of smoke and metal gallop of wheels provided the soundtrack to the last leg of the journey. John was the NVR General Manager in 1982 and the person who had agreed the film contract with Eon, and was on-site at the NVR every day of the pre-production and then filming. Both had lasted nearly three months and

John Pentlow had told me that the filming of *Octopussy* was his proudest achievement of his time at the NVR. The previous week when I had rung to check he was still coming to the 40th, he told me he'd just come out of hospital and wasn't sure if he was feeling up to it. I'm pleased he was up to it because as the train eased us gently back to Wansford, he sat and reminisced with Peter and John as if time had stood still.

It had been a beautiful day and, travelling in the company of two *Octopussy* circus girls, the most prolific director of the James Bond films, and the man who designed so many of the sets from *Goldfinger* in 1964 to *Casino Royale* in 2006; well, I've had worse train journeys.

All four of them made the day special for so many of the volunteers and as we all said our goodbyes at the platform, I noticed we were standing directly in front of the restored CCT Wagon from *Octopussy*. It brought nods of recognition and smiles

of appreciation from John and Peter. They both laughed when I told them that the wagon that once contained an atomic bomb during the plot for *Octopussy*, now contained boxes of crisps and other refreshments.

Later that evening ITV's *Anglia News* carried their report of the NVR's 40th. It included John Glen being interviewed, who said:

"I remember when we filmed here with Roger, and asking Roger to go under the carriage as it entered the tunnel. He gave me a long hard look and said, 'I will if you join me!' I explained that I was trying to keep the weight down on the rig under the carriage. He was not impressed and so I had to join him and camera crew under the train. We did bottom out on one occasion, but got a great shot. It's very tragic really, because Roger was such a large part of my career and the Bond films. His sense of humour was fantastic and it's wonderful that he will live on, on the screen for years to come."

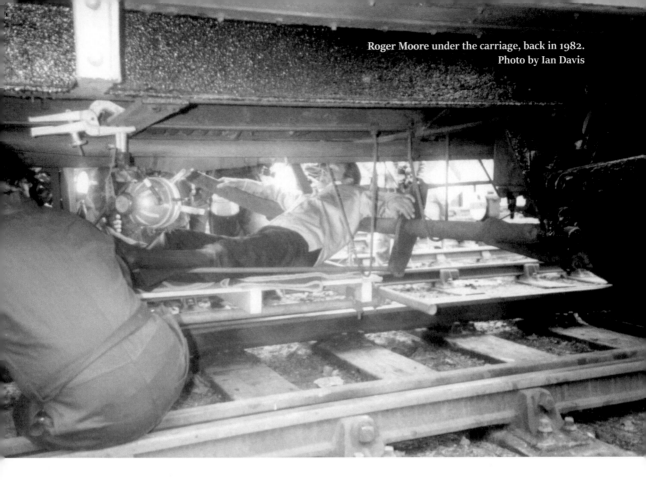

Roger Moore under the carriage, back in 1982.
Photo by Ian Davis

Peter added "Roger was a dear friend and on set he knew all the crew by their first name, which was fantastic. And he was a great raconteur as well."

I also spotted myself standing on the platform with Sarah as we were talking with our Bond guests and on the train I could be seen sitting next to Carole Ashby as the camera crew walked through the carriage. Finally! My own five seconds of fame recorded on film with a Bond girl.

There was a lot of interest in the local media about the NVR 40th and all gave mention to the presence of the Bond guests. Over the weekend of 4-5 June when the railway opened to the public, it became the railway's busiest weekend for over ten years. It was a real pleasure to have played a part in the NVR's 40th anniversary and it also jogged many people's memories about their own contribution to the NVR. Heather Beckett, who'd I met in the car park arriving at the 40th with Olive Gladden, had been

reunited with some of the NVR's first ladies of steam, including Carole Pinion, wife of Chris Pinion who was the fireman during some of the *Octopussy* shoot. Carole had been catering manager for many years at the NVR and along with Doreen Foster had been the NVR's first female directors in the 1980's, all proving that running a railway isn't just a case of boys with toys.

Olive Gladden, Heather Beckett and Carole Pinion.
Photo by Belinda Moncaster

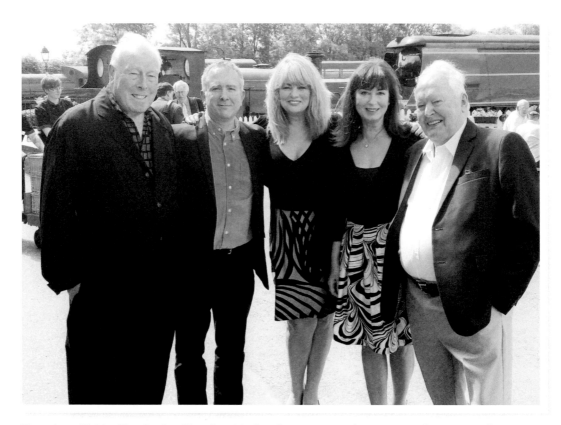

The author with John Glen, Carole Ashby, Alison Worth and Peter Lamont. Photo courtesy of Marc Hernandez

In the meantime the railway still continues to operate as a heritage railway to the public and still being used for filming. Shortly before Covid struck, Orton Mere station was temporarily renamed 'Walford Common' to feature in another episode of the BBC long running soap opera, *Eastenders,* as part of the 'Who Killed Lucy Beale?' storyline.

Then, once the railway was able to safely re-open for business, a BBC camera crew spent a week at NVR in September 2022 filming scenes for a two-part episode of *Silent Witness,* the third time they've used the NVR since the drama series began in 1996.

Shown on BBC1 in January 2023, episodes 7 & 8 of series 26 were titled 'Hearts Of Darkness' and began with a scene shot on Wansford platform (the restored CCT wagon from *Octopussy* clearly visible in the background) before a devastating train crash takes place in the Yarwell tunnel and the SW team arrive to investigate.

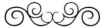

Before this book's journey reaches its destination, there's just time for one more NVR story.

Maud Adams & Roger Moore
go for a stroll at NVR Wansford,
during the filming of *Octopussy*,
1982. Photo by Steve Woodbridge

# EPILOGUE   ALL THAT'S GONE BEFORE

On 14 October 1982, the *Octopussy* Circus Train was steaming over the Nene Valley rails and approaching what was once Lynch Farm Bridge. As it got closer, a pipeline could be seen suspended above the train. Up on the carriage roof a blurred figure dressed in crimson and black spotted it coming towards him at speed and threw himself forward; diving over it, landing on the roof and somehow managing to stay on the roof.

This particular stunt in the finished film only last around 30 seconds, but was performed with split second timing by stuntman Paul Weston before close ups of Roger Moore as James Bond were edited into the film.

Interviewed for the behind-the-scenes documentary on *Octopussy: The Ultimate Edition* DVD/Blu-Ray, Paul recalled the stunt, saying:

"I think on *Octopussy* was probably the most dangerous thing I've ever done. Running along the top of the train; at one point there was a pipe which was about four feet above the train. I'd laid down underneath it, get up and carry on running and I said to the guys, if they see that on the rushes, they're going to say, Can I jump over it? And sure enough the next day I get a phone call. 'Is it possible to jump over the pipe?'"

In Ian Fleming's 1961 *Octopussy* short story there hadn't been a plot to detonate an atomic bomb smuggled inside a circus train travelling across the East German border into the West, but the train sequence devised especially for the film had all the hallmarks of Fleming's Bond; cold war intrigue, thrilling action and a race against time to avert disaster.

The pipeline obstacle that Paul Weston dived over was cleverly suspended above the track on two old stone bridge stanchions first constructed in 1844 to hold 'Lynch Farm Bridge'. The land either side of Lynch Farm when the railway was originally built was part of the Milton estate and owned by the Fitzwilliam family, who resided at nearby Milton Hall. The 5th Earl Fitzwilliam had chaired the first meeting of the various landowners and their representatives, when the proposals for the original 47 mile 'Nene Valley' railway from Northampton-Peterborough were first discussed in 1842. As one of the landowners himself, the Lynch Farm Bridge had been built for his own private use, allowing access across the Milton estate and which remained in place until the mid-1970s.

Lynch Farm Bridge circa 1974/5, prior to the metal bridge way being removed. NVR Archive

**Insert:** The pipeline on the stanchions for *Octopussy* (see pages 156-157)

Ironically, the reason it was taken down was to allow the NVR to accommodate the larger sized continental railway carriages underneath; the type that were now being used in a Bond film. The last of the remaining stone pier stanchions were eventually removed in 1984 with several tons of the stone carefully dropped over Lynch River bridge a few hundred yards away, and to bolster the East bank of the Nene where scouring had occurred.

The request made by director John Glen for Paul Weston to dive over the pipeline whilst filming *Octopussy* was made with both John and Paul, the film crew, and the railway staff, all unaware of what had occurred at this particular part of the railway during the last years of World War II: A highly secretive military operation codenamed: *Jedburgh*, that didn't become public knowledge until the 1990s.

Today, Milton Hall is one of the largest private houses in Cambridgeshire but in 1943 the Milton Hall estate was requisitioned by the *Special Operations Executive* (SOE). They turned it into an Allied Commando School to train a special forces unit called 'The Jedburghs'.

Set up by the *Special Operations Executive* and the U.S *Office of Strategic Service* (OSS) 'The Jedburghs' were formed to conduct sabotage and espionage operations in Nazi-occupied France. *Operation Jedburgh* saw 300 men recruited from the armed forces of Britain, America and France with a small contingent from the Netherlands, Belgium and Canada. They were to operate behind enemy lines; to parachute into occupied territory in small, mixed-nationality teams, to train resistance fighters and to co-ordinate activities to help the Allied D-Day armies at the Normandy landings, *Operation: Overlord*, and those in the South of France, *Operation: Dragoon*.

Milton Hall, identified as ME65, became the Jedburghs' HQ with the men and training staff arriving in early 1944 at the twenty-thousand-acre estate to undergo months of specialist training. It covered all aspects of modern guerrilla warfare; ambushes, unarmed combat, silent killing, use of small fire arms, demolition, and the techniques of receiving supplies by air. Another aspect to their training was learning how to sabotage bridges and railway lines.

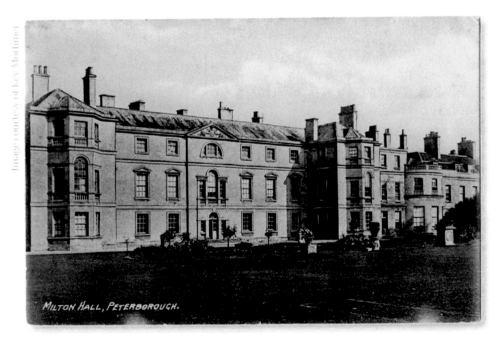

Image courtesy of Rev Mortimer

MILTON HALL, PETERBOROUGH.

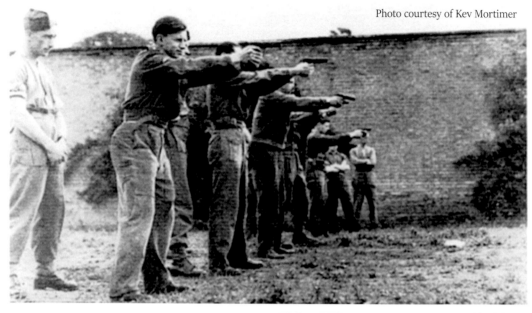

Jeds training at the pistol range and the obstacle course, Milton Hall, circa 1944. US National Archives

The 'Nene Valley' line ran either side of the Milton Hall estate they were training in. The private 'Lynch Farm Bridge' across it was owned by 'Lord Milton', Peter Wentworth-Fitzwilliam, the 8th Earl Fitzwilliam, and also a commando in the SOE, although not a part of Operation Jedburgh. There was also the Lynch River Bridge that crossed the River Nene, around 800 metres away from Lynch Farm bridge, all making it the ideal place for the Jedburgh teams to practice acts of railway and bridge sabotage.

ME65 had a staff of 236, including training instructors. Jedburgh recruits were put up in Nissen huts on the lawn in front of the house. The extensive private grounds gave the training areas a reasonable amount of protection from prying eyes and included an obstacle course, tracts in the woodland areas for combat manoeuvres, a climbing wall and a motorcycle track. A converted pistol range was set up in the large sunken kitchen garden, the dairy barn became a Morse code classroom, and the mansion house basement was converted into an armoury and indoor firing range. The large halls in the house were then used for group lectures, training films and perhaps most intriguing of all, demonstrating spy gadgets.

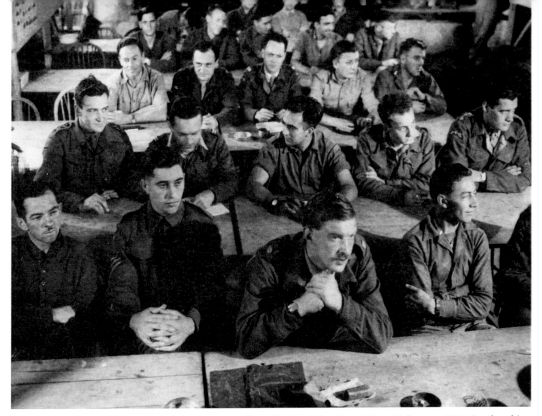

Audience in demolition class. Milton Hall, 1944. US National Archives

*The Jeds*, as they became known, were to work in mobile mix national teams of three, two officers and a radio operator. They had the motto, 'Surprise, Kill, Vanish'. Their undercover missions in occupied Europe would face the risk of Hitler's Commando Order of 1942 which stated that any Allied agents were to be executed immediately; every aspect of their training had to be thorough. To prepare for the types of missions they'd face, they would practice mock night raids on a target and subsequent withdrawal to hideouts. To achieve this, they were flown by the RAF at low altitude, dropped into remote areas of Wales and Scotland, and had to make their way back to Milton Hall without being detected. The Home Guard and local police forces were put on alert to look out for them. The Jeds then took part in other exercises codenamed, 'Spur', 'Spillout' and 'Megrin'. In 'Megrin', civilians from nearby villages in the Nene Valley comprising of boy scouts, girl guides and local shop workers, were organised by the Jeds to help with an attack on rail lines.

Whilst there is no documented evidence Ian Fleming had any direct involvement with *Operation Jedburgh*, or ever visited Milton Hall, there are parallels between 'The Jedburghs' and '30 Assault Unit', the British commando outfit devised by Fleming in his role in Naval Intelligence during World War II. 30 AU were set up two years prior to the Jedburghs, and were also tasked with carrying out covert operations against the Germans. Theirs was primarily to capture and obtain intelligence, but like The Jedburghs, 30 AU also saw action in occupied Europe following D-Day. Recruits for what Fleming called his 'Red Indians' were trained at other SOE locations, learning many of the same techniques later taught to the Jedburghs at their SOE HQ.

There was however, one member of 30 AU who would have known of, and travelled on, the original 'Nene Valley' Railway line during his school days; Tony Hugill (1916-1987). Hugill went to Oundle School from 1929-1934 and was part of their cadet force as a teenager and the school's debating committee. On one occasion, the

April 1934 edition of the Oundle School Chronicle reported, "Mr Hugill entertained the house with a spirited denunciation of the Vice-President as a snob." That ability to communicate engagingly and effectively would be something that would stand him in good stead during his war time roles. At the outbreak of war, he joined the Royal Navy Volunteer Reserve before being sent to Lisbon as Assistant Naval attaché. In 1943, he became a Lieutenant-Commander in 30 Assault Unit, landing in Normandy on Day 2 of the D-Day landings. During the campaign he was awarded the *Croix de Guerre*, mentioned in dispatches, and won the *Distinguished Service Cross* for taking the surrender of 280 troops under a Luftwaffe officer at a radio station near Brest. With only eight marines, he bluffed the Germans into thinking they were surrounded and threatened an aerial bombardment and tank attack which he was in no position to order. He later led the *Forward Interrogation Unit* in Hamburg, Germany, and, based on war diaries he kept, published a short book, *The Hazard Mesh* (1946) before embarking on a commercial career with *Tate & Lyle*, the sugar manufacturers. From 1954-1966 he was the Managing Director of their Caribbean operations; something his former superior in 30AU seemed to take note of.

In Ian Fleming's final James Bond novel *The Man With The Golden Gun*, in Jamaica Bond is told about a Tony Hugill who represents the islands sugar company. "We've had a lot to do with him, so he'll be friendly. He was in Naval Intelligence during the war, sort of commando job, so he knows the score."

The men of 'The Jedburghs' also knew the score and what was expected of them as commandos. Between D-Day and VE Day, the 300 men who had learnt acts of clandestine warfare along the Nene Valley made up Jedburgh teams that carried out 101 operations in Europe; 93 in support of the allied landings and eight in the Netherlands, six of which were part of *Operation: Market Garden*. Amongst the brave and resourceful men who took part in *Operation Jedburgh*, one name that stands out is an American intelligence officer called William Colby; he later became director of the CIA from 1973-1976.

**Left:** The Plaque commemorating 'The Jeds' at Milton Hall
**Right:** Memorial Tablet at Peterborough Cathedral

---

THIS PLAQUE COMMEMORATES THE ALLIED JEDBURGH TEAMS WHO TRAINED AT MILTON IN 1944 PRIOR TO PARACHUTING INTO OCCUPIED EUROPE TO SUPPORT AND ASSIST RESISTANCE FORCES.

IT WAS UNVEILED AT A REUNION OF AMERICAN, BRITISH AND FRENCH JEDBURGHS ON 15th MAY 1991.

# 'Jedburghs' meet for special service

SURVIVING members of a top secret World War Two army operation have attended a special commemorative service at Peterborough Cathedral.

The 40-plus members of the Special Operations Executive team, codenamed the Jedburghs, as well as members' widows and families, came together for the service and the unveiling of a memorial plaque for the 37 men who lost their lives during operations in Europe and the Far East.

City Mayor Mohammad Choudhary and his wife, Khalida, attended the special ceremony, as did the Lord Lieutenant of Cambridgeshire, James Crowden.

Ron Brierley, Jedburgh reunion committee chairman and former team radio operator, said: "The memorial service was terribly emotional, particularly for the widows and relatives of the people whose names were on the memorial.

"It was an old family coming together.

"It was a highly organised, but very moving service which everyone was very pleased with."

After the service, the men and their guests enjoyed lunch at the city's Bull Hotel, where they used to drink during their training.

The 300 Jedburgh members, all volunteers, were from army forces based in Britain, France and America, with small contingents coming from Holland, Belgium and Canada.

They were first brought together in 1943 and trained at Milton Hall before going off in small teams to arm, train and co-ordinate foreign resistance fighters in preparation for the D-Day landings in Normandy.

Between D-Day and VE Day, the Jedburghs carried out 101 operations in Europe.

The last time members of the group met in Peterborough was in 1991 when, following a reunion in London and a church memorial service, they attended a reception at Milton Hall.

● A photographic history of the Jedburghs is on display in the cathedral for a fortnight.

**EMOTIONAL REUNION:** Jedburgh members attending the memorial service at Peterborough Cathedral (Photo: 9605602/15)

Peterborough Evening Telegraph press cutting from May 1996

In June 2004, the remaining veterans met for 'The 60th Jedburgh Anniversary' at Milton Hall. There were only 22 still alive and due to dwindling numbers it was decided it would be the last reunion that they would hold at their former HQ.

To date, despite a number of books being published about *Operation Jedburgh*, there has yet to be a film or TV series made about it. When there is, I know a railway that would be perfect.

# FILMING LOCATIONS AT NVR

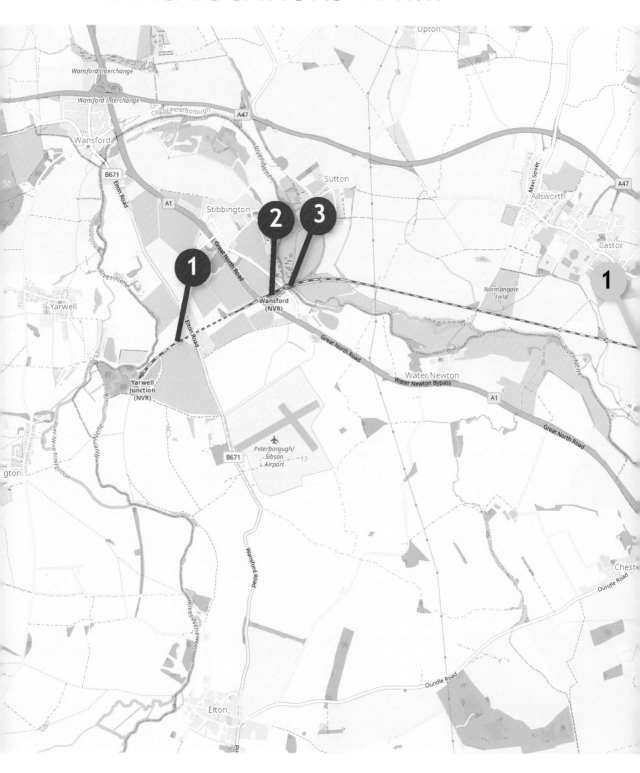

Wansford Station production sketch for *Octopussy*.
Collection Ian Davis

RIVER NENE

UNIT PARKING.

PROP STORE | PRIVATE GARAGE | PRIVATE

HUTCHINSON'S YARD

PRODUCTION OFFICE

COTTAGE

SIGNAL BOX

BRIDGE

CROSSING

NVR OFFICE

OLD GREAT-NORTH-ROAD

To A1, FERRYMEAD And OUNDLE HERE

STATION OFFICE

PLATFORM

STATION PLATFORM

TURNTABLE

STATION CAR PARK (SET AREA)

TRAIN SHED.

(SET AREA)

HEDGE/TREES

BIG TOP

A1

NORTH

SOUTH

NENE VALLEY RAILWAY.

NENE VALLEY RAILWAY

LOCATION

NR. PETERBOROUGH

## WANSFORD STATION

NVR's main station was used in multiple scenes, starting with the *Octopussy* circus departure from Karl-Marx-Stadt. It was also at Wansford that Bond drove the car onto the rails and started pursuing the train.

From the neighbouring bridge over Nene river, the Mercedes was catapulted into the water.

Wansford Station is located just next to the A1 North, below the town of Wansford, and is easily accessible. With a kiosk and cafe on site, it is the ideal starting point for any NVR trip.

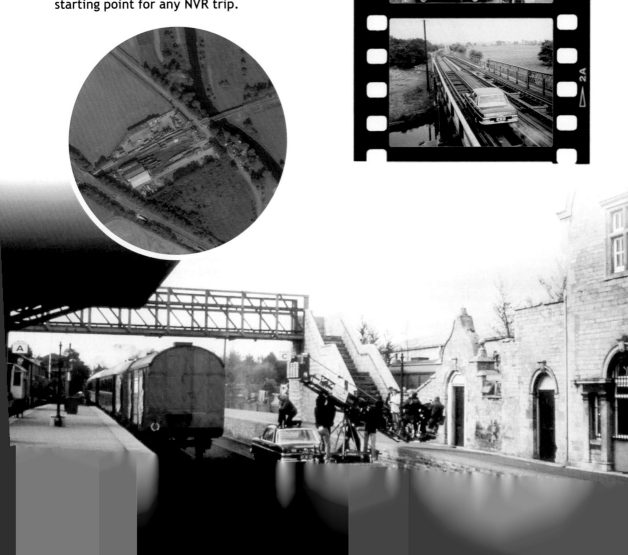

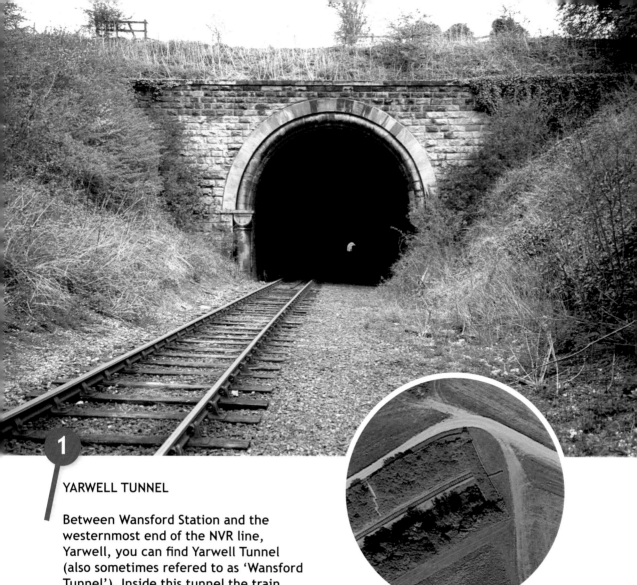

## YARWELL TUNNEL

**1**

Between Wansford Station and the westernmost end of the NVR line, Yarwell, you can find Yarwell Tunnel (also sometimes refered to as 'Wansford Tunnel'). Inside this tunnel the train carriages were switched in *Octopussy* and on the Yarwell side of the tunnel, depicted above, the gun fight took place between the soldiers and 007. Above the tunnel, the black Mercedes was parked.

Especially for the scenes, a wooden staircase was built next to the tunnel mouth. This no longer exists.

To access this location by rail, exit the NVR service at Yarwell and walk the footpath back towards Wansford. Do note you are not allowed to walk on the track and the area above the tunnel is on private property.

## CASTOR MILL LANE BRIDGE

In 1995's *GoldenEye*, the small bridge at Mill Lane below Castor became a massive Soviet tunnel. At this location, Alec Trevelyan's train exploded when it hit Bond's tank.

In the ditch that holds the tracks, Bond saved Natalya from the explosion.

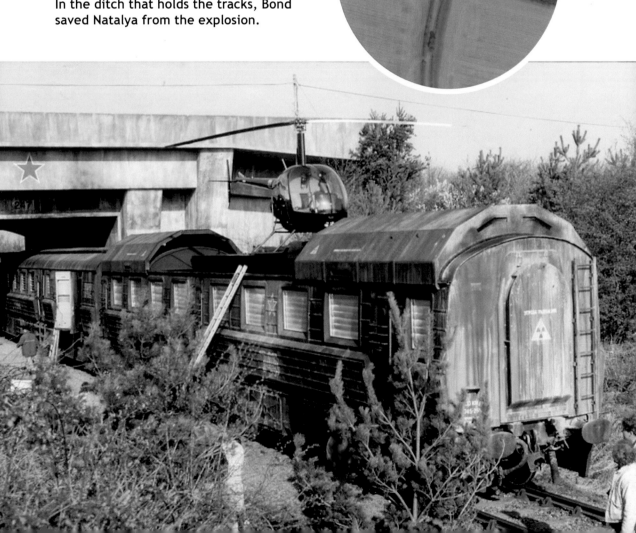

## OVERTON

Formerly known as Ferry Meadows, Overton Station can be seen in both *Octopussy* and *GoldenEye*. While in the latter one can mainly see the platform and (redressed) station building in a short scene in which the armoured train is passing by, the station saw most of its action in *Octopussy*.

The train yard on the opposite side is where General Orlov can be seen arriving at high speed, while General Gogol lands in his helicopter.

The tracks directly on the east side of the platform (towards Orton Mere) is where the border crossing was built. Here, Orlov is eventually shot by one of the border guards, just before Gogol arrives.

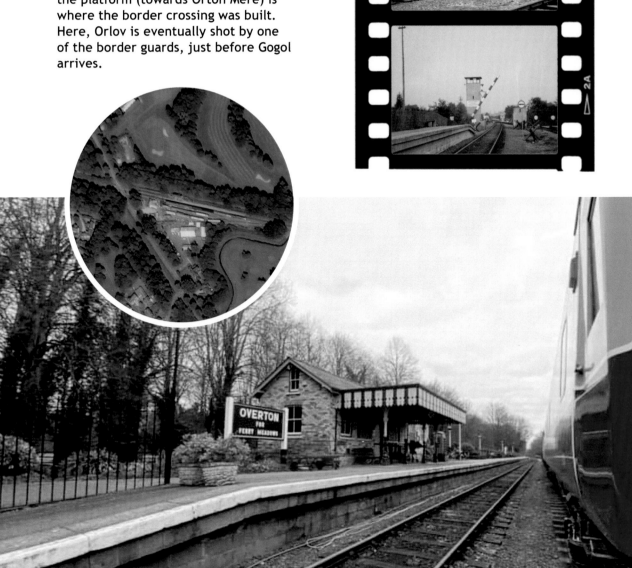

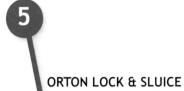

## 5 ORTON LOCK & SLUICE

Just a two minute walk from Orton Mere Station, on the north side of the track, you can find a lock and sluice in the River Nene.

Here, early on in *Octopussy*, Bond's colleague 009 is targeted by knife throwing twins Mischka & Grischka. He receives a knife in his back and falls into the river, all filmed here in 1982 at Orton Lock.

## 6 ORTON MERE

The train last stop before hitting Peterborough is Orton Mere, which can be seen in a short but important scene in *Octopussy*.

Bond pursues the train on the tracks in a car, when he passes Orton Mere Station, being stared at by ladies waiting for the train. It is here that a railroad employee in the signal box pulls a lever, switching Bond to the track next to the train.

Orton Mere Station has its own car park and is conveniently located next to the A1260 Nene Pkwy.

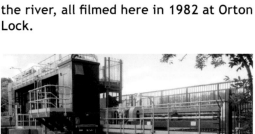

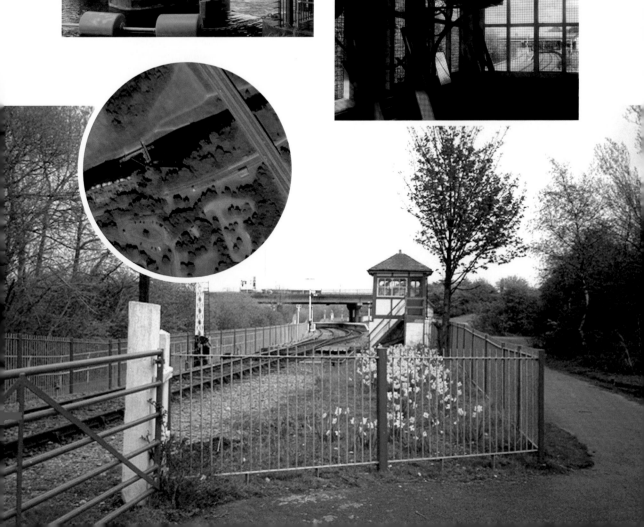

# 'A Scrapbook of Memories'

by Ian Davis

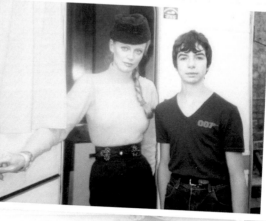

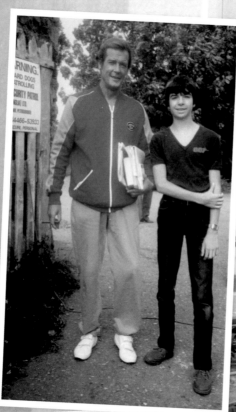

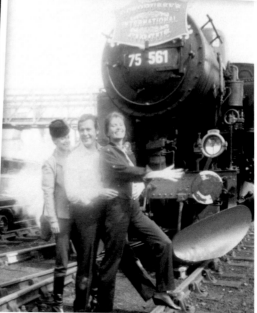

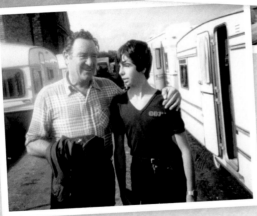

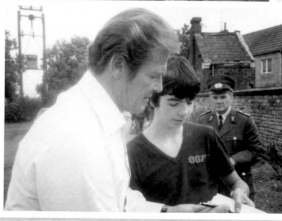

'OCTOPUSSY'

| CALL SHEET | | No. 16 | |
|---|---|---|---|

| PRODUCER: | CUBBY BROCCOLI | DATE: | MONDAY, 6TH SEPTEMBER '82 |
|---|---|---|---|
| DIRECTOR: | JOHN GLEN | UNIT CALL: | 07.30 Leave Hotel |
| EXECUTIVE PRODUCER: | MICHAEL WILSON | | 08.00 On Location |

LOCATION: NENE VALLEY RAILWAY
Wansford Station
Stibbington
Nr Peterborough

Contact: John Pentlow (Manager)
Tel: 0780 782854

| SET: | SCENE NOS: |
|---|---|
| EXT. KARL MARX STADT STATION Gate Area, Car Park & Platform | 595, 643, 596, 597, 598, 599, 626, 628, 629, 630, 631A, 642 DAY |

WEATHER COVER

| INT. TUNNEL | 633pt, 634, 635, 637, 638A, 638B, 638C, 638D, 638E, 641, 641A, 641B, 641C, 645A, 646, 655, 657, 680 DAY |
|---|---|

| ARTISTES | CHARACTER | P/UP | M/UP | ON SET |
|---|---|---|---|---|
| ROGER MOORE | JAMES BOND | - | 10.30 | 11.00 |
| MAUD ADAMS | OCTOPUSSY | 9.30 | 10.00 | 12.00 |
| LOUIS JOURDAN | KAMAL | 11.00 | 11.30 | 12.00 |
| KABIR BEDI | GOBINDA | 9.45 | 10.15 | 11.00 |
| STEVEN BERKOFF | ORLOV | 7.30 | 8.00 | 8.30 |
| KRISTINA WAYBORN | MAGDA | 8.00 | 10.00 | 12.00 |
| DAVID MEYER | TWIN 1 | Standby at Hotel | | |
| TONY MEYER | TWIN 2 | 9.45 | 10.15 | 11.00 |
| DERMOT CROWLEY | KAMP | Standby at Hotel | | |
| PETER ENSOR | KAMP ASSISTANT | Standby at Hotel | | |
| | | | | |
| SUZANNE JEROME | GWENDOLINE | | | |
| CHERIE GILLESPIE | MIDGE | | | |
| ALLISON WORTH | OCTOPUSSY GIRL | | | |
| JAN MICHELLE | " | | | |
| JONI FLYNN | " | | | |
| MARIE ELISE | " | 6.30 | 7.00 | 10.00 |
| LOUISE KING | " | | | |
| CHERYL ANN | " | | | |
| JANINE ANDREWS | " | | | |
| JULIE MARTIN | " | | | |
| MARY STAVIN | " | | | |
| TINA ROBINSON | " | | | |
| SAFIRA AFZAI | " | | | |
| CAMELLA THOMAS | " | | | |
| CAROLYN SEWARD | " | | | |
| CAROLE ASHBY | " | | | |
| HELENE HUNT | " | | | |
| GINA GIOVANNI | JUGGLER | | | |
| VERA FAWCETT | JUGGLER | | | |

| PRODUCER: | | FOR: | |
|---|---|---|---|
| | | ROGER MOORE | 7.30 leave Hotel |
| 1st ASST. | | MAUD ADAMS | |
| 2nd ASST. | | LOUIS JOURDAN | 8.00 on location |
| A.S. OTHER | | KABIR BEDI | |

| CROWD: | | | |
|---|---|---|---|
| 10 MEN | VOPOS | | |
| 15 MEN | SOLDIERS | | |
| 25 MEN | ROUSTABOUTS | | |
| 1 MAN | LUG DRIVER | 8.00 on location |
| 13 GIRLS | OCTOPUSSY GIRLS | | |
| 20 MIXED | PASSERSBY | | |

STUNT CO-ORDINATOR: BOB SIMMONS - 7.30 leave Hotel.

STUNT DOUBLE: ROCKY TAYLOR      FOR:
JAMES BOND - 7.30 leave Hotel

STUNT MEN: JIM DOWDALL      ORLOV'S CHAUFFEUR - 7.30 leave Hotel

ANIMALS:
Guard Dog and Handlers - 8.00 on location.
2 Chimpanzees with Handler 8.00 on location
6 Horses with Grooms - 8.00 on location
1 Elephant and Handler - 7.30 leave Hotel.

ACTION CARS:
Orlov's Car (Bond's Car)
Orlov's Command Car
Military Vehicles      To be available from
Circus Vehicles       8.00 as per the
                      Nene Valley Railway

TRAINS & CARRIAGES/BOX CAR

Circus Train
Lug
Jewellery Boxcar      To be available from 8.00 as per
Bomb Boxcar           the Nene Valley Railway
Armoured Car Train

PROPS:
Canister, Bond's Gun, Dummy Guns and actual for
soldiers, Vopos, 'Heavy's' with blanks, Circus
Props.

ART DEPT:
Big Top Circus Posters on side of Jewellery and
Bomb Boxcar, Steps for Jewellery Boxcar.

WARDROBE:
Twins Red Jacket for Bond, Protective overalls
for Unit Members who will be working in the
Tunnel.

PRODUCTION: Crane required on location, torches.

CAMERA: Car rigs.

SPECIAL EFFECTS:
Oxyacetylene Torch. Steam from Vacume pipes,
Wind Machine. Standby to give welding practice
to Tony Meyer.

ELECTRICAL: Practical lights in tunnel.

In the summer of 1982, I was 15 years old, I attended a Pinewood Studios Open Day with my family. In addition to visiting sets, I recall the war-room and others, the tour included workshops, in one the armoured cart was being constructed to a drawing which had the Nene Valley referred to. Long before the internet, we approached a local newspaper and learned the filming dates. Fortuitously, on the day we visited, most of the key cast and crew were there and we were even lucky enough to watch Kabir Bedi's scene moving between 2 carts being shot.

All the players were very welcoming, as my photographs show.

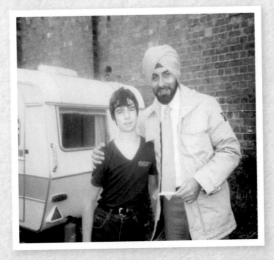

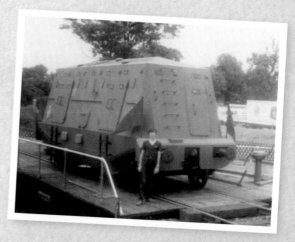

# THE END CREDITS

For a list of the Nene Valley Railway filming credits please see:
https://nvr.org.uk/article.php/17/filming-at-nvr

## IN MEMORIAM

The interviews conducted with those featured in this book took place between 2016 and 2020. Sadly, since then a number of those featured have passed away.

My sincere condolences go out to the family and friends of David Smith, Doreen Foster, Dave Martin, Olive Gladden and Mike Bratley (all NVR pioneers), as well as Paul Carrington and Tony Lawton who answered the call to arms to be extras in 1982.

## ACKNOWLEDGEMENTS

I am extremely grateful to everyone who shared their memories that feature throughout these pages. All the events discussed and recalled in this book are written to the best of my knowledge and to those interviewed. To all the now 'credited' extras and 'well-sung' volunteers featured, it was a pleasure and a privilege to help put your stories into print.

Whilst every effort has been taken to verify and present details accurately, if for any reason there are any corrections or amendments, I would be pleased to update them in a future edition. Likewise, if you were also involved in any of the Bond filming at the NVR or have a story or any details you would like to share, then please do get in touch.

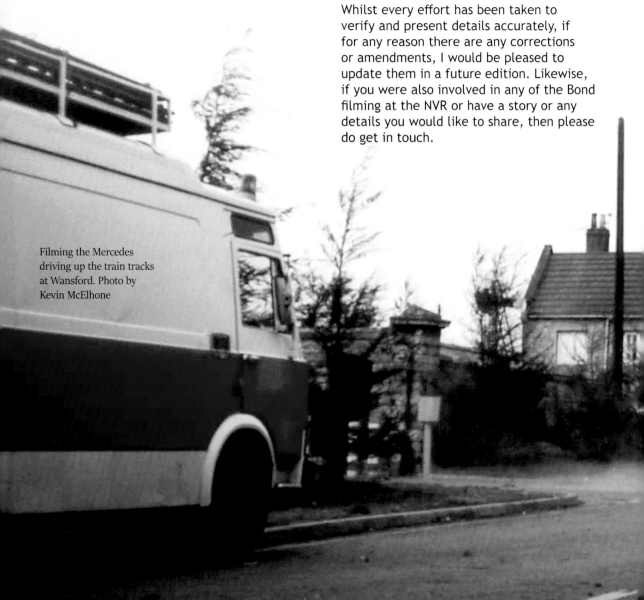

Filming the Mercedes
driving up the train tracks
at Wansford. Photo by
Kevin McElhone

The long running series of James Bond films made by EON Productions would not be possible without the award winning and award worthy talent responsible, both behind and in front of the cameras. I extend my gratitude to all at EON Productions and Danjaq LLC since 1962, and in particular the cast and crews of *Octopussy* (1983) and *GoldenEye* (1995).

In addition to those named throughout this book, I'm grateful to all those who have provided information, enthusiasm and or jogged my memory during the book's completion including: Anders Frejdh, Anthony Scotney, Ali Brudenell, Brian Dobson, Brian Sharpe, Chris Evans (not the actor, or radio presenter), Chris Johnson, Chris Wright, Clive Bassett, Darren Noble, Don Zuiderman, Frank Anderson, Fraser Lockley, Gary Bootle, Graham Malia, Ian Davis, Jamie Mitchell, Jason Carr, Jess & Ann DiCaprio, Jon Auty, John Warby, John Ward, Karen-Marie Pauls, Kieron Maughan, Lucy Noble, Nathan Foster, Mike Battams, Mina Hassani, Pete Brooker, Peter Waszak, Phil Latchford, Rebecca Andrews, Richard Neves, Rob Smith, Rory Couper, Sharon MacAllister, Simon Firth, Simon Gardner, Steve Spring, Steve Woodbridge, Terry Adlam, Tom Sears and Warren Ringham.

Special thanks for Martijn Mulder for his expertise, patience and support in bringing this book to fruition.

I am also indebted to all my friends and family for their encouragement over the years, my mother-in-law Kath who during the Octopussy shoot at RAF Northolt climbed onto the roof of Ruislip Gardens Primary School where she worked (just behind the airbase) in order to see the fake palm trees being put up, and above all to my wife Helen for her unfailing love and humour while I completed this little octobooky.

# BIBLIOGRAPHY

Fleming, Ian (2008), *The Penguin Collection* Boxed Set of 14, James Bond novels.

Benson, Raymond (1984), *James Bond – The Bedside Companion*, Galahad Books.

Gardner, John (1995), *GoldenEye. Novelisation*, Gildrose Publications/Hodder & Stoughton.

Chapman, James (2009), *Licence to Thrill: A Cultural History of the James Bond Films*, New York: I.B. Tauris.

Cork, John; Scivally, Bruce (2002), *James Bond: The Legacy*, Boxtree.

Cork, John; Stutz, Collin (2007), *James Bond Encyclopedia*, Dorling Kindersley.

Chancellor, Henry (2005), *James Bond: The Man and His World*, John Murray.

Darlington, Joseph (2013), *Being James Bond*, Sns Publishing

Duns, Jeremy (2014), *Diamonds in the Rough*, CreateSpace Independent Publishing.

Duncan, Paul (2012), *The James Bond Archive*s, Taschen.

Edlitz, Mark (2019), *The Many lives of James Bond.* Lyons Press

Field, Matthew & Chowdhury Ajay (2015), *Some Kind of Hero*, History Press UK.

Glancey, Jonathan (2012),*Giants of Steam: The Great Men & Machines of Rail's Golden Age*, Atlantic Books Ltd.

Glen, John (2015), *For My Eyes Only: Directing the James Bond Films*, Signum Books UK.

Gregan, John & Mace, Martin (2012), *Unearthing Churchill's Secret Army: The Official List of SOE Casualties and Their Stories*, Pen & Sword Books Ltd.

Hearn, Marcus & Barnes, Alan (2001), *Kiss Kiss Bang Bang – the unofficial James Bond film companion*, Overlook Press.

Hernu, Sandy (1999), *Q – the biography of Desmond Llewellyn*, S&B Publishing.

Hollis, Richard (1989), *James Bond: The official 007 Fact-File,* Hamlyn UK.

Hugill, J.A.C (2011), *The Hazard Mesh*, Faber & Faber.

Irwin, William (2006), *The Jedburghs: The Secret History of Allied Special Forces, France 1944*, PublicAffairs

Lamont, Peter (2016), *The Man with the Golden Eye: Designing the James Bond Films*, Signum Books UK.

Lycett, Andrew (1995), *Ian Fleming: The Man who created James Bond 007*, Phoenix mass market p/b.

Moore, Roger (2012), *Bond on Bond,* Michael O'Mara Books.

Macintyre, Ben (2008), *For Your Eyes Only*, Bloomsbury Publishing.

O'Connell, Mark (2012), *Catching Bullets – Memoirs of a Bond Fan*, Splendid Books.

Parker, Matthew (2015), *Goldeneye – Where Bond was Born: Fleming's Jamaica*, Penguin Random House UK.

Pearson, John (2008), *James Bond: The Authorized Biography*, Random House UK.

Pfeiffer, Lee; Worrall, Dave (1998), *The Essential Bond*, Boxtree.

Rankin, Nicholas (2011), *Ian Fleming's Commandos: The Story of 30 Assault Unit in WWII*, Faber & Faber.

Rhodes, John (1983), *The Nene Valley Railway*, Turntable Publications.

Rye, Graham (1999), *The James Bond Girls*, Boxtree.

Roger Moore checking the details with continuity lady Elaine Schreyeck at Wansford. Photo courtesy of Steve Woodbridge

Maud Adams posing in between takes. Photo courtesy of Steve Woodbridge

BS - #0019 - 050224 - C192 - 260/185/13 - PB - 9789083338705 - Gloss Lamination